VISITO

SILENT
CITIES
IN FLANDERS FIELDS

www.lannoo.com

TEXTS BOOK AND GUIDE Loesje Corremans, Luc Corremans, Wayne Evans, Pierre Vandervelden
PICTURES Annemie Reyntjens
COVER Studio Lannoo
LAY-OUT AND PREPRESS Keppie & Keppie

Not to be sold separately.

© Uriel Publishers, Rumst, Belgium, 2013
Special licence publication Lannoo Publishers nv, Tielt, Belgium, 2013
D/2013/45/496
ISBN 978 94 014 0857 8

WAYNE EVANS PIERRE VANDERVELDEN
LUC CORREMANS

VISITOR'S GUIDE

SILENT CITIES

IN FLANDERS FIELDS

YPRES SALIENT & WEST FLANDERS
WORLD WAR I CEMETERIES

VISITOR'S GUIDE
ACCOMPANYING THE BOOK

 LANNOO

PREFACE

'The Great Carnage'. There is not an epithet more suitable to conjure up the First World War than this one. Indeed, never before 1914 had 9 million soldiers died in an armed conflict between two alliances. 500,000 of them fell in the Westhoek, in what has become known as Flanders Fields. Among them were approximately 195,000 Commonwealth soldiers, from the United Kingdom, Canada, Australia, New Zealand, South Africa and India.

After the war, the Imperial War Graves Commission (IWGC), whose name would later change to Commonwealth War Graves Commission, was faced with two options. One option was to repatriate the bodies of the fallen Commonwealth soldiers

and bury them in their native villages. However, the IWGC chose the other option, which would see her soldiers buried near the battlefields. They were all laid to rest in rows of identical white standing tombstones.

Tyne Cot Cemetery in Zonnebeke, which like all other war cemeteries is meticulously attended to by the Commonwealth War Graves Commission, is the largest military burial site on the continent. It justly occupies a prominent place in the 'Silent cities in Flanders Fields' reference book, which covers all World War I cemeteries in West Flanders with at least one identified tomb.

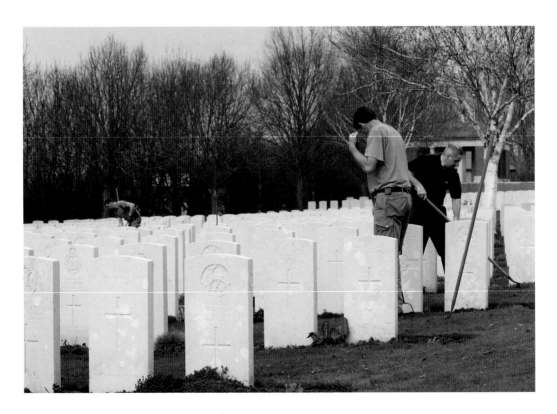

It is the first time that the history of 231 tiny and large war cemeteries around Ypres, in the Westhoek and the rest of West Flanders has been recorded, spanning the alphabet from 'Abeele Aerodrome Cemetery' to the Zillebeke cemetery.

Although the Commonwealth cemeteries receive the largest coverage, the authors also describe ten Belgian and four German war cemeteries, the only American war cemetery (situated in Waregem) and the French cemetery of Saint-Charles-de-Potyze, both in text and in over 1,000 pictures.

Nothing would have come of this Herculean task without the vast digitized archives on 3,569 World War I and II Commonwealth war cemeteries kept by the publication's co-author Pierre Vandervelden.

It highlights over 500 tombs of special interest, interspersed with the narration of the lives and last hours of illustrious soldiers, such as the Irish poet Ledwidge and his Welsh colleague Hedd Wyn, who died together in the Battle of Passchendaele, which adds to the dynamism of this carefully illustrated work.

This work of reference is bound to meet a lot of interest from abroad. For the next of kin of the fallen Commonwealth soldiers in particular, this publication may serve as a guide to the resting place of their beloved forebears.

The publication highly contributes to the commemoration project which in my capacity as Flemish Minister for Tourism and Immovable Heritage I have the honour to coordinate. At the heart of it are the war relics, among which the cemeteries, so prominent in Flanders and West Flanders in particular.

The words spoken by King George V in 1922 at the occasion of his visit to West Flanders have lost nothing of their power. "In the course of my pilgrimage, I have many times asked myself whether there can be more potent advocates of peace upon Earth through the years to come, than this massed multitude of silent witnesses to the desolation of war."

The landscape which was shaped by the battlefields of the First World War, indeed conveys the "No more war" message and is an invitation to tolerance and lasting peace among the nations.

'Silent cities in Flanders Fields' helps to drive home these intentions.

Geert Bourgeois
Vice-Minister-President of the Government of Flanders

COMMONWEALTH WAR GRAVES COMMISSION

The Commonwealth War Graves Commission (previously Imperial War Graves Commission) is currently responsible for the continued commemoration of 1.69 million deceased Commonwealth military service members in 150 countries. Since its inception, the Commission has constructed approximately 2,500 war cemeteries and numerous memorials. The Commission is currently responsible for the care of war dead at over 23,000 separate burial sites and the maintenance of more than 200 memorials worldwide. In addition to commemorating Commonwealth military service members, the Commission maintains, under arrangement with applicable governments, over 40,000 non-Commonwealth war graves and over 25,000 non-war military and civilian graves. The vast majority of burial sites are pre-existing communal cemeteries located in the United Kingdom. The Commission has also constructed or commissioned memorials to commemorate the dead who have no known grave; the largest of these is the Thiepval Memorial in France.

The Commonwealth War Graves Commission only commemorates those who have died during the designated war years, while in Commonwealth

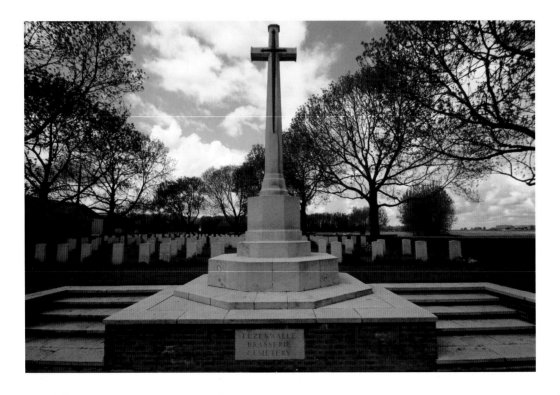

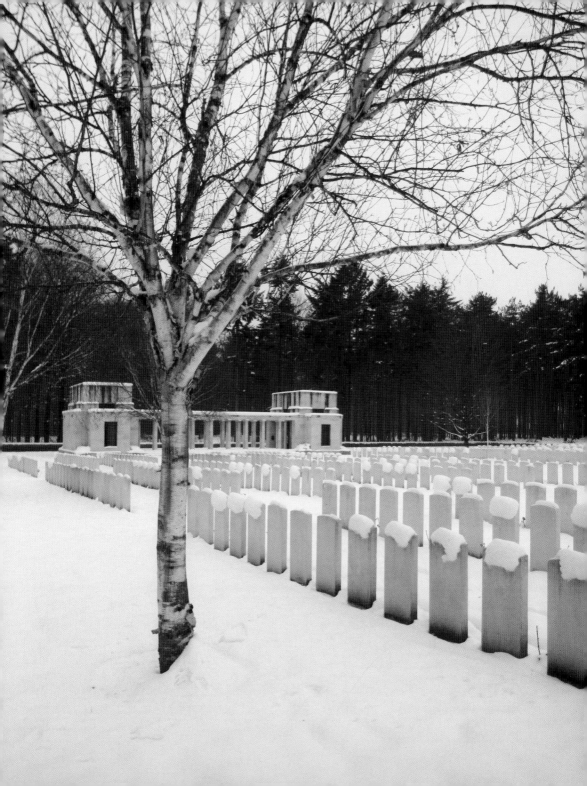

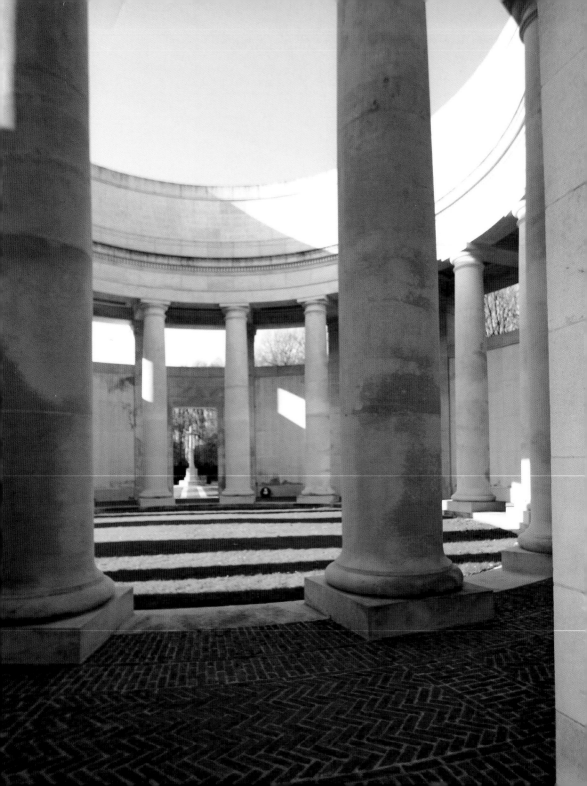

military service or of causes attributable to service. The applicable periods of consideration are August 4 1914 to August 31 1921 for the First World War, and September 3 1939 to December 31 1947 for the Second World War.

THE HIGHEST STANDARDS

The Commonwealth War Graves Commission owes its existence to the vision and determination of one man, Sir Fabian Ware. Under his supervision, the Commission set the highest standards for all its work. Three of the most eminent architects of the day, Sir Edwin Lutyens, Sir Herbert Baker and Sir Reginald Blomfield, were chosen to begin the work of designing and constructing the cemeteries and memorials. Rudyard Kipling was tasked, as literary advisor, with advising on inscriptions. Ware asked Sir Frederic Kenyon, the Director of the British Museum, to interpret the different approaches of the principal architects. The report he presented to the Commission in November 1918 emphasised equality as the core ideology, outlining the principles the Commission abides by today. As reports of the grave registration work became public, the commission began to receive letters of enquiry and requests for photographs of graves from relatives of deceased soldiers.

In March 1915, the commission, with the support of the Red Cross, began to dispatch photographic prints and useful location information in answers to the requests. The Graves Registration Commission became the 'Directorate of Graves Registration and Enquiries' in the spring of 1916 in recognition of the fact that the scope of work began to extend beyond simple grave registration, and began to include responding to enquiries from relatives of those killed. The directorate's work was also extended beyond the Western Front and into other theatres of war, with units deployed in Greece, Egypt and Mesopotamia. Once land for cemeteries and memorials had been guaranteed, the enormous task of recording the details of the dead could begin.

TWO KEY ELEMENTS

By 1918, some 587,000 graves had been identified and a further 559,000 casualties were registered as having no known grave. A committee under Frederic Kenyon presented a report in November 1918 on how the cemeteries should be developed. Two key elements of this report were that bodies should not be repatriated and that uniform memorials should be used to avoid class distinctions. Beyond the logistical nightmare of returning home so many corpses, it was felt that repatriation would conflict with the feeling of brotherhood that had developed between all serving ranks. Both of these issues generated considerable public discussion, which eventually led to a heated debate in Parliament on May 4 1920.

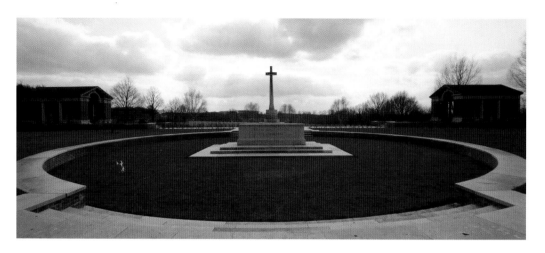

The matter was settled with Kenyon's proposal being accepted. At the end of 1919, the Commission had spent £ 7,500, and this figure rose to £ 250,000 in 1920 as construction of cemeteries and memorials increased. 4,000 headstones a week were being sent to France in 1923. In 1927, when the majority of construction had been completed, over 500 cemeteries had been built, with 400,000 headstones and 1,000 Crosses of Sacrifice. In many cases small cemeteries were closed and the graves concentrated in larger ones.

WESTMINSTER ABBEY

The cemetery building and grave concentration program was completed in 1938, just before the outbreak of the Second World War. With the increased number of civilian casualties in World War II, compared with the First World War, Winston Churchill agreed to Fabian Ware's proposal that the Commission also maintain a record of Commonwealth civilian war deaths. This book, containing the names of nearly 67,000 men, women and children, has been kept in Westminster Abbey since 1956.

When the war began turning towards the Allied Forces, the Commission was able to begin restoring its 1914-1918 cemeteries and memorials to their pre-war standard. So too, it began the task of commemorating the 600,000 Commonwealth casualties from the Second World War. In 1949, the Commission completed Dieppe Canadian War Cemetery, the first of 559 new cemeteries and 36 new memorials. Eventually, over 350,000 new headstones were erected. The wider scale of the Second World War, coupled with manpower shortages and unrest in some countries, meant that the construction program was not completed until the 1960s.

SAT NAV

See **www.poigraves.co.uk** for the exact location of all Commonwealth cemeteries of World War I.

www.inmemories.com is dedicated to the continued memory of those men and women of the Commonwealth who died as a result of the World Wars.

<div align="center">

PART 1

YPRES - ZONNEBEKE

</div>

AEROPLANE CEMETERY

— **YPRES**

Aeroplane Cemetery is located 3.5 km north east of Ypres town centre on the Zonnebeekseweg. From the Ypres market square take Korte and Lange Torhoutstraat onto the small roundabout, then go right into Basculestraat, at the crossroads turn left into Zonnebeekseweg. As indicated, the cemetery is 3.5 km on your right hand side, just beyond the French cemetery. Easy access and parking, also at the garden centre across the street.

IDENTIFIED COMMONWEALTH HEROES

 317 17 15 119 1

 GRAVES OF INTEREST (P. 12)

Thompson, Shot at Dawn, II A 6
Robinson, Shot at Dawn, II A 7
Hartells, Shot at Dawn, II A 8

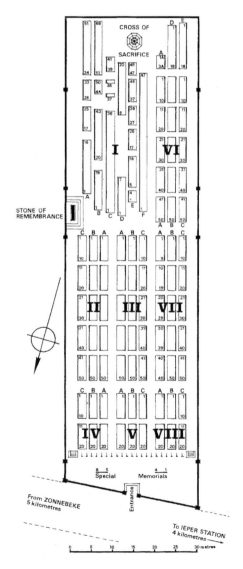

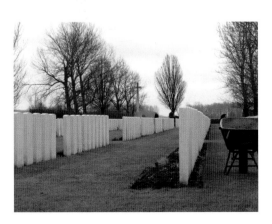

ARTILLERY WOOD CEMETERY

— BOEZINGE (YPRES)

Boezinge is part of Ypres, its location about 4 km north of that city. In Ypres, take the N369 in the direction of Diksmuide, then to the right into Brugstraat. Go to the end of Brugstraat over the bridge and straight on along Molenstraat. The cemetery is located on Poezelstraat, which is the second turning on the right after the bridge. Artillery Wood Cemetery can be seen on the right hand side of the road, about 200 m from the junction with Molenstraat.

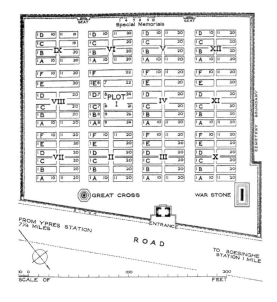

IDENTIFIED COMMONWEALTH HEROES

 783 17 1

 GRAVES OF INTEREST (P. 14-17)

Hornblow, I A 24

Francis Ledwidge, II B 5

Hedd Wyn (E.H. Evans), II F 11

Henry Evans, II F 20

Jones, VI B 18

Lynam, X C 18

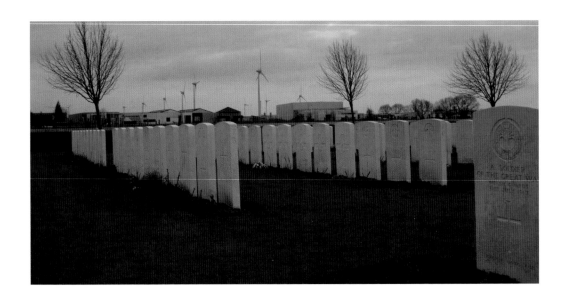

BARD COTTAGE CEMETERY

— BOEZINGE (YPRES)

The village of Boezinge is part of Ypres. Bard Cottage Cemetery is located on the Diksmuidseweg (N369) in the direction of Ypres. From Ypres railway station turn left into Fochlaan and drive to the roundabout, then turn right to the next roundabout. Turn left here and drive to the third roundabout, where you turn to the right (Oude Veurnestraat). Then take the second turning on the left, which is the Diksmuidseweg, and go further under the motorway bridge. Bard Cottage Cemetery, designed by Sir Reginald Blomfield, is another 300 m on the left hand side of the road. It is the first cemetery you see, the second being Talana Farm Cemetery.

IDENTIFIED COMMONWEALTH HEROES

 1583 15 2

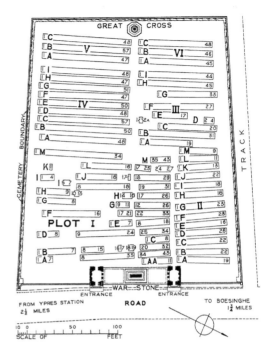

GRAVES OF INTEREST (P. 18-19)

Davie, III C 3

Whyte, IV F 17

Noble, IV I 32

Rev. Wilks, V A 1

Skirrow, VI A 45

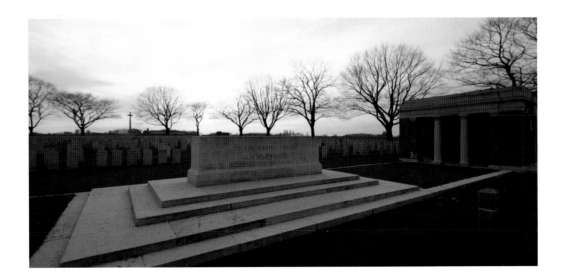

BEDFORD HOUSE CEMETERY

— ZILLEBEKE (YPRES)

Zillebeke is part of Ypres, and Bedford House Ceme-
tery is located 2.5 km south east of Ypres town cen-
tre. The cemetery lies on the Rijselseweg (N336), the
road connecting Ypres to Armentières. From Ypres
town centre the Rijselstraat runs from the market
square, through the Lille Gate (Rijselsepoort) and
directly over the crossroads with the Ypres ring road.
The road name then changes into Rijselseweg. The
cemetery itself is located 2 km after this crossroads,
on the left hand side of the Rijselseweg.

IDENTIFIED COMMONWEALTH HEROES

 1826 218 17 122

 3 8

GRAVES OF INTEREST (P. 22-25)

Craddock, Encl. 2, I E 26
Private Peaceful, Encl. 2, IV A 26
Murray, Encl. 2, IV C 42
Heartfield, Encl. 2, VI A 93
Hallowes, VC, Encl. 2, XIV B 36
Patmore, Encl. 4, I D 1
Thompson, Encl. 4, I G 13
Clingersmith, Encl. 4, I R 5
Reidler, Encl. 4, III L 10
Turner, Encl. 4, IV A 18
Matthews, Encl. 4, V B 1
Vyvian, Encl. 4, Mem. 3

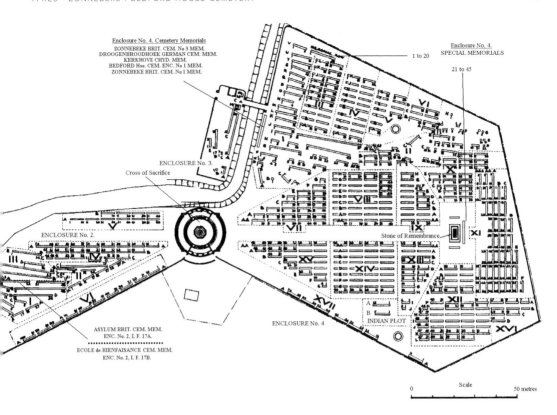

Enclosure No. 4. Cemetery Memorials
ZONNEBEKE BRIT. CEM. No 3 MEM.
DROOGENBROODHOEK GERMAN CEM. MEM.
KERKHOVE CHYD. MEM.
BEDFORD Hse. CEM. ENC. No 1 MEM.
ZONNEBEKE BRIT. CEM. No 1 MEM.

Enclosure No. 4.
SPECIAL MEMORIALS

1 to 20

21 to 45

ENCLOSURE No. 3.
Cross of Sacrifice

ENCLOSURE No. 2.

Stone of Remembrance.

INDIAN PLOT

ENCLOSURE No. 4

ASYLUM BRIT. CEM. MEM.
ENC. No. 2, I. F. 17A.
ECOLE de BIENFAISANCE CEM. MEM.
ENC. No. 2, I. F. 17B.

Scale

0 50 metres

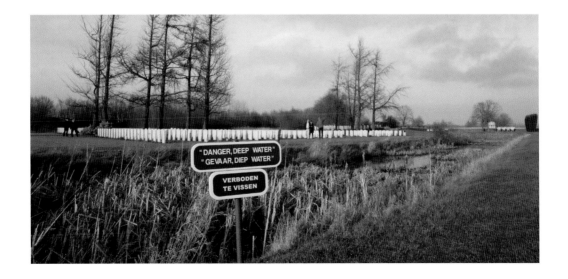

"DANGER, DEEP WATER"
"GEVAAR, DIEP WATER"

VERBODEN
TE VISSEN

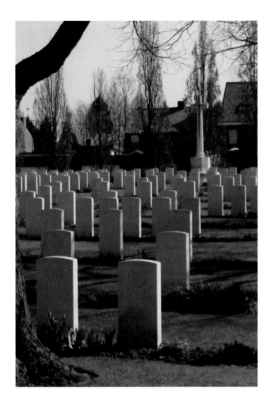

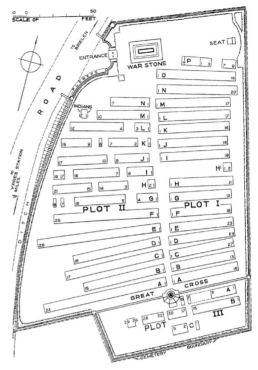

BELGIAN BATTERY CORNER CEMETERY

— YPRES

Belgian Battery Corner Cemetery is located 2 km south west of Ypres town centre, on a road called Omloopstraat, a road leading from the Dikkebusseweg. From Ypres town centre the Dikkebusseweg is reached via Elverdingestraat, straight over a roundabout onto Capronstraat, then left along Fochlaan. Immediately after the train station, the first right hand turning is Dikkebusseweg. 1.5 km along Dikkebusseweg is the right hand turning onto Frezenbergstraat. 200 m further on the right hand side is Omloopstraat. The cemetery is located immediately on the right hand side of Omloopstraat.

IDENTIFIED COMMONWEALTH HEROES

 426 7 8 123

GRAVES OF INTEREST (P. 26)

 Marchment, II I 9

Dhani Ram and Kirpa, two Hindu soldiers

SAT NAV

See **www.poigraves.co.uk** for the exact location of all Commonwealth cemeteries of World War I.

www.inmemories.com is dedicated to the continued memory of those men and women of the Commonwealth who died as a result of the World Wars.

BIRR CROSS ROADS CEMETERY

— ZILLEBEKE (YPRES)

Zillebeke is part of Ypres and is situated appr. 2 km south east of that town. Birr Cross Roads Cemetery, designed by Sir Edwin Lutyens, is located 3 km east of Ypres town centre, on the Meenseweg (N8), connecting Ypres to Menen. From Ypres town centre the Meenseweg is located via Lange and Korte Torhoutstraat and right onto Basculestraat. Basculestraat ends at a main crossroads, directly over which begins Meenseweg. Birr Cross Roads Cemetery is located 2.5 km along the Meenseweg on the right hand side of the road.

IDENTIFIED COMMONWEALTH HEROES

 372 4 9 112

 GRAVES OF INTEREST (P. 32-33)

Jago, II B 18

De Wattine, Spec. Mem.

Ackroyd, VC, Spec. Mem. 7

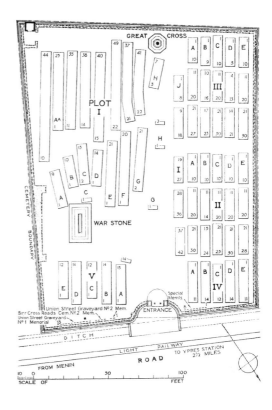

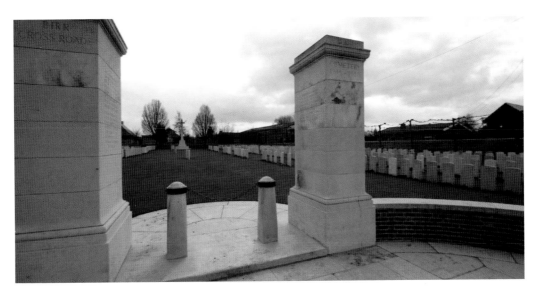

BLAUWEPOORT FARM CEMETERY

— ZILLEBEKE (YPRES)

Zillebeke is part of Ypres. The village is situated appr. 2 km south east of Ypres. Blauwepoort Farm Cemetery is located 3 km south east of Ypres town centre, on a single track road leading from the Komenseweg (connecting Ypres to Komen), N336. From Ypres town centre the Komenseweg is located via the Rijselstraat, through the Rijselsepoort (Lille Gate) and crossing the Ypres ring road, towards Armentières and Lille. The road name then changes to Rijselseweg. 1 km along the Rijselseweg lies the left hand turning onto Komenseweg. After 2 km turn right towards house number 34 Komenseweg; Blauwepoort Farm Cemetery is a further 500 m down this track.

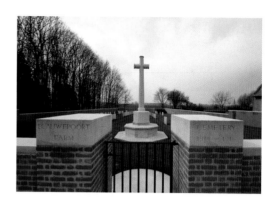

IDENTIFIED COMMONWEALTH HEROES

 82

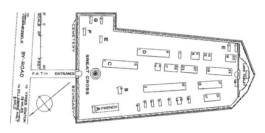

BLEUET FARM CEMETERY
— ELVERDINGE (YPRES)

Elverdinge is part of Ypres. The town is located 8 km north west of Ypres. From Ypres take the N8, Veurnseweg, this is the road that goes in the direction of Veurne. After appr. 3 km, go to the right at the traffic lights and then turn right (Steenstraat). After 50 meters take Boezingestraat to the right. Bleuet Farm Cemetery, designed by Sir Reginald Blomfield, can be found 500 metres along this street on the left hand side.

IDENTIFIED COMMONWEALTH HEROES

 445 2

 GRAVES OF INTEREST (P. 35)
Colley, II B 20
Storey, II C 2

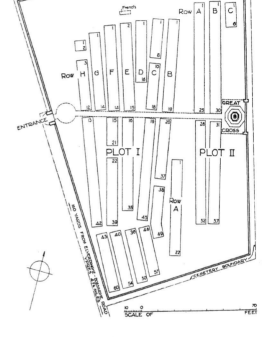

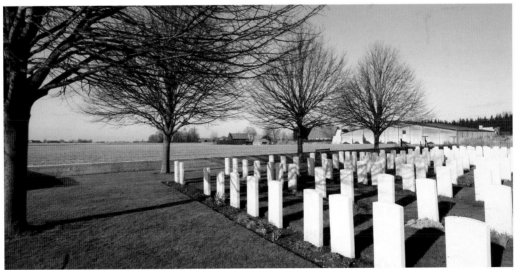

BOEZINGE CHURCHYARD

— BOEZINGE (YPRES)

Boezinge is part of Ypres and is located appr. 6 km
north of that town, on the N369 road in the direction
of Diksmuide (Dixmude). The churchyard is in the
centre of the village, on the south side of the main
road.

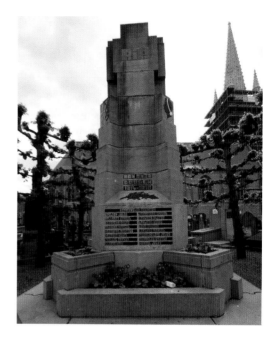

IDENTIFIED COMMONWEALTH HERO

 1

 GRAVES OF INTEREST (P. 34)
E F M Urquhart, I A 1

B&B @ ROOM'S

Having a surname like she did, it seems like Nancy Room had
a predisposition to become the hostess of a B&B. In 2011,
her dream became true. Together with her husband Dirk, she
bought a stately town house at Ypres, in the heart of Flanders
Fields and close to all the World War I places of interest.

@ Room's is located in the Pennestraat, within walking distance
(400 m) of both the Market Square and the Menin Gate.

This extremely stylish B&B offers you two guest rooms with a
brand new, timeless interior.

B&B @ ROOM'S

Pennestraat 90 - 8900 Ypres
Tel: +32 (0)57 36 39 69
E-mail: info@rooms-ieper.be
www.at-rooms-ieper.be

BRANDHOEK MILITARY CEMETERY

— VLAMERTINGE (YPRES)

Vlamertinge is part of Ypres and is located appr. 3 km west of that town. Brandhoek Military Cemetery is 6.5 km west of Ypres town centre. Follow the road indicated in the presentation of Brandhoek New Military Cemetery, until the Grote Branderstraat (Ypres). The cemetery is located 300 m along this street, on your left hand side, beyond the N38 dual carriageway, which you have to cross.

IDENTIFIED COMMONWEALTH HEROES

 598 63 4

BRANDHOEK NEW MILITARY CEMETERY NO. 3

— VLAMERTINGE (YPRES)

Vlamertinge is part of Ypres and is located appr.
3 km west of that town. Brandhoek New Military
Cemetery No. 3 is located 6.5 km west of Ypres town
centre. Follow the road indicated in the presentation
of Brandhoek New Military Cemetery. This cemetery
is also along the Zevekotestraat, on the left hand
side of the road.

IDENTIFIED COMMONWEALTH HEROES

 850 54 18 46 5

 GRAVES OF INTEREST (P. 37)

Bahgate, II B 10

Eberli, II D 1

Strutt, IV A 5

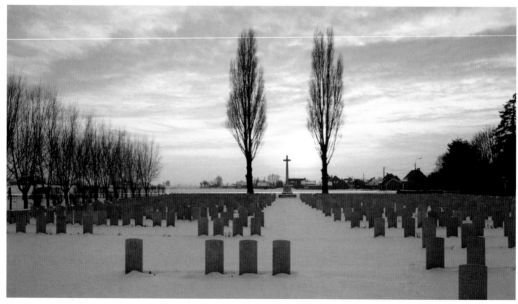

BRANDHOEK NEW MILITARY CEMETERY

— VLAMERTINGE (YPRES)

Vlamertinge is part of Ypres and is located appr. 3 km west of that town, Brandhoek being a hamlet belonging to Vlamertinge. Brandhoek New Military Cemetery is located 6.5 km west of Ypres town centre, on the Zevekotestraat, a road leading from the N308 connecting Ypres to Poperinge. From Ypres town centre, this N308 (Poperingseweg) is reached via Elverdingestraat, then directly over two small roundabouts into Capronstraat. The Poperingseweg is a continuation of the Capronstraat and begins after a prominent railway level crossing. 6 km along the N308, after passing the village of Vlamertinge and just beyond the church in Brandhoek, take the left hand turning onto the Grote Branderstraat. After crossing the N38 Westhoekweg, the first right hand turning leads onto the Zevekotestraat. The cemetery is located 300 m along the Zevekotestraat on the right hand side of the road, beyond the N38 dual carriageway, which you have to cross. 28 Germans are buried here.

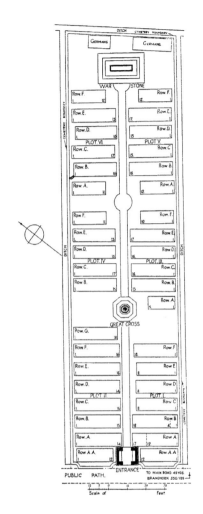

IDENTIFIED COMMONWEALTH HEROES

 512 6 11 1

GRAVES OF INTEREST (P. 38)

Chavasse, VC and Bar, III B 1

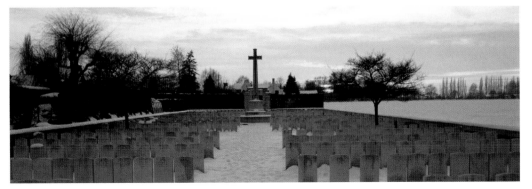

BUFFS ROAD CEMETERY

— SINT-JAN (YPRES)

Sint-Jan is part of Ypres, situated appr. 2 km north east of that town. From the Ypres station turn left and drive along Fochlaan to the roundabout, then turn right and go to the next roundabout. Here turn left into Haiglaan and drive to the next roundabout. Turn right into Oude Veurnestraat, this then changes into Diksmuidseweg and Brugseweg. Drive along this road and continue straight over the traffic lights to the end of the road. At the T junction turn left (still Brugseweg) and continue along this road to the village of Sint-Jan (N313). Follow this road to the end. At the junction with the N38, go straight across this junction into Hogeziekenweg. After 50 m the road bends sharply to the left. Buffs Road Cemetery, designed by A.J.S. Hutton, is about 150 m after the bend, on your right hand side.

IDENTIFIED COMMONWEALTH HEROES

 198 4 1

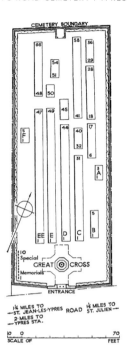

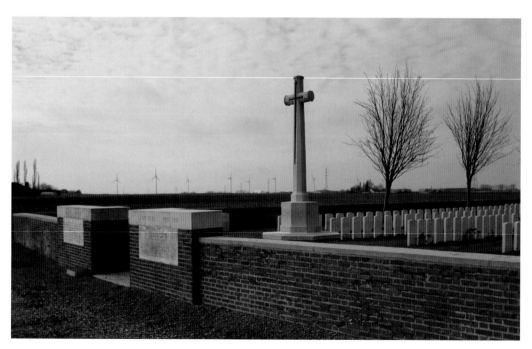

BUS HOUSE CEMETERY

— VOORMEZELE (YPRES)

Voormezele is part of Ypres and is located south of that town. Bus House Cemetery is located 4 km south of Ypres town centre, on the Sint-Elooisweg, a road leading from the Rijselseweg (N365 Ypres-Armentières). 4 km along the Rijselseweg, the road forks and branching immediately from the right hand fork is Sint-Elooisweg. Bus House Cemetery lies 500 m along Sint-Elooisweg on the left hand side of the road towards Voormezele.

IDENTIFIED COMMONWEALTH HEROES

 183 1 10

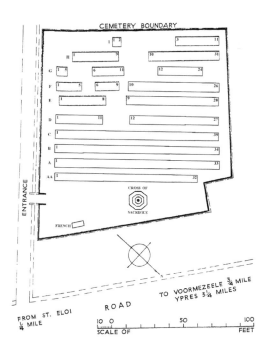

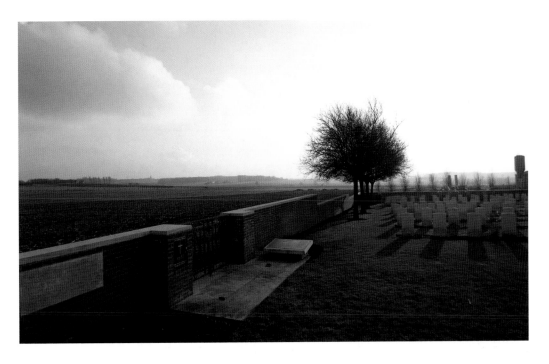

BUTTES NEW BRITISH CEMETERY, POLYGON WOOD

— ZONNEBEKE

GRAVES OF INTEREST (P. 45)

Scott, II A 12

Zonnebeke is a town east of Ypres. Buttes New British Cemetery is located 8 km east of Ypres town centre on the Lange Dreve, a road leading from the Meenseweg (N8) connecting Ypres to Menen. From Ypres town centre the Meenseweg is located via Lange and Korte Torhoutstraat and right onto Basculestraat. Basculestraat ends at a main crossroads; directly over this crossroads begins Meenseweg. 4.5 km along Meenseweg, after the Bellewaerde theme park, lies the left hand turning onto Oude Kortrijkstraat. 2 km along the Oude Kortrijkstraat the road crosses the A19 motorway, and immediately after this bridge is the left hand turning onto Lotegatstraat, which borders Polygon Wood. 800 m along Lotegatstraat is the right hand turning onto Lange Dreve. Buttes New British Cemetery, Polygon Wood is located 1 km along the Lange Dreve on the right hand side of the road.

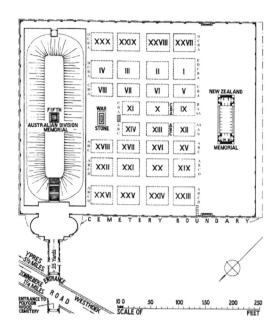

IDENTIFIED COMMONWEALTH HEROES

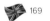 169 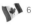 6 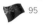 95 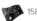 158

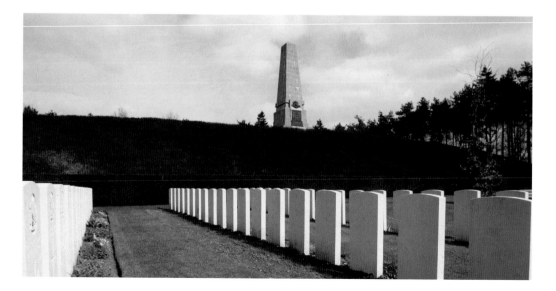

DÉCOUVERTE

Restaurant Découverte is located right in the centre of Ypres, in the Rijselstraat, the street running from the main square to the Lille Gate. Thousands of soldiers marched through this street during World War One.

Découverte is really a bon viveur's treat, an intimate and comfortable dining experience, with a flavourful, well-judged menu of classics and new discoveries.

Visitors of Ypres and the battlefields and cemeteries of the Ypres Salient really should experience this cosy restaurant offering excellent home-made fare.

DÉCOUVERTE

Rijselstraat 43 - 8900 Ieper
Tel: +32 (0) 57 48 92 48
or +32 (0) 472 611 294
E-mail: resto.decouverte@hotmail.com
 www.decouverte-ieper.be

CANADA FARM CEMETERY

— ELVERDINGE (YPRES)

Elverdinge is part of Ypres. Location: 8 km north west of Ypres. From Ypres take Elverdingestraat, then turn to the right onto Haiglaan, Veurnseweg (N8). At Elverdinge take the N333 Steentjesmolen-straat, and 2 km further the Elzendammestraat. The cemetery is 1 km on the right hand side of the road.

IDENTIFIED COMMONWEALTH HEROES

 898 9

 GRAVES OF INTEREST (P.48-49)

Davies, VC, II B 18

Fair, II C 1

Tennant, II D 1

Lutyens, III G 3

Carruthers, VII A 38

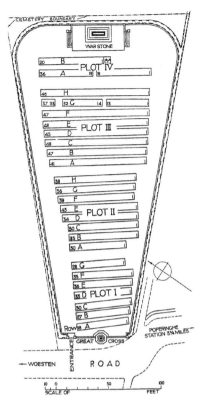

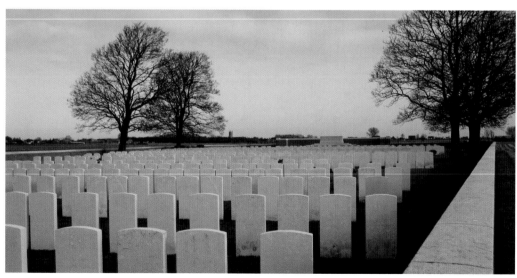

CHESTER FARM CEMETERY

— ZILLEBEKE (YPRES)

Zillebeke is part of Ypres, it is located appr. 2 km south east of that town. Leave Ypres through the Lille Gate (Rijselsepoort) and cross the Ypres ring in the direction of Armentières and Lille. The road then takes the name of Rijselseweg and after 1 km turns left into Komenseweg. A further 2.3 km on the right is the turn onto Vaartstraat; the cemetery is 1.5 km along this road, on your right hand side.

IDENTIFIED COMMONWEALTH HEROES

 305 87 21

 GRAVES OF INTEREST (P. 51)

Carlos, I K 36
Barnes, II AA 1A
Taylor, II AA 1B

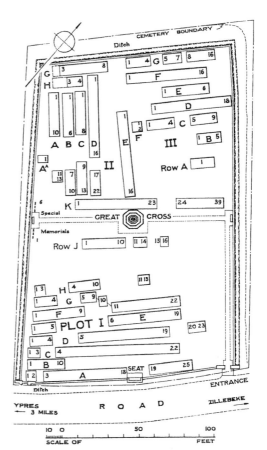

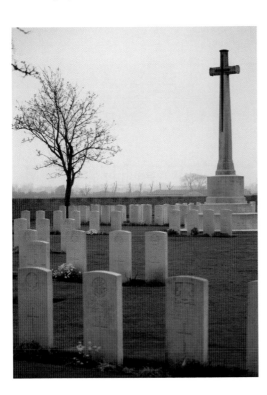

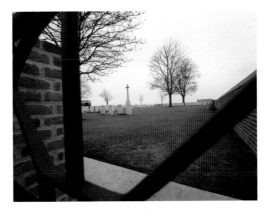

COLNE VALLEY CEMETERY

— BOEZINGE (YPRES)

Boezinge is part of Ypres and is located appr. 4 km north of that town, on the N369 road in the direction of Diksmuide. Colne Valley Cemetery is located in Kleinepoezelstraat east of the village. From the N369 turn right into Brugstraat, go over the bridge and then turn right into Langemarkseweg. Go further onto the crossroads and turn right into Kleine Poezelstraat. The cemetery is 500 m further, on the right hand side of the road.

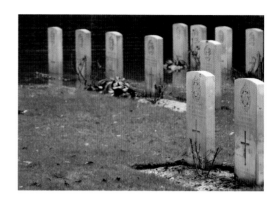

IDENTIFIED COMMONWEALTH HEROES

 43

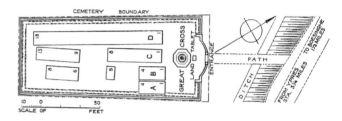

DICKEBUSCH NEW MILITARY CEMETERY

— DIKKEBUS (YPRES)

Dikkebus is part of Ypres and is located appr. 4 km south west of that town, on the road to Bailleul. From Ypres town centre, the Dikkebusseweg (N375) is reached via Elverdingestraat, straight over a roundabout onto Capronstraat, then left along Fochlaan.

Dikkebusseweg is to be found immediately after the train station. On reaching the village of Dikkebus, the cemetery is located on the Kerkstraat, which is a small street turning left off Dikkebusseweg. 200 metres along this street, and just beyond the village church, lies the cemetery. Dickebusch New Military Cemetery Extension faces it, on the other side of the road.

IDENTIFIED COMMONWEALTH HEROES

 521 84 11

 GRAVES OF INTEREST (P. 53-54)
Fox, Shot at Dawn, D 15
Amos, H 15
Cyril and **Horace Hill**, J 28 and J 29
Sterling, D 28

DICKEBUSCH NEW MILITARY CEMETERY EXTENSION

— DIKKEBUS (YPRES)

Location of this cemetery: see info Dickebusch New Military Cemetery.

IDENTIFIED COMMONWEALTH HEROES

 515 2 24 1

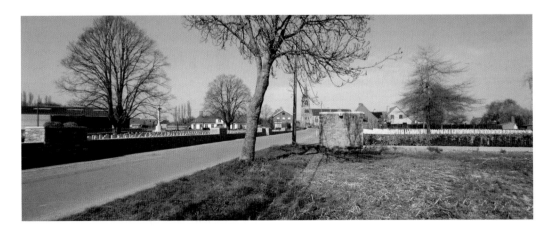

DICKEBUSCH OLD MILITARY CEMETERY

— DIKKEBUS (YPRES)

IDENTIFIED COMMONWEALTH HEROES

 41 3

Location of this cemetery: see info Dickebusch New Military Cemetery. Dickebusch Old Military Cemetery is located just beyond the village church, forming the southern side of Neerplaats.

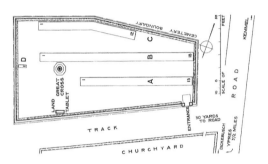

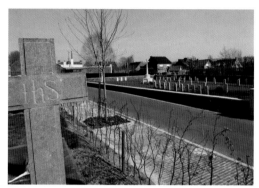

DIVISIONAL CEMETERY

— VLAMERTINGE (YPRES)

Vlamertinge is part of Ypres and is located on the N38 road from Ypres to Poperinge. Divisional Cemetery, Dickebusch Road, is located 2 km west of Ypres town centre. From Ypres town centre take the Poperingseweg N38, which is reached via Elverdingestraat. Then go straight over two small roundabouts into Capronstraat. The Poperingseweg is a continuation of Capronstraat and begins after a prominent railway level crossing. 1 km along Poperingseweg lies the left hand turning onto Omloopstraat. The cemetery itself is located 100 metres along Omloopstraat on the right hand side of the street.

IDENTIFIED COMMONWEALTH HEROES

 187 25 65

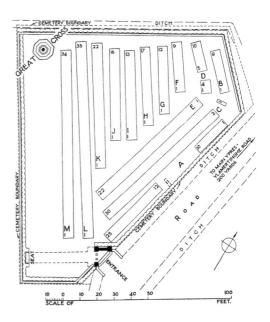

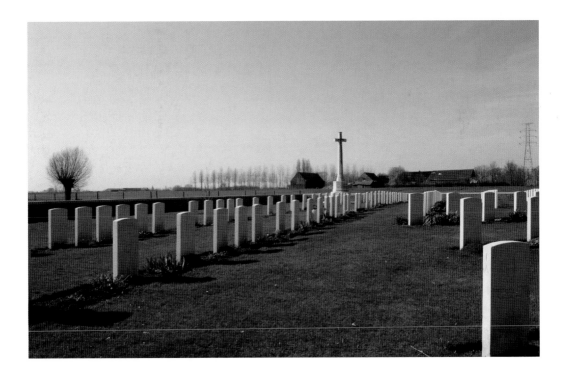

DIVISIONAL COLLECTING POST CEMETERY & EXTENSION

— SINT-JAN (YPRES)

Sint-Jan is part of Ypres and is located appr. 2 km north east of that town. From the station of Ypres turn left and drive along Fochlaan to the roundabout, turn right and go to the next roundabout. Turn left here into Haiglaan and drive to the traffic lights. Here turn right onto the dual carriageway direction Poelkapelle/A19. Carry on for about 1 km (crossing the river) and you will see a sign for New Irish Cemetery. Turn left here to the crossroads and turn left again, the cemetery is appr. 50 m on the right. Across the road is La Belle Alliance Cemetery.

IDENTIFIED COMMONWEALTH HEROES

 200　　19　　3　　31

 GRAVES OF INTEREST (P. 58)

Francis, I B 7

Cooper, I H 13

Marshman, I J 1

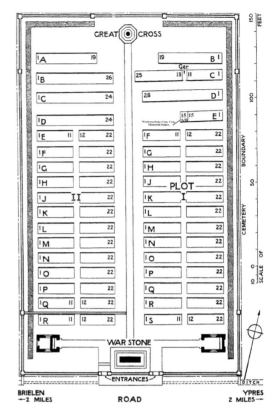

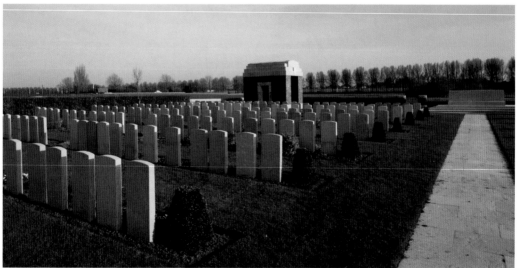

DRAGOON CAMP CEMETERY

— BOEZINGE (YPRES)

Boezinge is part of Ypres and is located appr. 4 km north of that town, on the N369 road, in the direction of Diksmuide. The cemetery is located in Kleine Poezelstraat east of the village. From the N369 turn right into Brugstraat, over the bridge and then to the right, Langemarkseweg. Follow this road to the first crossroads and turn right into Kleine Poezelstraat. Dragoon Camp Cemetery is located on the left hand side of the road, appr. 200 metres past the crossroads.

IDENTIFIED COMMONWEALTH HEROES

 56

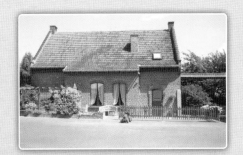

DUHALLOW A.D.S. CEMETERY
— YPRES

The cemetery is located on the Diksmuidseweg (N369) in the direction of Boezinge. From Ypres station turn left into Fochlaan and go to the roundabout, then turn right and go to the next roundabout. Here turn left and drive to the third roundabout, where you turn right into Oude Veurnestraat. Then take the second turning on the left, which is Diksmuidseweg. Duhallow Advanced Dressing Station Cemetery is on the right hand side of the road, just past the first turning on the right.

IDENTIFIED COMMONWEALTH HEROES

1254　　38　　6　　13

3　　2

GRAVES OF INTEREST (P. 68-69)

Atkinson, II E 7
Seymour, III F 10
Archer, IV E 33
Joyce, VII F 11

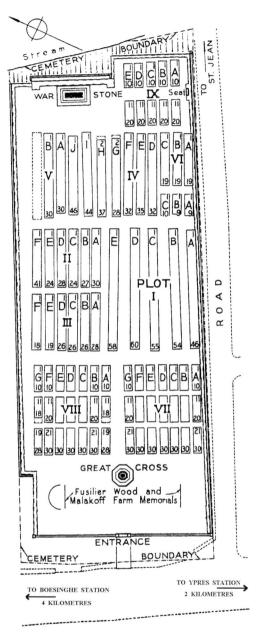

ELZENWALLE BRASSERIE CEMETERY

— VOORMEZELE (YPRES)

Voormezele is part of Ypres and is located a few km south of that town. Leave Ypres through the Lille Gate (Rijselsepoort) and continue towards Armentières (N365). Appr. 1 km further is a right turn onto Kemmelseweg (close to the level crossing). The cemetery is appr. 4 km further on the right hand side of the road.

IDENTIFIED COMMONWEALTH HEROES

 103 41

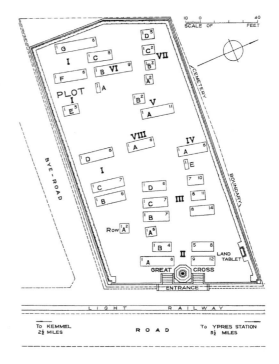

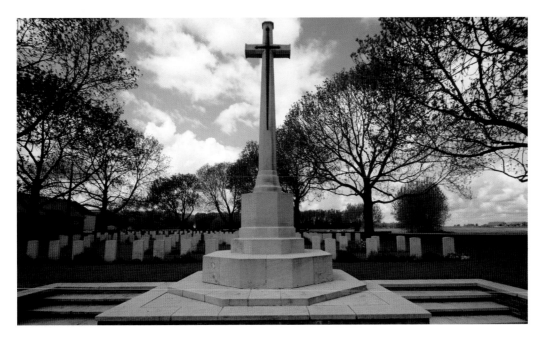

ESSEX FARM CEMETERY

— BOEZINGE (YPRES)

Boezinge is part of Ypres and is located appr. 6 km north west of that town. From Ypres station turn left info Fochlaan and go to the roundabout, then turn right and continue to the next roundabout. Turn right here, into Oude Veurnestraat, and then take the second turn on the left, which is the Diksmuidseweg, leading north. Follow the road under the motorway bridge. Essex Farm Cemetery is on the right hand side of the road.

IDENTIFIED COMMONWEALTH HEROES

 1091 6

GRAVES OF INTEREST (P. 74-75)
Pusch, I A 1
Strudwick, I U 8
Barratt, VC, I Z 8
Batty, II C 1
Appleby, II M 6

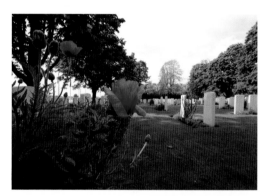

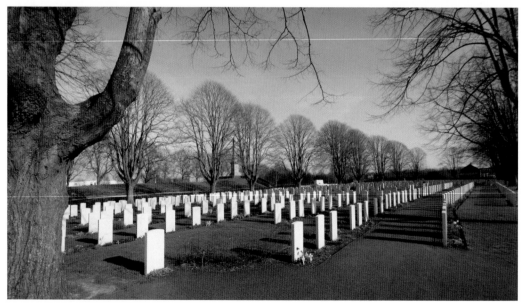

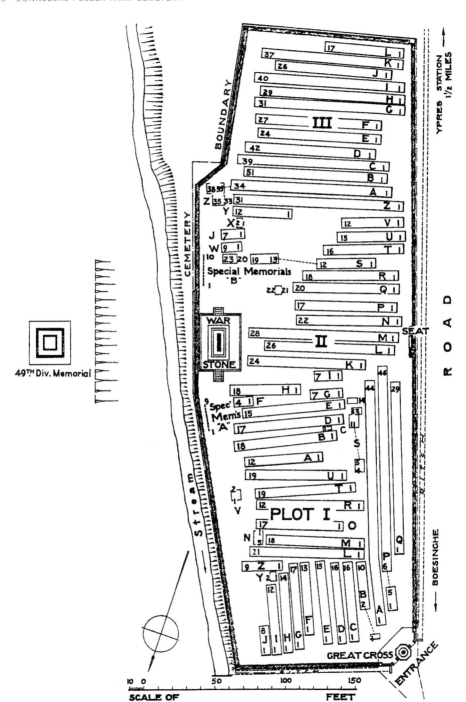

FERME OLIVIER CEMETERY
— ELVERDINGE (YPRES)

Elverdinge is part of Ypres. Location: 8 km north west of Ypres. From Ypres take Elverdingestraat, then turn to the right onto Haiglaan, Veurnseweg (N8), which goes in the direction of Veurne. At Elverdinge take the N333 Steentjesmolenstraat, the cemetery is 1,5 km further on the left hand side of the road, with very easy access and parking.

IDENTIFIED COMMONWEALTH HEROES

 403

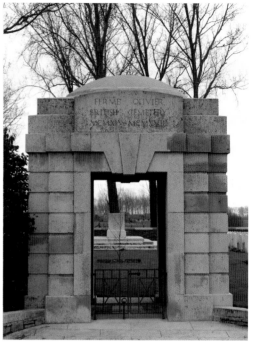

GRAVES OF INTEREST (P. 78-79)

Preen, II E 2

Watkins, III C 12

Hogan, III E 18

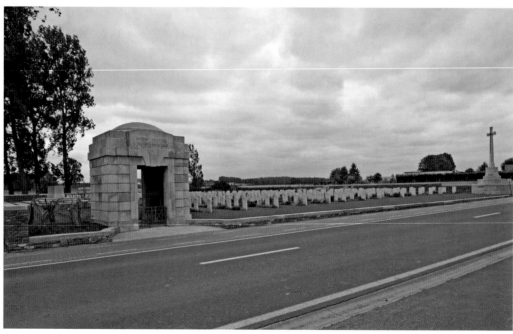

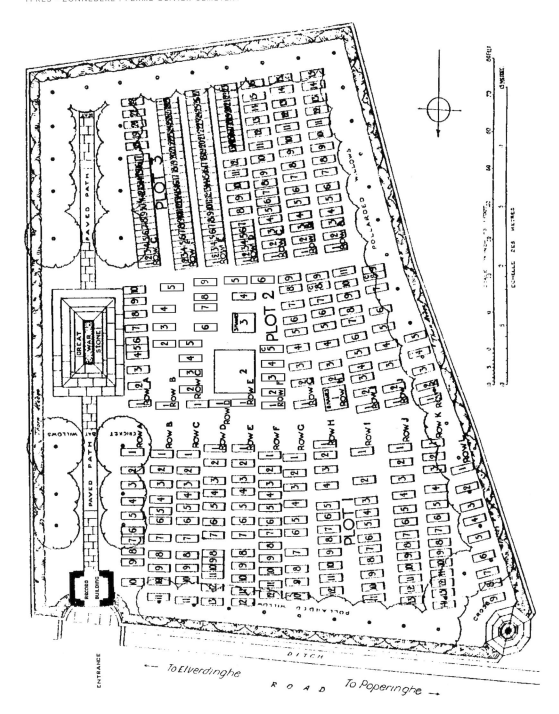

FIRST D.C.L.I. CEMETERY

— ZILLEBEKE (YPRES)

Zillebeke is part of Ypres and is located a few km south east of that town. Leave Ypres through the Lille Gate (Rijselsepoort), and cross the Ypres ring road in the direction of Armentières and Lille. The road name then changes to Rijselseweg. 1 km along Rijselseweg lies the left hand turning onto Komenseweg. 2.5 km along the Komenseweg lies the right hand turning onto Vaartstraat. Follow Vaart-straat for appr. 1 km and then take the left hand turning onto Verbrandemolenstraat. 400 m along this street is First D.C.L.I. Cemetery, very close to Hedge Row Trench Cemetery and Woods Cemetery.

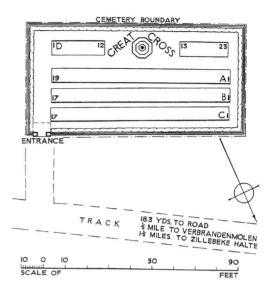

IDENTIFIED COMMONWEALTH HEROES

 63

 GRAVES OF INTEREST (P. 80)
Glassman, C 1

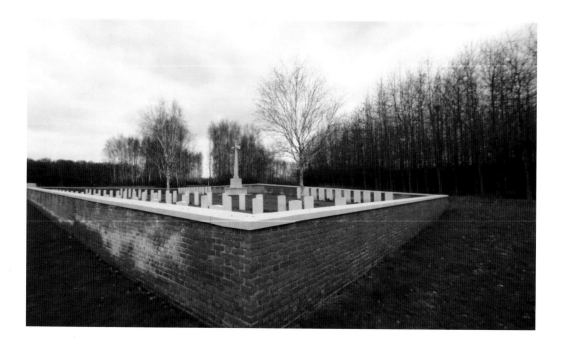

ANTHONY'S FARM

Anthony's Farm offers you a luxurious holiday house with a capacity of 14 people. We have five bedrooms and two bathrooms (each with bath and shower). There is also a perfectly equipped kitchen at your disposal.

The whole house stands for a modern decor allied to smartly refurbished rooms.

We are located at Kortemark, which is quite close to the battlefields and cemeteries of the Great War in the Ypres Salient. (Distance Kortemark-Ypres is only 30 kms). Bruges is at 40 kms, Dixmude (Yser Tower, Trench of Death) at only 12 kms.

ANTHONY'S FARM

Steenstraat 94 - 8610 Kortemark

Tel: +32 (0) 477 58 22 32
Fax: +32 (0) 51 58 32 22
E-mail: info@anthonysfarm.be
www.anthonysfarm.be

HAGLE DUMP CEMETERY

— ELVERDINGE (YPRES)

Elverdinge is part of Ypres. From Ypres take the N308 in the direction of Poperinge. After passing a prominent railway crossing (6 km further), and then going through the villages of Vlamertinge and Brandhoek, go right into Galgestraat. After 1 km pass the crossroads with Sint-Pieterstraat, then go 300 m further. Easy access and parking. Hagle Dump Cemetery is indicated from the N308.

IDENTIFIED COMMONWEALTH HEROES

 280 7 10

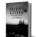 GRAVES OF INTEREST (P. 90)
Anderson, I D 7

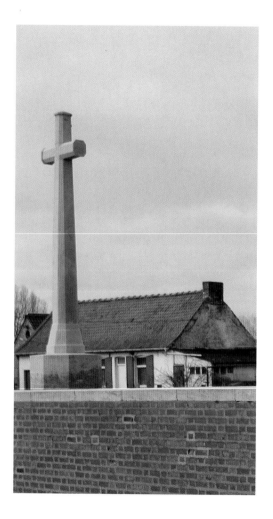

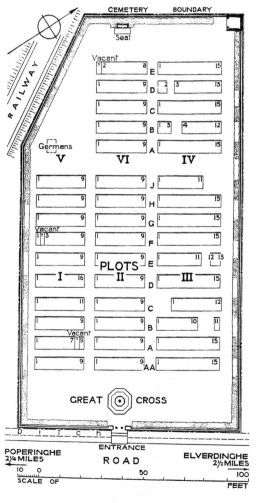

HEDGE ROW TRENCH CEMETERY
— ZILLEBEKE (YPRES)

Zillebeke is part of Ypres. Hedge Row Trench Cemetery is located appr. 4 km south east of Ypres on Verbrandemolenstraat. Leave Ypres through the Lille Gate (Rijselsepoort) and cross the ring in the direction of Armentières and Lille. The road name changes to Rijselseweg. After 1 km there is a left turn into Komenseweg. Follow this road for 2.5 km and turn right into Vaartstraat. After about 1 km is the left turn into Verbrandemolenstraat. The grassed path to the cemetery is about 400 m along on the right hand side of the road.

IDENTIFIED COMMONWEALTH HEROES

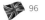 96 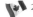 2

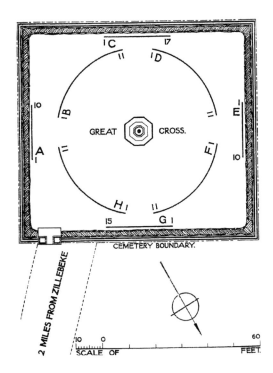

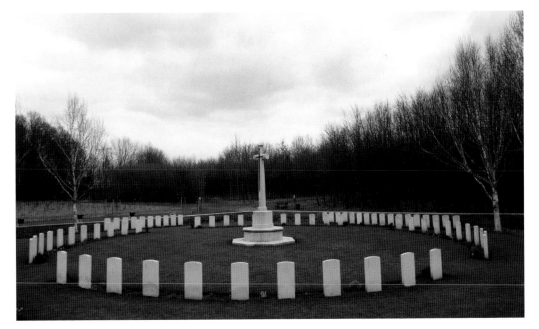

HOOGE CRATER CEMETERY

— ZILLEBEKE (YPRES)

Zillebeke is part of Ypres and is located a few km south east of that town. Hooge Crater Cemetery is 4 km east of Ypres town centre on the Meenseweg (N8), a road connecting Ypres to Menen. The cemetery is located 3.5 km along the Meenseweg on the right hand side of the road.

IDENTIFIED COMMONWEALTH HEROES

 1862 69 78 335

GRAVES OF INTEREST (P. 93-95)

Gammons, VI A 17

Bugden, VC, VIII C 5

Marsh, IX A J 19

Cadogan, IX A L 11

Dooner, IX A L 12

Hodgson, XIV E 14

Monaghan, Spec. Mem. 13

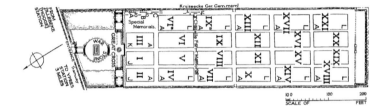

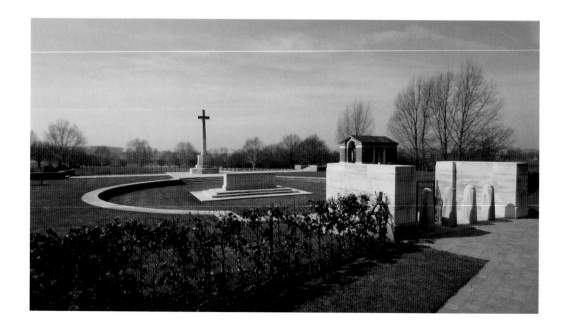

HOP STORE CEMETERY

— VLAMERTINGE (YPRES)

Vlamertinge is part of Ypres and is located appr. 3 km west of that town. From Ypres take the Poperingseweg (N308). This is reached via Elverdingestraat and then straight over two small roundabouts on Capronstraat. Poperingseweg is a continuation of Capronstraat, it starts after a prominent railway crossing. Follow this road for appr. 5 km; immediately after the village of Vlamertinge is a right turn onto Casselstraat. Hop Store Cemetery is a further 100 m on your right hand side. Attention: parking near the cemetery is quite difficult.

IDENTIFIED COMMONWEALTH HEROES

 250 1

 GRAVES OF INTEREST (P. 96-97)

Philby, 1 A 16
Pallett, 1 A 44
Craig, 1 B 34
Lynn, 1 E 9
King, 1 E 13

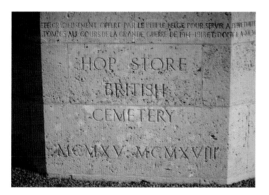

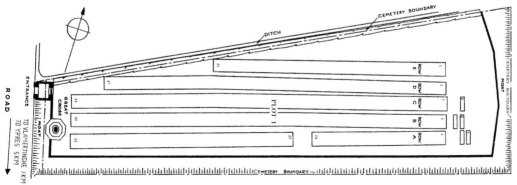

HOSPITAL FARM CEMETERY
— ELVERDINGE (YPRES)

Elverdinge is part of Ypres. From Ypres take Elver-
dingestraat. You pass two small roundabouts into
Capronstraat. After the prominent railway crossing
the name of this road changes into Poperingseweg
(N308). You go on for 4 km into Vlamertinge and
you'll find Hospitaalstraat just beyond the church
on the right. You continue 2.5 km. Hospital Farm
Cemetery is on your left hand side. Attention: access
to the cemetery is via a very bumpy field, which is of-
ten used for livestock and can be very muddy. How-
ever, when the weather is fine, this is one of the most
beautiful Commonwealth cemeteries in Flanders!

IDENTIFIED COMMONWEALTH HEROES

 111

 GRAVES OF INTEREST (P. 98)
Marcel Top

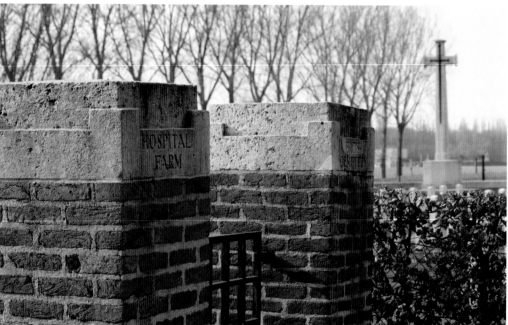

LA BELLE ALLIANCE CEMETERY

— SINT-JAN (YPRES)

Sint-Jan is part of Ypres and is to be found appr. 2 km north east of that town. From the Ypres railway station go left and drive along Fochlaan to the roundabout. Go right and follow the road to the next roundabout. Turn left and drive to the traffic lights, then right onto the dual carriageway (A19) in the direction of Poelkapelle. Continue for about 1 km over the river, you will then see a sign for New Irish Farm Cemetery. Turn left here to the crossroads and left again. La Belle Alliance Cemetery is on your left hand side, about 50 m past Divisional Collecting Post Cemetery and Extension. There is no area for parking, but you can park your car outside Divisional Collecting Post Cemetery and Extension and walk down to the cemetery.

IDENTIFIED COMMONWEALTH HEROES

 50

LA BRIQUE MILITARY CEMETERY NO. 1

— SINT-JAN (YPRES)

Sint-Jan is part of Ypres and is located appr. 2 km north east of that town. Turn left at Ypres station and drive along Fochlaan to the roundabout, then turn right and continue to the next roundabout. Turn left into Haiglaan and drive to the next roundabout. Turn right into Oude Veurnestraat, this changes into Diksmuidseweg and then to Brugseweg. Continue to the traffic lights; at the lights turn left into Industrielaan; then go first right into Pilkemseweg. The cemetery is appr. 300 metres on your right hand side, very close to Jan Yperman Hospital.

IDENTIFIED COMMONWEALTH HEROES

 87

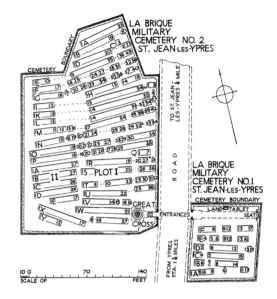

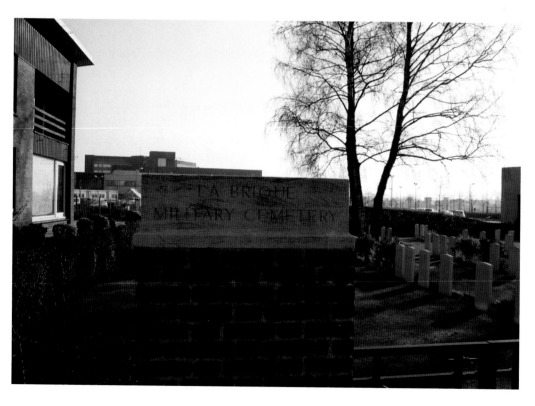

LA BRIQUE MILITARY CEMETERY NO. 2

— SINT-JAN (YPRES)

For the exact location of this cemetery, see info La Brique Military Cemetery No. 1, which is located across the road.

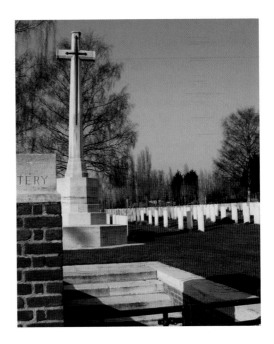

IDENTIFIED COMMONWEALTH HEROES

 432 8 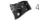 7 4

 2 1

 GRAVES OF INTEREST (P. 108)

Drake, VC, I C 2

LARCH WOOD (RAILWAY CUTTING) CEMETERY
— ZILLEBEKE (YPRES)

Zillebeke is part of Ypres and is situated appr. 3 km south east of that town. Leave Ypres via the Lille Gate (Rijselsepoort) heading towards Armentières and Lille. After 1 km go left onto Komenseweg. 2.7 km further take a left turn onto a rough track. The cemetery is a further 400 m, across the railway line.

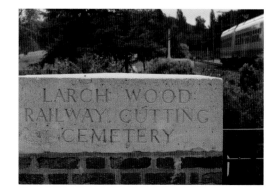

IDENTIFIED COMMONWEALTH HEROES

 435 76 24

 GRAVES OF INTEREST (P. 112)
Peel, Sp. Mem. B 27

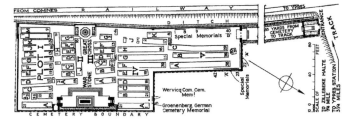

MAPLE COPSE CEMETERY
— ZILLEBEKE (YPRES)

Zillebeke is part of Ypres and is located a few km south east of Ypres town centre. From Ypres take Meenseweg (N8) towards Menen. 2.5 km along this road is a right turn onto Wulvestraat. After a further 1 km take the left turn onto Schachteweidestraat. Maple Copse Cemetery is a further 2 km, on the right hand side of the road. Please note that parking is difficult.

IDENTIFIED COMMONWEALTH HEROES

 114 142

 GRAVES OF INTEREST (P. 134)
Laing, C 25
Cupis, J 21

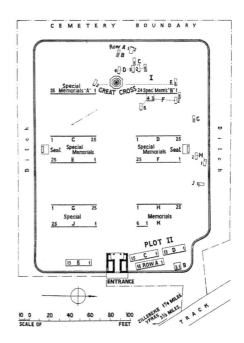

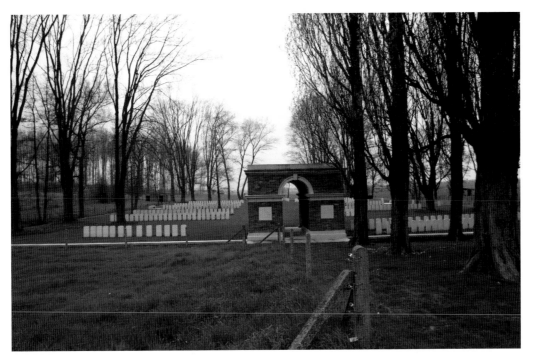

MENIN ROAD SOUTH MILITARY CEMETERY

— YPRES

Menin Road South Military Cemetery is located 2 km east of Ypres town centre, on the N8 (Meenseweg), connecting Ypres to Menen. From Ypres town centre take Torhoutstraat (in fact Lange Torhoutstraat and Korte Torhoutstraat), then right onto Basculestraat. This road ends at a main crossroads, directly over which begins the Meenseweg. The cemetery is located 800 m along the Meenseweg on the right hand side of the road.

IDENTIFIED COMMONWEALTH HEROES

 1081 146 52 259

 GRAVES OF INTEREST (P. 138-139)

Rowe, I T 30

Colyer-Fergusson, VC, II E 1

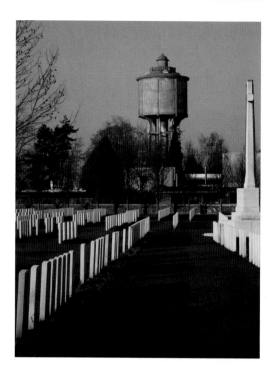

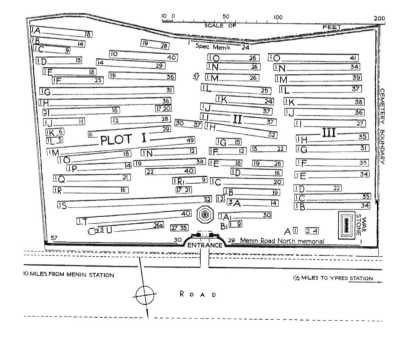

MINTY FARM CEMETERY

— SINT-JAN (YPRES)

Sint-Jan is part of Ypres and is located a few km north east of that town. From the centre of Ypres take Boezingestraat. After 500 m take the first turning left into Ieperstraat. Follow this road to the T junction at the end, then turn right into Briekestraat. 1st left still Briekestraat, take again the first turning left called Hemelrijkstraat. Minty Farm Cemetery is 200 m along this road on the left hand side.

IDENTIFIED COMMONWEALTH HEROES

 186

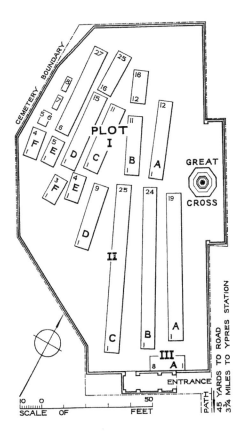

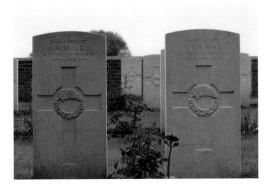

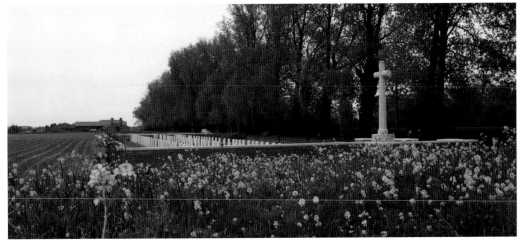

NEW IRISH FARM CEMETERY

— SINT-JAN (YPRES)

Sint-Jan is part of Ypres and is to be found appr. 2 km
north east of that town. From Ypres station turn left
and follow along Fochlaan to the roundabout. Turn
right and at the next roundabout turn left into Haig-
laan. Follow along this road to the traffic lights and
at the lights turn left into Pilkemseweg, then take the
first right into Zwaanhofweg, a small country road.
Follow this road to the crossroads. You will find New
Irish Farm Cemetery on your right hand side.

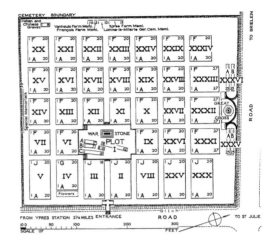

IDENTIFIED COMMONWEALTH HEROES

 1356 28 18 39

4 3

 GRAVES OF INTEREST (P. 144-145)

Singh, II J 17

Speight, IV B 16

Maddock, XIII B 15

Sutton, IX F 2

Bowes-Lyon, XXX D 11

Jempson, Spec. Mem. 6

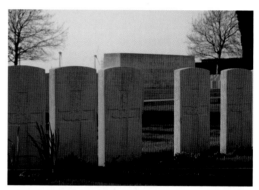

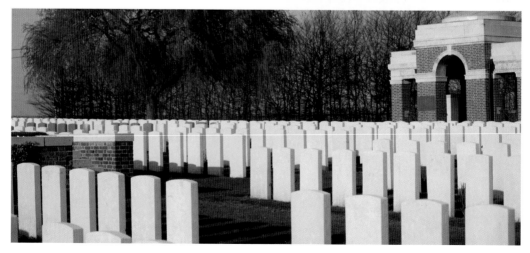

NO MAN'S COT CEMETERY

— BOEZINGE (YPRES)

Boezinge is part of Ypres. From Ypres station turn left and follow Fochlaan to the roundabout, turn right and go to the next roundabout. Turn left here into Haiglaan and drive to the traffic lights. Turn right here onto the dual carriageway direction Poelkapelle (A19). Continue for about 1 km, going over the river. Turn left into Briekestraat, go past New Irish Farm Cemetery, and continue to the crossroads. Go straight over into Moortelweg and to the next crossroads before turning left. The cemetery is 400 m on the left hand side. Parking can be difficult and access is via a grassed path.

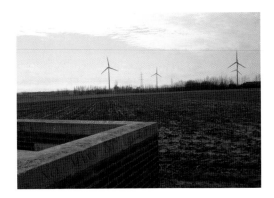

IDENTIFIED COMMONWEALTH HEROES

 77

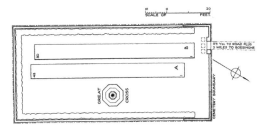

OAK DUMP CEMETERY

— VOORMEZELE (YPRES)

Voormezele is part of Ypres and is located a few km south of that town. Leave Ypres via the Lille Gate (Rijselsepoort) and take the N365 in the direction of Armentières. After 3 km go left into Vaartstraat and a further 1 km along this road is a right turn into Bernikkewallestraat. Oak Dump Cemetery is located 1 km along this street, on your right hand side.

IDENTIFIED COMMONWEALTH HEROES

 104 2

 GRAVES OF INTEREST (P. 148)

Nicholson, J 7

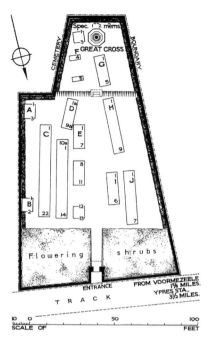

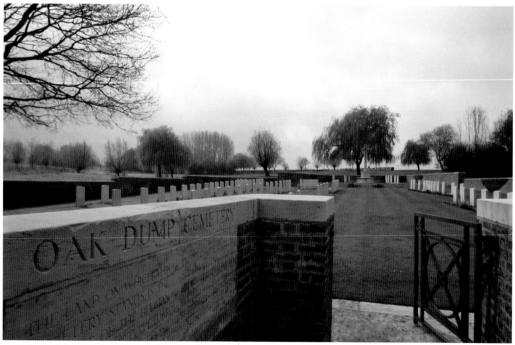

OXFORD ROAD CEMETERY

— SINT-JAN (YPRES)

Sint-Jan is part of Ypres and is located a few km north east of that town. From Ypres station turn left and drive along Fochlaan to the roundabout. Turn right there and drive to the next roundabout. Here turn left into Haiglaan and drive to the next roundabout. Turn right here into Oude Veurnestraat, this then changes into Diksmuidseweg and Brugseweg. Drive along this road to the traffic lights, then straight over the lights to the end of the road. At the T junction turn left (still Brugseweg) and continue along this road through the village of Sint-Jan (N313). After the village you come to a fork in the road, take the right hand fork and the cemetery is 50 m along, on the right hand side of the road.

IDENTIFIED COMMONWEALTH HEROES

403 83 34 34

GRAVES OF INTEREST (P. 151)

Robertson, VC, III F 7

Benoit, V H 3

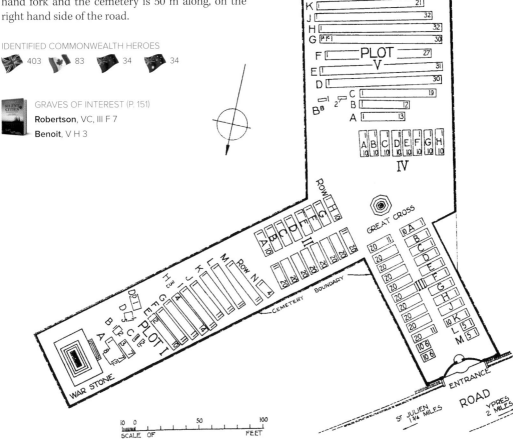

PASSCHENDAELE NEW BRITISH CEMETERY

— PASSENDALE (ZONNEBEKE)

Passendale is part of Zonnebeke and is located appr. 5 km north east of that town, and appr. 12 km north east of Ypres. From the market square in Ypres, take Torhoutstraat (Lange Torhoutstraat and Korte Torhoutstraat) and drive onto the small roundabout, then go right into Basculestraat. At the crossroads turn left onto Zonnebeekseweg. Continue for 7 km until you reach the village of Zonnebeke. There you go left into Langemarkstraat, this street then changes its name to Zonnebekestraat. After 2 km and after having passed Dochy Farm British Cemetery, is the right turn into 's Graventafelstraat. You follow this street for appr. 4 km; Passchendaele New British Cemetery is on the left hand side of the road, very close to the New Zealand Memorial.

IDENTIFIED COMMONWEALTH HEROES

 132 204 43 121 1

 GRAVES OF INTEREST (P. 153)

McMillan, VII B 1

Decoteau, XI A 28

Croke, XII A 10

Rev. Dickinson, Spec. Mem. 5

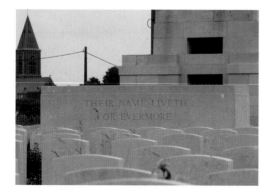

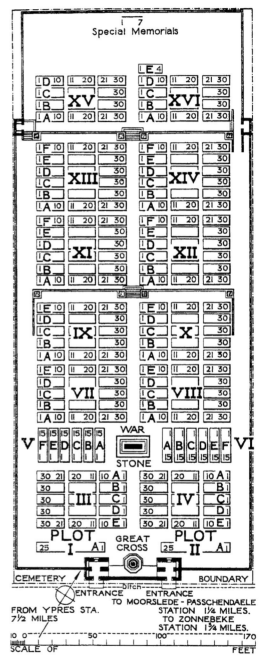

DE MEIDOORN

Bed & Breakfast De Meidoorn ('The Hawthorn' in English) is ideally located at Beauvoorde-Veurne, only 60 kms from Calais, 20 kms from Dixmude, and very close to the battlefields, cemeteries and monuments of the Great War in the Ypres Salient.

This beautiful farm with spacious garden offers you three brand-new and tremendously characterful rooms. The hearty and rustic breakfast will make your stay unforgettable.

DE MEIDOORN

Houtemstraat 32 - 8630 Beauvoorde-Veurne
Tel: +32 (0)58 52 08 79
E-mail: info@hoteloxalis.com
www.hoteloxalis.com

PERTH CEMETERY (CHINA WALL)

— ZILLEBEKE (YPRES)

Zillebeke is part of Ypres and is located 3 km south east of that town. Leave Ypres via Torhoutstraat (Lange Torhoutstraat and Korte Torhoutstraat) and turn right onto Basculestraat. At the main cross-roads continue straight on, this road now becomes the Meenseweg (N8), connecting Ypres to Menen. After about 1.7 km at a major roundabout, take the right hand turning onto Maaldestedestraat. Perth Cemetery (China Wall) is located 1 km along Maald-estedestraat, on the left hand side of the road.

IDENTIFIED COMMONWEALTH HEROES

1212 56 19 128 7

GRAVES OF INTEREST (P. 154-156)

Birks, VC, I G 3

Chapman, I J 9

Johnston, VC, III C 12

McLellan, V B 13

Fellows, Shot at Dawn, V K 13

Harris, Shot at Dawn, V K 14

Magnus, VI A 13

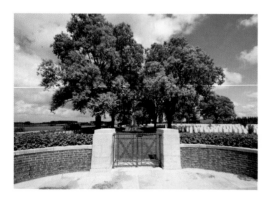

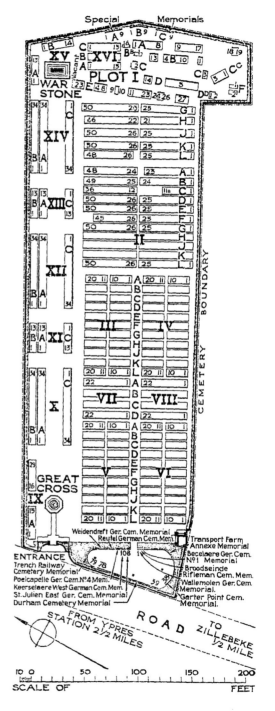

POLYGON WOOD CEMETERY

— **ZONNEBEKE**

Zonnebeke is a town east of Ypres. Polygon Wood Cemetery is located on the N8 Meenseweg, which connects Ypres to Menen. It can be reached via Torhoutstraat (Lange Torhoutstraat and Korte Torhoutstraat) and then going right into Bascule-straat. This road ends at a main crossroads, directly over which starts the N8 Meenseweg. 4.7 km along Meenseweg and after passing the Bellewaerde theme park lies the left hand turning onto Oude Kortrijkstraat. 2 km along Oude Kortrijkstraat the road crosses the A19 motorway. Immediately after this bridge is the left hand turning onto Lotegat-straat, which borders Polygon Wood. 800 m further on is the right turn into Lange Dreve. The cemetery is a further 1 km on your left hand side. Access is easy although parking can be a little difficult.

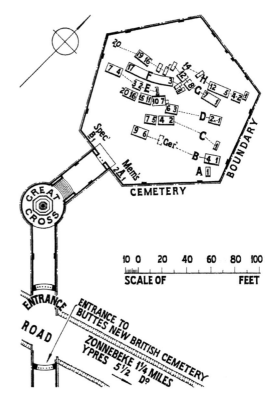

IDENTIFIED COMMONWEALTH HEROES

 28 58

 GRAVES OF INTEREST (P. 164)

Thomson, D 2A

Arnott, D 7

Dunford, D 8

Gorringe, D 9

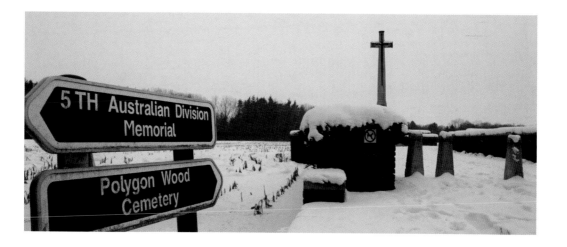

POTIJZE BURIAL GROUND CEMETERY

— POTIJZE (YPRES)

Potijze is part of Ypres and is located appr. 1.5 km north east of that town. From Ypres station, go left along Fochlaan to the roundabout, turn right and go to the next roundabout. Here turn left into Haiglaan and drive to the next roundabout. Turn right here into Oude Veurnestraat; this road then changes into Diksmuidseweg and Brugseweg. Continue on this road to and over the traffic lights to the end of the road. At the T junction turn left (still Brugseweg) and continue along this road through the village of Sint-Jan (N313). At the crossroads in the village turn right onto the N345 Potijzestraat. Follow this road for 400 m and you will find Potijze Burial Ground Cemetery on the right hand side.

IDENTIFIED COMMONWEALTH HEROES

 559 1 3

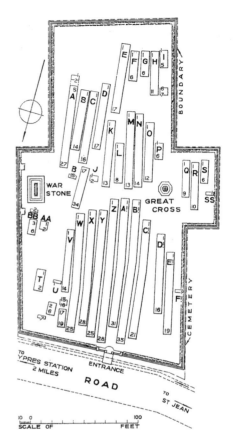

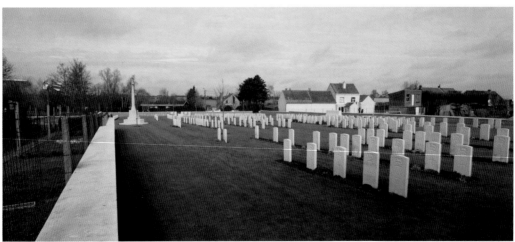

POTIJZE CHATEAU GROUNDS CEMETERY

— POTIJZE (YPRES)

For information on the exact location of Potijze Chateau Grounds Cemetery, see info on Potijze Burial Ground Cemetery. On the N345 (Potijzestraat), continue along this road to the next crossroads and turn left into Zonnebeekseweg. The cemetery is located on the left hand side of the road, by the crossroads.

IDENTIFIED COMMONWEALTH HEROES

 293 47 2 22 1

GRAVES OF INTEREST (P. 170)
Chapman, I A 12

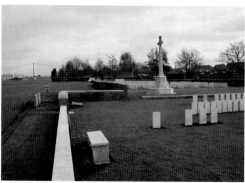

POTIJZE CHATEAU LAWN CEMETERY

— POTIJZE (YPRES)

For information on the exact location of Potijze Chateau Lawn Cemetery, see info on Potijze Chateau Grounds Cemetery. Only a small path separates both cemeteries.

IDENTIFIED COMMONWEALTH HEROES

 162 22 4 9

GRAVES OF INTEREST (P. 171)
Doig, G 22

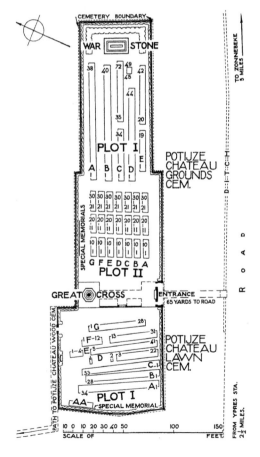

POTIJZE CHATEAU WOOD CEMETERY

— POTIJZE (YPRES)

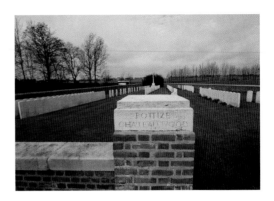

For information on the exact location of Potijze Chateau Wood Cemetery, see info on Potijze Chateau Grounds Cemetery. Also this cemetery is located on the left hand side of Zonnebeekseweg, appr. 50 m after the crossroads.

IDENTIFIED COMMONWEALTH HEROES

 145 6

 GRAVES OF INTEREST (P. 171)
JF Barrett, A 27
D Barrett, F 2

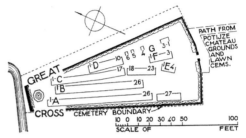

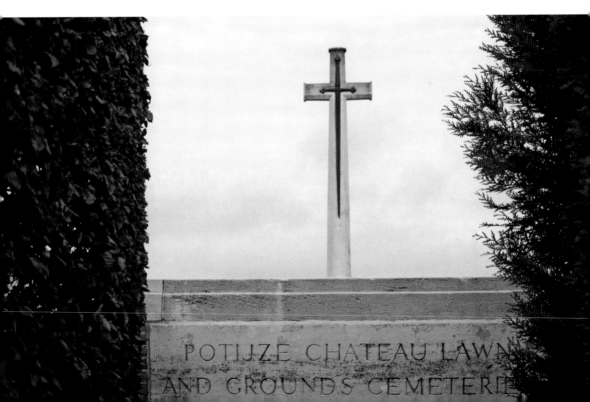

POTIJZE CHATEAU LAWN AND GROUNDS CEMETERIE

RAILWAY CHATEAU CEMETERY

— VLAMERTINGE (YPRES)

Vlamertinge is part of Ypres and is located appr. 3 km west of that town. Leave Ypres via the Elverding-estraat and continue straight over two small rounda-bouts into Capronstraat. Poperingseweg (N308) is a continuation of this road and begins after the railway crossing. Continue for 1 km along this road and turn right into Adriaansensweg, avoiding the road which forks right. The cemetery is located 500 m along Adriaansensweg, on the left hand side of the road.

IDENTIFIED COMMONWEALTH HEROES

 99

 GRAVES OF INTEREST (P. 174)

May, B 7

Willis, B 7

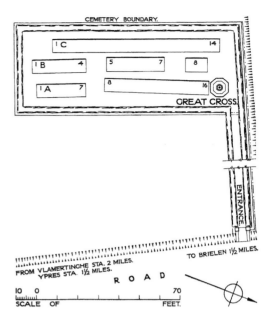

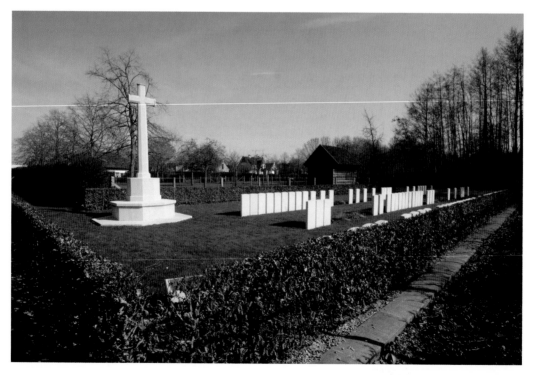

RAILWAY DUGOUTS BURIAL GROUND (TRANSPORT FARM)

— ZILLEBEKE (YPRES)

Zillebeke is part of Ypres. The village is located appr. 2 km south east of Ypres. Railway Dugouts Burial Ground (Transport Farm) is located on the Komenseweg, a road connecting Ypres to Komen (N336). From Ypres town centre the Komenseweg is located via the Rijselstraat, through the Rijselsepoort (Lille Gate) and crossing the Ypres ring road, in the direction of Armentières and Lille. The road name then changes to Rijselseweg. 1 km along Rijselseweg lies the left hand turning onto Komenseweg. The cemetery itself is located 1.2 km along Komenseweg, on the right hand side of the road.

GRAVES OF INTEREST (P. 175-177)

Youens, VC, I O 3
Finch, II H 3
Gladwinfield, V B1
Allan, VI D 17
Merchant, VI D 4
Service, VI J 1
Tate, VI K 9
Dening, VI M 29
Polston, VI P 12
FG Wild, Cem. Mem. D 8
R Wild, Cem. Mem. D 9
Sharples, Spec. Mem. C 1

IDENTIFIED COMMONWEALTH HEROES

1342 551 1 134 1

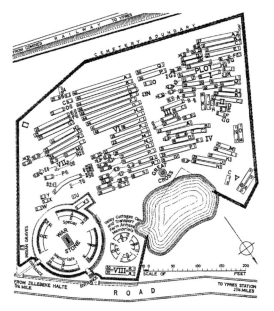

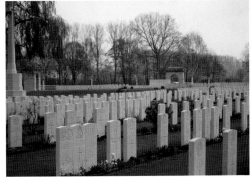

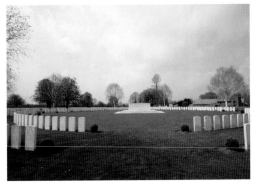

RAMPARTS CEMETERY, LILLE GATE

— YPRES

The cemetery lies within the town of Ypres itself. It can be found 1 km south of Ypres Market Square, at the top of Rijselstraat, where the road meets the Rijselsepoort (Lille Gate). Just before passing through the Lille Gate turn right onto Kanonweg and the cemetery is located up the steps on top of the old ramparts. Access and parking are easy. Cars can be safely left on Kanonweg, although the cemetery can also be reached via a 20 minute walk from the Menin Gate around the ramparts. At the cemetery the visitor will also find the start of the 'Rose Coombs walk'. Rose Coombs, who had her ashes scattered in Ramparts Cemetery, was the author of the Great War classical travel guide 'Before Endeavours Fade'. She did much to popularise Ypres and the Ypres Salient for tourists and pilgrims.

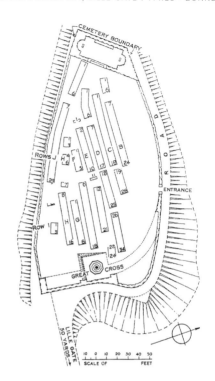

IDENTIFIED COMMONWEALTH HEROES

 153 10 14 11

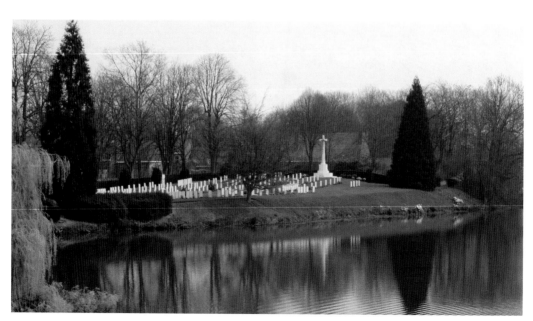

R.E. GRAVE, RAILWAY WOOD CEMETERY

— ZILLEBEKE (YPRES)

Zillebeke is part of Ypres and is located a few km south east of Ypres town centre. From Ypres town centre the Meenseweg is located via Torhoutstraat (Lange Torhoutstraat and Korte Torhoutstraat), then go right onto Basculestraat. This street ends at a main crossroads, directly over which begins the Meenseweg. 3 km along Meenseweg lies the left hand turning onto Begijnenbosstraat. 1 km along this street is the right hand turning onto Oude Kortrijkstraat. The cemetery itself is located 500 m along Oude Kortrijkstraat, on the right hand side of the road.

IDENTIFIED COMMONWEALTH HEROES

 12

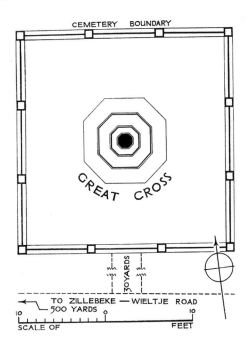

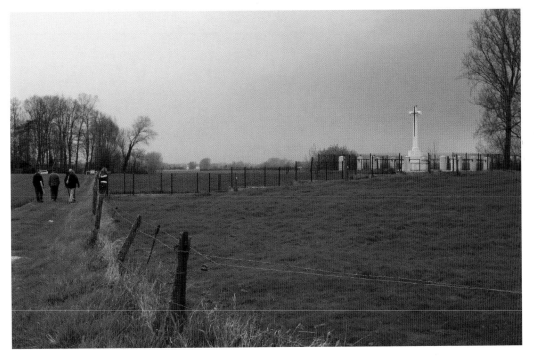

RED FARM MILITARY CEMETERY

— VLAMERTINGE (YPRES)

Vlamertinge is part of Ypres and is located 4 km west of that town. Leave Ypres by taking Elverdingestraat, then over two roundabouts into Capronstraat. Poperingseweg is a continuation of Capronstraat and begins after a prominent railway level crossing. Follow this Poperingseweg (N308) for 7 km and you will find Red Farm Military Cemetery on the right hand side of the road, after passing through the villages of Vlamertinge and Brandhoek.

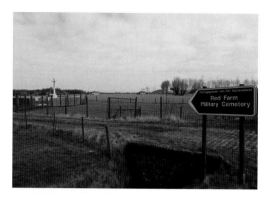

IDENTIFIED COMMONWEALTH HEROES

 29

RIDGE WOOD MILITARY CEMETERY
— VOORMEZELE (YPRES)

Voormezele is part of Ypres and is located a few km south of that town. Leave Ypres through the Lille Gate and continue towards Armentières (N365). Appr. 1 km further take the right hand turn onto Kemmelseweg (N331) close to the level crossing. Continue along this road for a further 4 km, before turning right at Elzenwalle Brasserie Cemetery (at the junction with Slijpstraat). Ridge Wood Cemetery is a further 1 km along Slijpstraat, after a small staggered crossroads.

IDENTIFIED COMMONWEALTH HEROES

 255 292 3 44

 GRAVES OF INTEREST (P. 182)
Watmough, II A 8
Taylor, III W 7

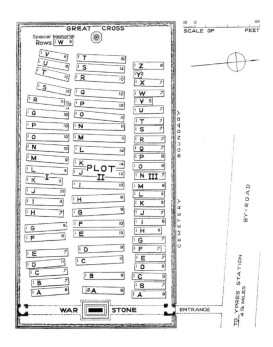

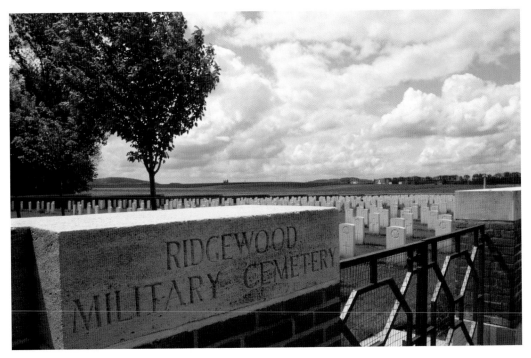

SANCTUARY WOOD CEMETERY

— ZILLEBEKE (YPRES)

Zillebeke is part of Ypres and is located a few km south east of that town. From Ypres town centre take Torhoutstraat (Lange Torhoutstraat and Korte Torhoutstraat) and right onto Basculestraat. Basculestraat ends at a main crossroads, directly over which begins the Meenseweg. 3 km along Meenseweg lies the right hand turning onto Canadalaan. Sanctuary Wood Cemetery is located 1.5 km along Canadalaan on the right hand side of the road.

IDENTIFIED COMMONWEALTH HEROES

 520 74 4 35 3

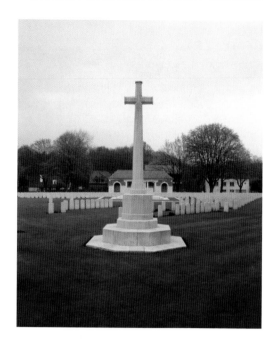

GRAVES OF INTEREST (P. 185)

Talbot, I G 1

Roberts, Spec. Mem.

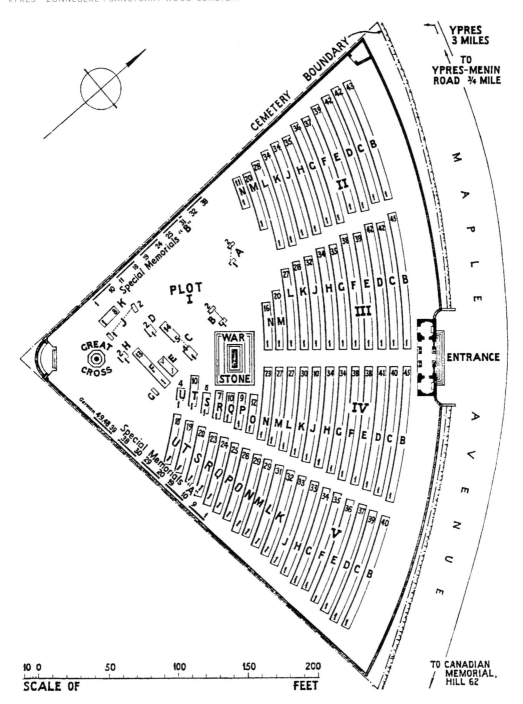

SOLFERINO FARM CEMETERY

— BRIELEN (YPRES)

Brielen is part of Ypres and is located a few km
north west of that town. From Ypres station turn left
and drive along Fochlaan to the roundabout, then
turn right and go to the next roundabout. Turn left
here into Haiglaan and drive to the traffic lights. Go
straight over the lights and follow the N8 direction
Veurne. Drive through the village of Brielen and for
appr. another km to the first turning on the right
(past the farm). This street is called Kapellestraat.
Solferino Farm Cemetery is appr. 500 m further, on
your right hand side.

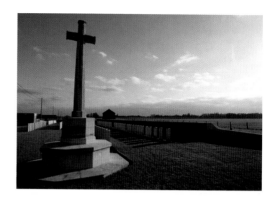

IDENTIFIED COMMONWEALTH HEROES

 293 2

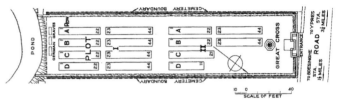

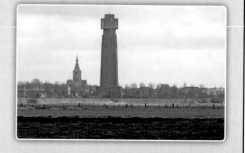

SPOILBANK CEMETERY

— ZILLEBEKE (YPRES)

Zillebeke is part of Ypres and is located a few km south east of that town. Leave Ypres via the Lille Gate (Rijselsepoort) and cross the Ypres ring road in the direction of Armentières and Lille (N365). The road then changes name to Rijselseweg. After 1 km turn left into Komenseweg. Continue for 2.3 km before going right into Vaartstraat. Spoilbank Cemetery is a further 1.5 km on your right hand side.

IDENTIFIED COMMONWEALTH HEROES

 323 10 62

 GRAVES OF INTEREST (P. 188)
Nightall, I E 14

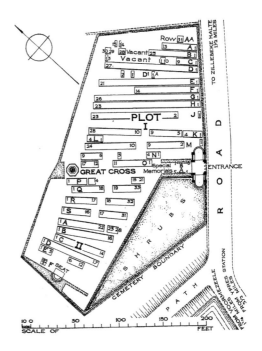

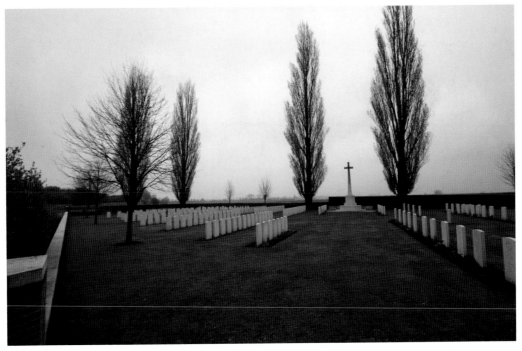

TALANA FARM CEMETERY

— BOEZINGE (YPRES)

Boezinge is part of Ypres and is located appr. 6 km north of that town. From Ypres railway station turn left into Fochlaan and go to the roundabout, turn right and go to the next roundabout, then turn left to the third roundabout. Turn right here into Oude Veurnestraat. Take the second turning on the left, which is the Diksmuidseweg, and carry on under the motorway bridge. The cemetery is a further 600 m on the left hand side of the road.

IDENTIFIED COMMONWEALTH HEROES

 515

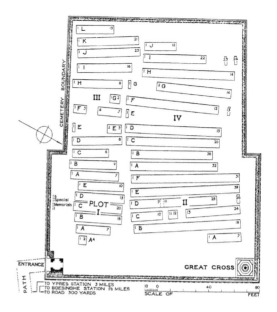

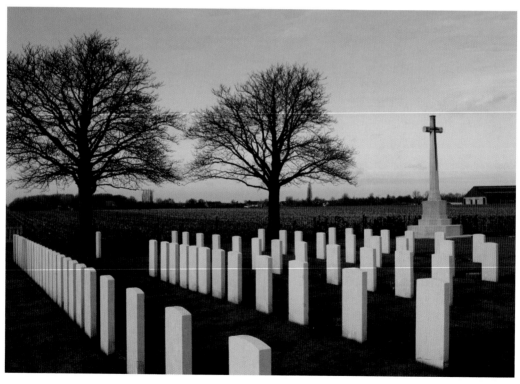

THE HUTS CEMETERY

— DIKKEBUS (YPRES)

Dikkebus is part of Ypres and is located appr. 5 km south west of that town. Dikkebusseweg (N375) is reached via Elverdingestraat (at Ypres), straight over a roundabout onto Capronstraat, then left along Fochlaan. Immediately after the train station the first right hand turning is Dikkebusseweg. On reaching Dikkebus village The Huts Cemetery is reached by taking a right hand turning onto Melkerijstraat. This road continues for 1 km, over a crossroads and bending sharply to the right, then meeting a junction with Steenakkerstraat. The Huts Cemetery is located appr. 200 m after this junction, on Steenakkerstraat.

IDENTIFIED COMMONWEALTH HEROES

816 5 19 243

4 1

GRAVES OF INTEREST (P. 194)

Slough, XII A 1

Hall, XII D 18

Spencer, Shot at Dawn, XV B 10

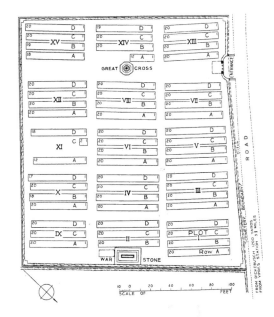

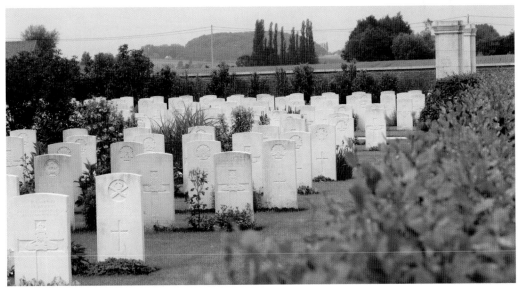

TRACK 'X' CEMETERY

— SINT-JAN (YPRES)

Sint-Jan is part of Ypres and is located north east of that town. From the station, go left along Fochlaan, continue to the roundabout and go right, continue again to the next roundabout and turn left into Haiglaan. At the next roundabout, turn right into Oude Veurnestraat, this then changes name, first to Diksmuidseweg and then Brugseweg. Continue on this road and over the traffic lights to the end of the road. At the T junction turn left (still Brugseweg), and continue along this road through Sint-Jan (N313). Follow this road to the end, where you come to a junction with the N38. Straight across the junction is Hogeziekenweg. After 50 m the road bends sharply to the left. Follow the road to the crossroads and then turn right into Moortelweg. Track 'X' Cemetery is a further 150 m on your right hand side.

IDENTIFIED COMMONWEALTH HEROES

 118 4

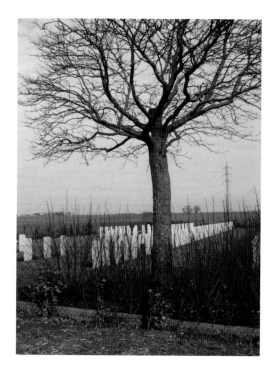

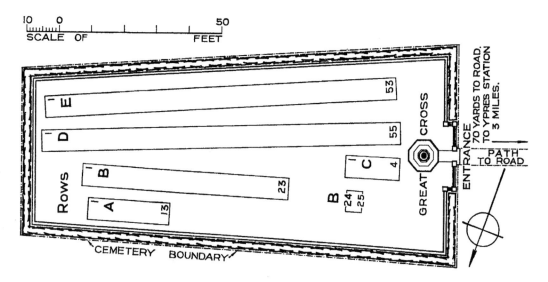

TUILERIES BRITISH CEMETERY
— ZILLEBEKE (YPRES)

Zillebeke is part of Ypres and is located a few km south east of that town. Leave Ypres via Torhout-straat (Lange Torhoutstraat and Korte Torhout-straat), and right onto Basculestraat. This street ends at a main crossroads, directly over which begins the Meenseweg. 1.5 km along Meenseweg lies the right hand turning onto Maaldestedestraat (signed Zillebeke). Tuileries British Cemetery is located 1.2 km along Maaldestedestraat, on the right hand side of the road.

IDENTIFIED COMMONWEALTH HEROES

 79

TYNE COT CEMETERY

— ZONNEBEKE

Zonnebeke is situated north east of Ypres. Tyne Cot Cemetery is located appr. 9 km north east of Ypres town centre, on the Tynecotstraat. From the centre in Ypres take Lange Torhoutstraat onto a small roundabout. Go right here into Basculestraat and at the crossroads turn left onto Zonnebeekseweg. Continue to the village of Zonnebeke, then turn left at the roundabout in the direction of Passendale. After 500 m turn left into Tynecotstraat. Follow this road around and the cemetery is on your right hand side.

GRAVES OF INTEREST (P. 200-208)

Turner, Middleton, Greenwood, I B1
Schonewald, VII D6
Spilsbury, VII H9
Spencer, XII A12
McGee, XX D1
Westerman, XXI H17
Johnson, Withams, Halliwell, Clifton, XXVII H18
Stevenson, XXXV E6
Jeffries, XL E1
Serls, XLI B20
Robertson, LVII D26
Goss, LVII F14
Marks, LXI J22

IDENTIFIED COMMONWEALTH HEROES

2336 451 198 578 24

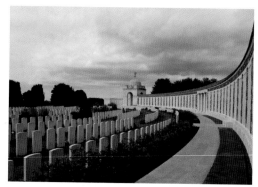

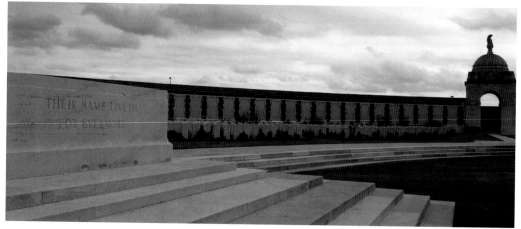

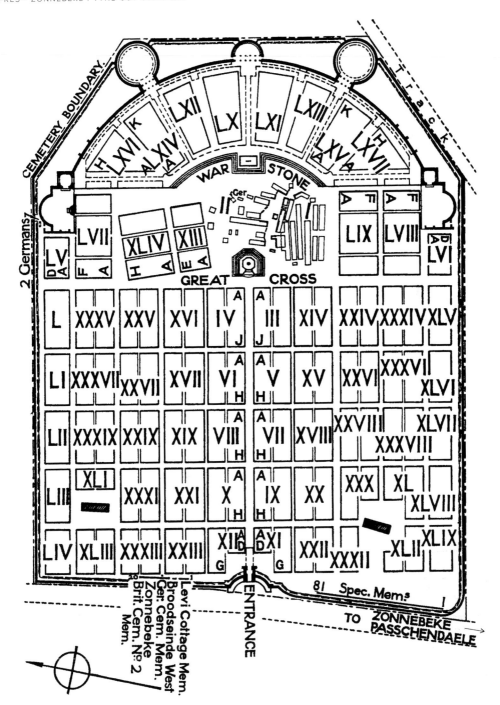

VLAMERTINGHE MILITARY CEMETERY

— VLAMERTINGE (YPRES)

Vlamertinge is located between Ypres and Poperinge and is part of Ypres. Leave Ypres by taking the Elverdingestraat, then go over two roundabouts and take Capronstraat. The Poperingseweg is a continuation of this road and begins after the railway crossing. Continue to the village of Vlamertinge and the cemetery is located on Hospitaalstraat, which is the second right after the village church.

IDENTIFIED COMMONWEALTH HEROES

 1094　　54　　4　　2　　3

GRAVES OF INTEREST (P. 210)
Mitford, I E 8
Grenfell, VC, II B 14

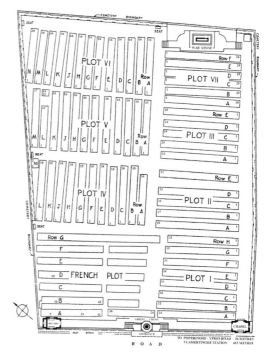

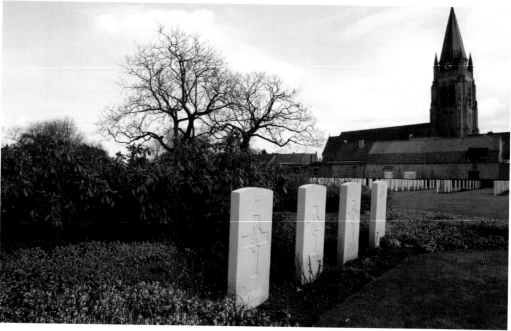

VLAMERTINGHE NEW MILITARY CEMETERY

— VLAMERTINGE (YPRES)

Vlamertinge is located between Ypres and Poperinge and is part of Ypres. How to get there: see info on Vlamertinghe Military Cemetery. At Vlamertinge, take the Verrieststraat (N315). The road then crosses the railway and the main N38, where the name of the road changes to Bellestraat. The cemetery is a further 200 m on the left after crossing the N38. Attention: access to the cemetery is via a grassed path between two houses, parking is available on the road. Also seven German soldiers are buried in this cemetery.

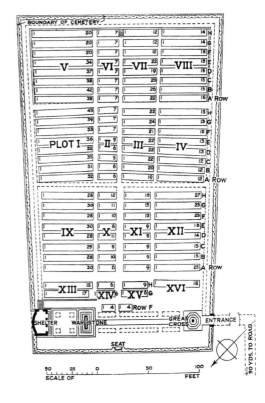

IDENTIFIED COMMONWEALTH HEROES

 1600　 154　 1　 44　 3

GRAVES OF INTEREST (P. 212-214)

Bagley, I G 22
SG Smith, III G 12
AE Smith, III G 16.
Moore, VIII B 2
Skinner, VC, XIII H 15

VOORMEZELE CHURCHYARD
— VOORMEZELE (YPRES)

Voormezele is part of Ypres and is located south of that town. Voormezele Churchyard is located 4 km south west of Ypres town centre, on the Ruuschaartstraat, a road leading from the Kemmelseweg (connecting Ypres to Kemmel N331). From Ypres town centre the Kemmelseweg is reached via the Rijselstraat, through the Lille Gate (Rijselsepoort), and straight on towards Armentières (N365). 900 m after the crossroads is the right hand turning onto Kemmelseweg (made prominent by a railway level crossing). Turn right onto Kemmelseweg and follow this road to the first crossroads, then turn left into Ruuschaartstraat. The church and churchyard are located 1 km along this street on the left hand side of the road.

IDENTIFIED COMMONWEALTH HERO

 1

VOORMEZELE ENCLOSURES NO. 1 & 2

— VOORMEZELE (YPRES)

For detailed information on the location of this cemetery, see info on Voormezele Churchyard. Follow Kemmelseweg to the first crossroads, then turn left into Ruusschaartstraat. The cemetery is located 1 km after this junction on the right hand side of the road, in the village of Voormezele.

IDENTIFIED COMMONWEALTH HEROES

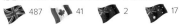

487 41 2 17

SAT NAV

See **www.poigraves.co.uk** for the exact location of all Commonwealth cemeteries of World War I.

www.inmemories.com is dedicated to the continued memory of those men and women of the Commonwealth who died as a result of the World Wars.

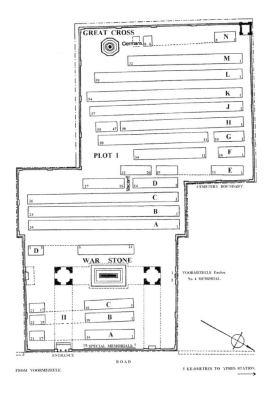

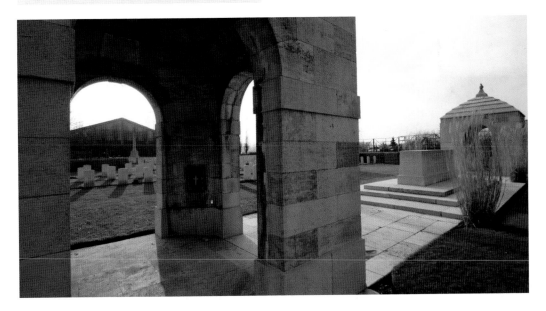

VOORMEZELE ENCLOSURE NO. 3
— VOORMEZELE (YPRES)

For detailed information on the location of this cemetery, see info on Voormezele Churchyard and Voormezele Enclosures No. 1 & 2.

IDENTIFIED COMMONWEALTH HEROES

 904 88 2 8

 GRAVES OF INTEREST (P. 216)

Davies, II E 2

Butcher, VIII B 2

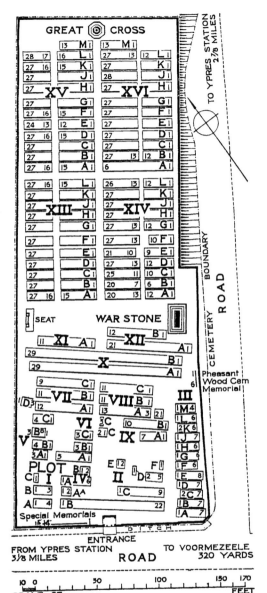

WELSH CEMETERY (CAESAR'S NOSE)
— BOEZINGE (YPRES)

Boezinge is part of Ypres and is located north of that town, on the N369 road in the direction of Diksmuide. Welsh Cemetery (Caesar's Nose) is located in Kleine Poezelstraat east of the village. From the N369 go right into Brugstraat, over the bridge and then to the right into Langemarkseweg, then to the crossroads. Turn right into Kleine Poezelstraat, follow this road to the crossroads and turn left into Moortelweg. The cemetery is appr. 100 m along on the right hand side.

IDENTIFIED COMMONWEALTH HEROES

 59

WHITE HOUSE CEMETERY

— SINT-JAN (YPRES)

Sint-Jan is part of Ypres and is located appr. 2 km north east of that town. White House Cemetery is located on the Brugseweg (N313) in the direction of Roeselare/Bruges. From the Grote Markt (Market Square) in Ypres take the Korte Torhoutstraat and at the end turn left into Lange Torhoutstraat. Follow this road over the roundabout into Kalfvaart and continue to the traffic lights. At the traffic lights turn right into Brugseweg. The cemetery is on your left hand side, before the village of Sint-Jan and very close to Jan Yperman Hospital.

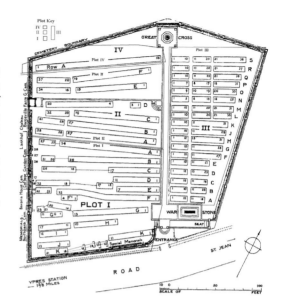

IDENTIFIED COMMONWEALTH HEROES

 713 70 24 38

2 1

 GRAVES OF INTEREST (P. 221)

Gawler, III L 9

Eveleigh, III L 10

Morrow, VC, IV A 44

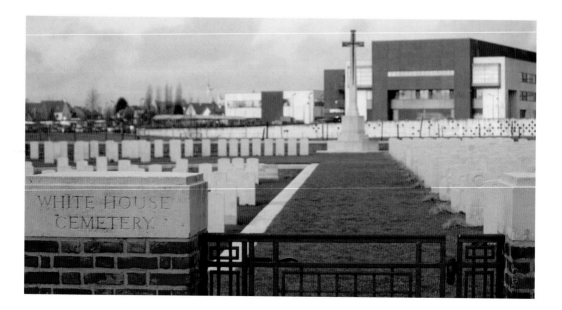

WIELTJE FARM CEMETERY
— SINT-JAN (YPRES)

Sint-Jan is part of Ypres and is located a few km to the north east of that town. From Ypres station turn left (Fochlaan) to the roundabout, then turn right to the next roundabout. Here turn left (Haiglaan) and drive to the next roundabout. Turn right here into Oude Veurnestraat, the name of this road then changes into Diksmuidseweg and Brugseweg. Drive along this road to the traffic lights, and further in the same direction to the end of the road. At the T junction turn left (still Brugseweg) and continue along this road to the village of Sint-Jan. The cemetery is on the left hand side of the road, appr. 200 m after the village.

IDENTIFIED COMMONWEALTH HEROES

 103 1 1

 GRAVES OF INTEREST (P. 222)
Brettoner, A 6

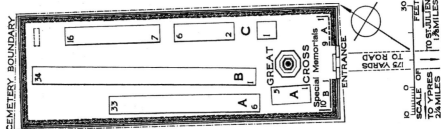

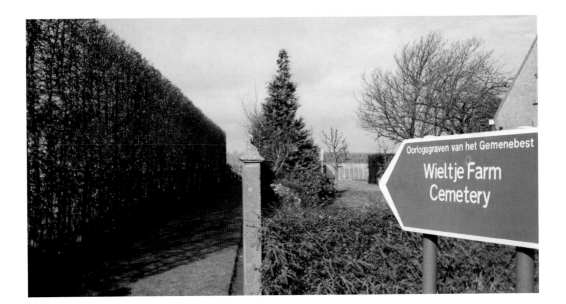

WOODS CEMETERY

— ZILLEBEKE (YPRES)

Zillebeke is part of Ypres and is located a few km south east of that town. Woods Cemetery is located on the Verbrandemolenstraat, a road leading from the Komenseweg (N366), connecting Ypres to Komen. In Ypres take Rijselstraat and go through the Lille Gate (Rijselsepoort), crossing the Ypres ring road, in the direction of Armentières and Lille in France. The road name then changes to Rijselseweg. 1 km along the Rijselseweg lies the left hand turning onto Komenseweg. 2.5 km along Komenseweg turn right (Vaartstraat), and 900 km further is the left hand turning into Verbrandemolenstraat. Woods Cemetery is located 400 m along this street. Attention: there is a 200 m grassed access path which is not accessible by vehicles. This cemetery is very close to First D.C.L.I. and Hedge Row Trench cemeteries.

IDENTIFIED COMMONWEALTH HEROES

 180 111 3

 GRAVES OF INTEREST (P. 222)
Coward, I B 18
Brand, II Z 1
Wann, II Z 2
Morton, II Z 3

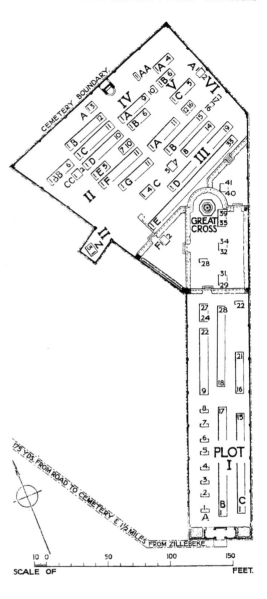

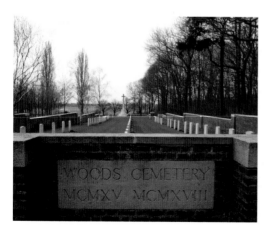

YPRES RESERVOIR CEMETERY

— YPRES

Ypres Reservoir Cemetery is located to the north west of Ypres. It is one of both Ypres military cemeteries 'intra muros'. From the station turn left and drive along Fochlaan to the roundabout, turn right and go to the next roundabout. Turn left here into Haiglaan and continue for appr. 300 m. Then turn right into Plumerlaan. Ypres Reservoir Cemetery is on the right hand side, appr. 200 m along the road.

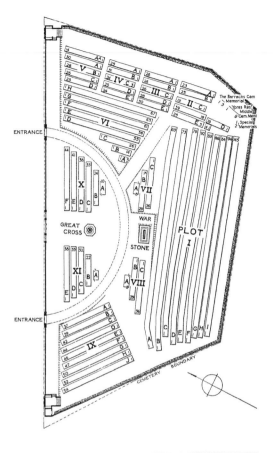

IDENTIFIED COMMONWEALTH HEROES

1326 106 18 121

7 1

 GRAVES OF INTEREST (P. 225-226)

Birkhead, I A 18

T Leany, I D 76

Merrill, I I 91

H B Knott, V B 15

J L Knott, V B 16

Maxwell, I A 37

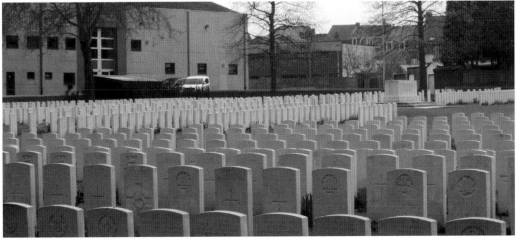

YPRES TOWN CEMETERY

— YPRES

Ypres Town Cemetery is located on the N345 which connects Ypres to Menen. Leave Ypres via the Menin Gate, continue to the traffic lights and turn right onto the N345. The cemetery is located a further 300 m on Zonnebeekseweg, on the right hand side of this road. Easy access and parking.

IDENTIFIED COMMONWEALTH HEROES

135 1

GRAVES OF INTEREST (P. 227-228)

Prince Maurice of Battenberg, I B

Liebert, E II 21

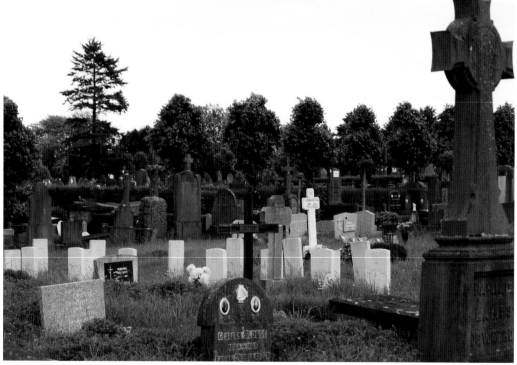

YPRES TOWN CEMETERY EXTENSION

— YPRES

For the exact location of this cemetery, see info on Ypres Town Cemetery.

IDENTIFIED COMMONWEALTH HEROES

 430 16 13 1 1

 GRAVES OF INTEREST (P. 230-231)

Pelham, Lord Worsley, II D 4

Marchant, III AA 1

Percival, III AA 2

Paley, III AA 3

Kerr, III AA 4

Chenevix Trench, III AA 5

Ommanney, III AA 6

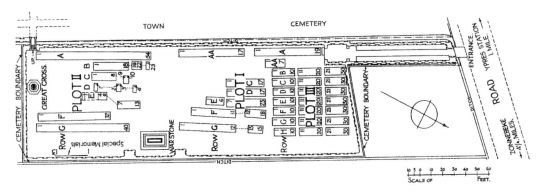

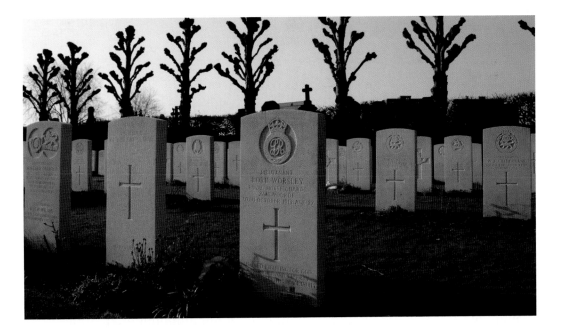

ZANDVOORDE CHURCHYARD

— ZANDVOORDE (ZONNEBEKE)

Zandvoorde is part of Zonnebeke and is located appr. 8 km south east of Ypres town centre, on a road leading from the Meenseweg (N8), connecting Ypres to Menen. From Ypres town centre take Torhoutstraat (Lange Torhoutstraat and Korte Torhoutstraat) and then right onto Basculestraat. Basculestraat ends at a main crossroads, directly over which begins the Meenseweg. 7.5 km along Meenseweg (in the village of Geluveld) lies the right hand turning to Zandvoorde (Zandvoordestraat). At the end of Zandvoordestraat, take the right hand turning onto Zandvoordeplaats. The churchyard itself is located 50 m along the Zandvoordeplaats on the left hand side of the road.

IDENTIFIED COMMONWEALTH HEROES

 4

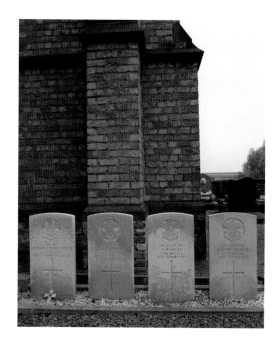

ZANTVOORDE BRITISH CEMETERY

— ZANDVOORDE (ZONNEBEKE)

Zandvoorde is part of Zonnebeke and is located appr. 8 km south east of Ypres town centre. See also info on Zandvoorde Churchyard. At the end of Zandvoordestraat is the left hand turning onto Kruisekestraat. Zantvoorde British Cemetery is located 100 m along Kruisekestraat on the left hand side of the road, very close to Zandvoorde Churchyard.

IDENTIFIED COMMONWEALTH HEROES

 441 5 1 1

 GRAVES OF INTEREST (P. 233)

McGuffie, I D 12

Brooke, VI E 2

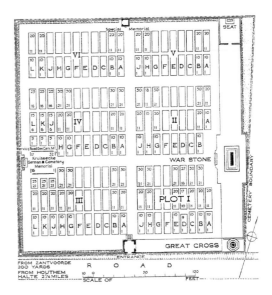

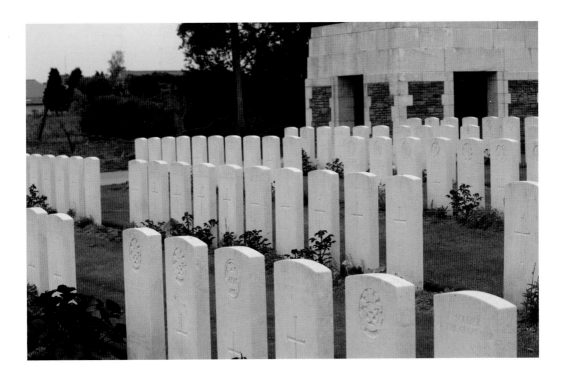

ZILLEBEKE CHURCHYARD

— ZILLEBEKE (YPRES)

Zillebeke is part of Ypres and is located appr. 3 km south east of Ypres town centre. From Ypres town centre take Torhoutstraat (Lange Torhoutstraat / Korte Torhoutstraat) and immediately onto Basculestraat. This street ends at a main crossroads, directly over which begins the Meenseweg. 2 km along Meenseweg lies the right hand turning onto Maaldestedestraat. The churchyard itself is located 1.8 km along Maaldestedestraat on the left hand side of the road, within the village of Zillebeke.

IDENTIFIED COMMONWEALTH HEROES

 20 6

 GRAVES OF INTEREST (P. 234)
Whitfield, A 1
Baron Alexis de Gunzburg, B 1
Steere, F 1

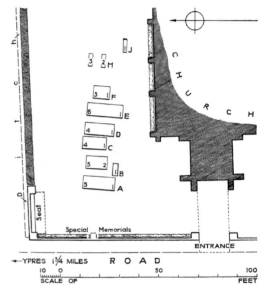

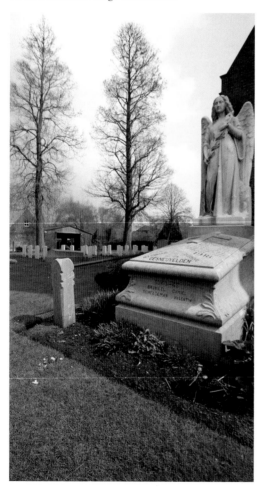

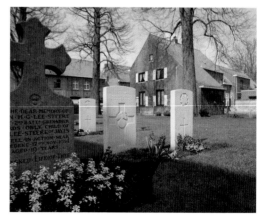

PART 2

HEUVELLAND
POPERINGE
COMINES-WARNETON

ABEELE AERODROME MILITARY CEMETERY

— ABELE (POPERINGE)

Abele is part of Poperinge and is to be found appr. 4 km south west of that city. It is appr. 16 km west of Ypres town centre. The cemetery is on the N38, a road leading from the N308 connecting Ypres to Poperinge. On reaching Poperinge the N308 joins the left hand turning onto the R33 (Poperinge ring road). The R33 continues to the left hand junction with the N38 Frans Vlaanderenweg. 4 km along the N38 you follow the right hand turning onto the Dodemanstraat. The cemetery is located 450 m along the Dodemanstraat on the right hand side of the road. Attention: there is a 150 m grassed access path which is not suitable for vehicles.

IDENTIFIED COMMONWEALTH HEROES

 104

GRAVES OF INTEREST (P. 11)

Drake-Brockman, II B 7

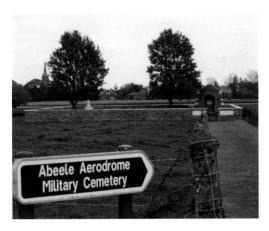

LANDHUIS MOLENHOF

Landhuis (in English 'Country-house' or 'Manoir') Molenhof is located in the picturesque village of Westouter, Heuvelland, on top of 'Rodeberg' (Red Mountain). The cemeteries and memorials of Flanders Fields are never far away.

In 1997, Cindy and Joris became the new owners of Molenhof. They turned the restaurant into a luxurious heaven of creativity and originality, boasting out-of-the-ordinary dishes and mainly using seasonal, fresh flavours. At Molenhof, you will always feel the magic of good energy.

The Crystal Waters Room, hall for parties and receptions, has a capacity of 250 people.

LANDHUIS MOLENHOF

Lijstermolendreef 4
8950 Westouter-Heuvelland
Tel: +32 (0)57 44 44 77
E-mail: info@molenhof.be
 www.molenhof.be

BERKS CEMETERY EXTENSION

— COMINES-WARNETON

Berks Cemetery Extension is located 12.5 km south of Ypres. From Ypres town centre follow the Rijsel-straat running from the central market square, through the Lille Gate (Rijselsepoort) and directly over the crossroads with the Ypres ring road. The road name then changes to Rijselseweg (N336). Follow this road for 3.5 km, you then see the fork junction with the N365, which forms the right hand fork leading to the town of Mesen (Messines). The cemetery is to be found 3 km beyond Mesen on the right hand side of the N365, opposite Hyde Park Corner (Royal Berks) Cemetery.

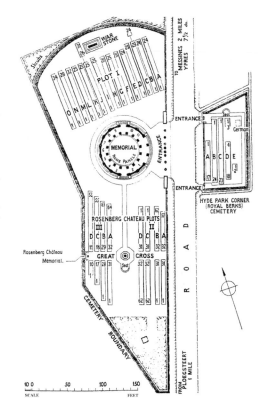

IDENTIFIED COMMONWEALTH HEROES

 464 149 80 180

 GRAVES OF INTEREST (P. 27)

L Crossley, I E 20

W Crossley, I E 21

Morris, G 22

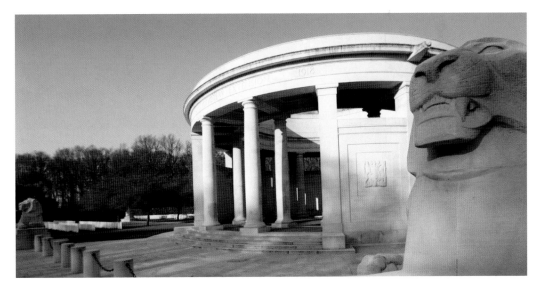

BETHLEEM FARM EAST CEMETERY

— MESEN (MESSINES)

Mesen is appr. 8 km south of Ypres; it is the smallest 'city' in Belgium. Bethleem Farm East Cemetery is located 10 km south of Ypres town centre and 1 km south east of Menen, on a road called the Rijselstraat, which leads from the market square of Mesen. The cemetery lies 1 km further along the Rijselstraat, on the left hand side of the road. Attention: visitors to this site should note a 200 m grassed access path which is unsuitable for vehicles.

IDENTIFIED COMMONWEALTH HEROES

 1 35

GRAVES OF INTEREST (P. 30)
Tustin, A 1

BETHLEEM FARM EAST CEMETERY, MESSINES

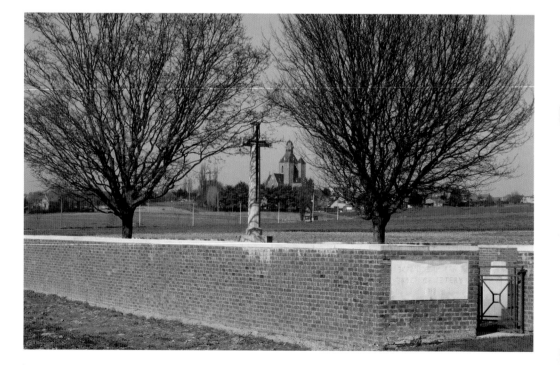

BETHLEEM FARM WEST CEMETERY

— MESEN (MESSINES)

For the location of this cemetery, see indications concerning Bethleem Farm East Cemetery. Bethleem Farm West Cemetery lies on the right hand side of Rijselstraat, towards a farmstead.

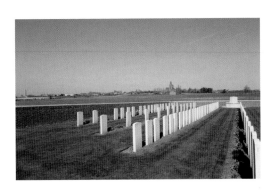

IDENTIFIED COMMONWEALTH HEROES

 24 27 113

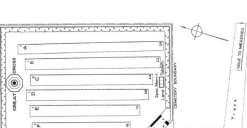

BEVEREN-IJZER CHURCHYARD

— ALVERINGEM

IDENTIFIED COMMONWEALTH HEROES

 20

Beveren-IJzer Churchyard is located appr. 25 km north west of Ypres on the N364, a road leading from the N308 connecting Ypres to Poperinge and on to Roesbrugge-Haringe. From Ypres town centre the Poperingeweg (N308) is reached via Elverding-estraat, then directly over two roundabouts in the Capronstraat. The Poperingeweg is a continuation of the Capronstraat and begins after a prominent railway level crossing. On reaching the ring road of Poperinge (R33, Europalaan), the left hand clockwise route circles the town of Poperinge and rejoins the N308 towards Oost-Cappel. 13 km after rejoining the N308 lies the village of Roesbrugge-Haringe and the right hand turning onto the N364 Roesbrugge-straat. 3.5 km along the N364 lies the village of Beve-ren-IJzer. The cemetery is located next to the church on the Sint-Brigida square.

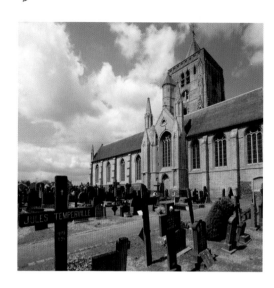

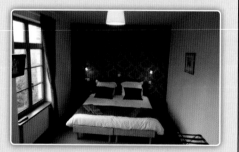
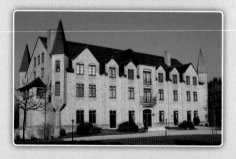

BRIDGE HOUSE CEMETERY

— SINT-JULIAAN (LANGEMARK-POELKAPELLE)

Sint-Juliaan is part of Langemark, Langemark being part of the village Langemark-Poelkapelle. Bridge House Cemetery is located 5 km north east of Ypres town centre on the Roeselarestraat, a road leading from the Brugseweg (N313), connecting Ypres to Brugge. At Ypres, Lange and Korte Torhoutstraat lead from the market square onto Kalfvaart. At the end of Kalfvaart is a large junction on which Brugseweg is the first right hand turning. 5 km along Brugseweg, just before the village of Sint-Juliaan, lies the right hand turning onto Peperstraat. 1 km along Peperstraat lies the right hand turning onto Roeselarestraat. Bridge House Cemetery is located immediately after this junction, on the left hand side of Roeselarestraat. There is a 50 m grassed path to this cemetery.

IDENTIFIED COMMONWEALTH HEROES

 41

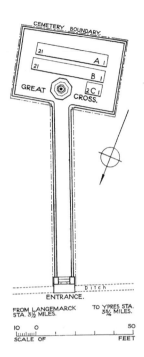

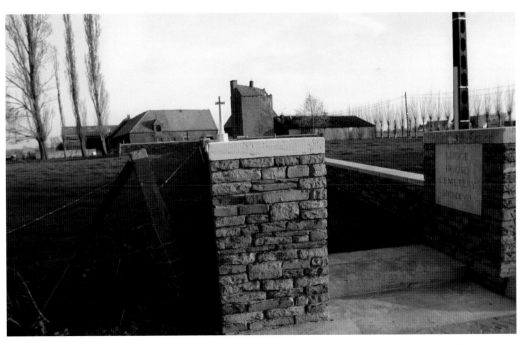

CABIN HILL CEMETERY

— WIJTSCHATE (HEUVELLAND)

Wijtschate is part of Heuvelland and is located appr. 5 km south of Ypres. Cabin Hill Cemetery is located 8.5 km south of Ypres town centre on a road leading from the Rijselseweg (N365) connecting Ypres to Wijtschate and on to Armentières. On passing through the village of Wijtschate, take the left hand turning onto a street called Langebunderstraat. This street leads to Torreken Farm Cemetery and beyond reaching a crossroads after 1.5 km Cabin Hill Cemetery is located 100 m behind the crossroads, having taken the left hand turning. Attention: visitors should note a small grassed access path to this cemetery which is unsuitable for vehicles.

IDENTIFIED COMMONWEALTH HEROES

 42 25

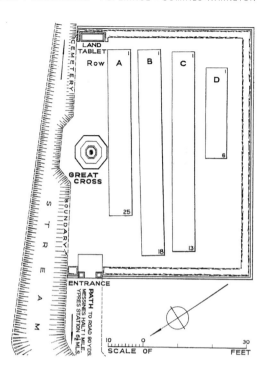

CALVAIRE (ESSEX) MILITARY CEMETERY

— COMINES-WARNETON

Calvaire (Essex) Military Cemetery is located appr. 16 km south east of Ypres. From Ypres town centre the Rijselstraat runs from the market square, through the Lille Gate (Rijselsepoort) and directly over the crossroads with the Ypres ring road. The road name then changes to Rijselseweg. 2 km after passing through the village of Ploegsteert, take the left hand turning onto Chemin de la Blanche (Witteweg in Flemish). The cemetery lies 1 km along this road, on the left hand side, about 200 m from Gunners Farm Military Cemetery.

IDENTIFIED COMMONWEALTH HEROES

 218

 GRAVES OF INTEREST (P. 47)
Pillman, IV D 10

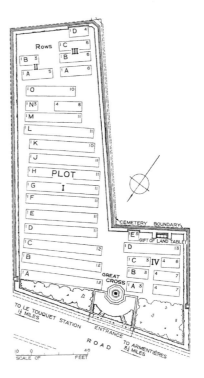

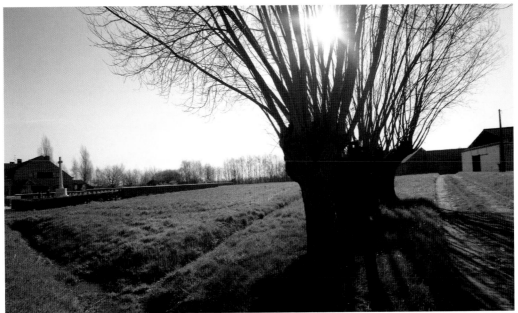

CEMENT HOUSE CEMETERY

— LANGEMARK-POELKAPELLE

Langemark-Poelkapelle is situated north east of Ypres, off the N313. From the market square at Langemark-Poelkapelle, take the Korte Ieperstraat, at the end turn right into Boezingestraat, then past the first turning on the left and Cement House Cemetery is located 100 m on the left hand side.

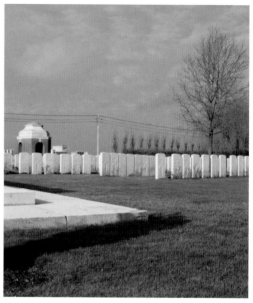

IDENTIFIED COMMONWEALTH HEROES

 1133 28 2 4 1

 GRAVES OF INTEREST (P. 50)

Mason, XII A 6

Rogers, XIII E 11

Lovatt, XIII E 12

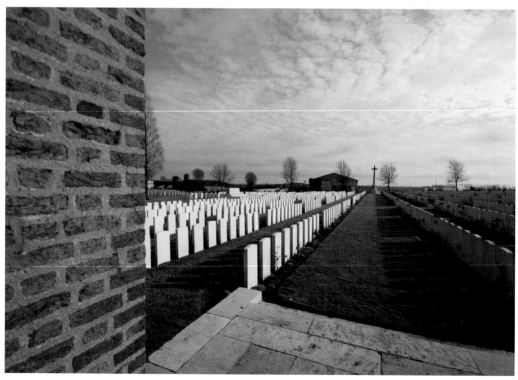

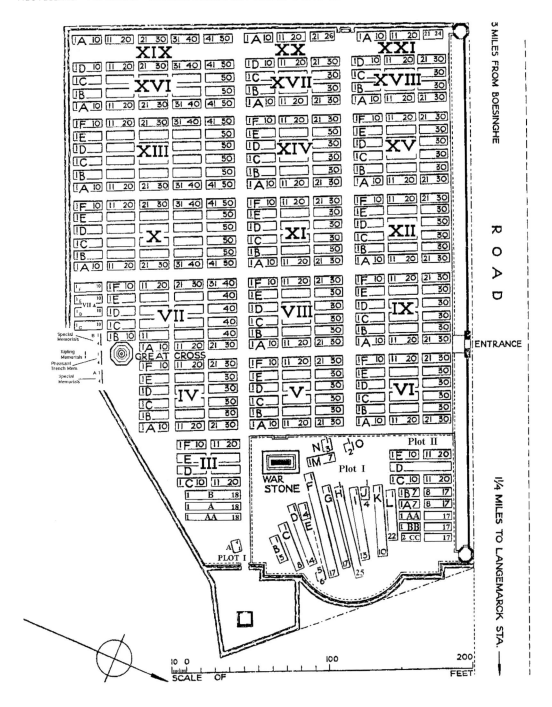

ROMANTIK HOTEL MANOIR OGYGIA

Romantik Hotel Manoir Ogygia **** is located in a castle park in the Veurnestraat.

Lijssenthoek Cemetery, the biggest World War One cemetery in Belgium as far as identified burials are concerned, is only a few kms away, as are many other monuments and cemeteries in the Ypres Salient. We also have a Vespa to rent.

As on the eponymous Greek island you will find an oasis of tranquillity at Romantik Hotel Manoir Ogygia. We aim for bon vivants. In the evening our restaurant is also open for non-hotel guests.

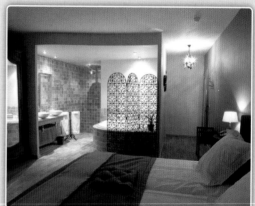

ROMANTIK HOTEL MANOIR OGYGIA

Veurnestraat 108 - 8970 Poperinge
Tel: +32 (0) 57 33 88 38
Fax: +32 (0) 57 33 29 11
E-mail: info@ogygia.be
 www.ogygia.be

CROONAERT CHAPEL CEMETERY

— WIJTSCHATE (HEUVELLAND)

Wijtschate is part of Heuvelland and is located appr. 5 km south of Ypres. Croonaert Chapel Cemetery is located 6 km south of Ypres town centre, between the villages of Voormezele and Wijtschate. The village of Voormezele is reached via the Kemmelseweg (N331). From Ypres town centre the Kemmelseweg is reached via the Rijselstraat, through the Lille Gate (Rijselsepoort), and straight on towards Armentières (N365). 900 m after the crossroads is the right hand turning onto Kemmelseweg (at the railway level crossing). Follow this road for 2 km, then take Ruuschaartstraat on the left, towards Voormezele

village. Opposite the church of Voormezele is the right hand turning onto a road called Wijtschat-estraat. You will find Croonaert Chapel Cemetery 1.5 km further, on the right hand side of Wijtschat-estraat. Attention: there is a 400 m grassed access path which is unsuitable for vehicles.

IDENTIFIED COMMONWEALTH HEROES

 68

 GRAVES OF INTEREST (P. 52)
Chang Chi Hsuen

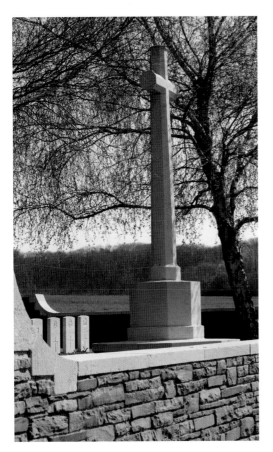

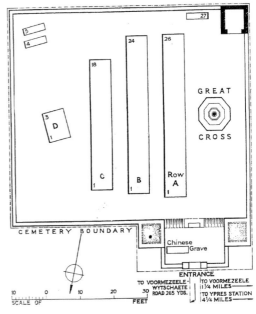

DERRY HOUSE CEMETERY NO. 2

— WIJTSCHATE (HEUVELLAND)

Wijtschate is part of Heuvelland and is located appr. 5 km south of Ypres. Derry House Cemetery No. 2 is located 8 km south of Ypres town centre, on a road leading from the Rijselseweg N365, which connects Ypres to Wijtschate and on to Armentières. From Ypres town centre the Rijselstraat runs from the central market square, through the Lille Gate (Rijselsepoort) and directly over the crossroads with the Ypres ring road. The road name then changes to Rijselseweg. Derry House Cemetery No. 2 is reached by turning left in the village of Wijtschate along the Houtemstraat. The first right hand turning along Houtemstraat leads onto Krommestraat. 800 m along the Krommestraat lies a turning to the left. Derry House Cemetery No. 2 is located 50 m beyond this left hand turning.

IDENTIFIED COMMONWEALTH HEROES

 126 37

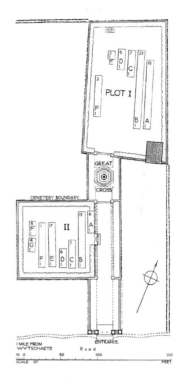

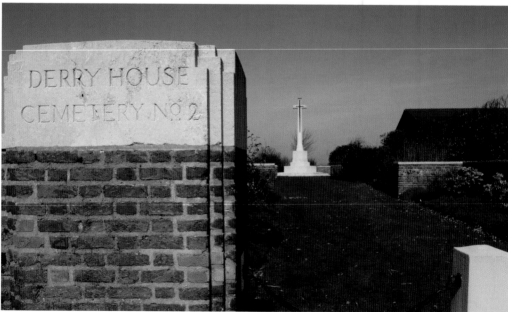

IN BEVEREN

'In Beveren' restaurant hasn't stolen its name: it is situated close to the church of Beveren aan de IJzer, lying in the centre of the Westhoek area, where many monuments and cemeteries of the Great War are located. (Distance Beveren aan de IJzer – Ypres: 25 km = 15,5 miles)

'In Beveren' restaurant offers well-priced menus and skilful, accomplished, modern cooking. Groups (15 – 100 p.) are welcome every day on request. The restaurant is open on Fridays, Saturdays and Sundays, and during school holidays exceptionally on Wednesday.

In Beveren, of the same owner, is a luxurious holiday-residence with a capacity of 6 people. Contact Gilbert Maelstaf for more information.

IN BEVEREN

Huis Maelstaf
Roesbruggestraat 20 - Beveren aan de Ijzer
Tel: +32 (0) 57 30 05 73
or +32 (0) 476 83 50 28
E-mail: huis.maelstaf@telenet.be
www.inbeveren.be

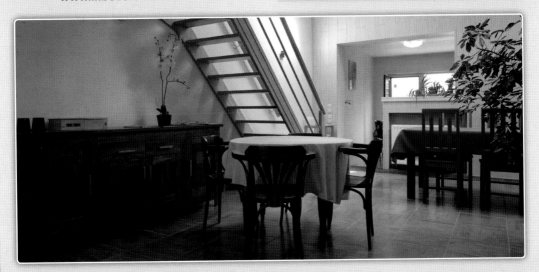

DOCHY FARM
NEW BRITISH CEMETERY

— LANGEMARK-POELKAPELLE

Langemark-Poelkapelle is north east of Ypres. Dochy Farm New British Cemetery is on the north east side of the road from Zonnebeke to Lange-mark, a little south of the point where it crosses the road from Wieltje to Gravenstafel. The cemetery is located on Zonnebekestraat, a road leading from the Zonnebeekseweg (N332) connecting Ypres to Zonnebeke. Two roads connect Ypres town cen-tre onto the Zonnebeekseweg. Lange and Korte Torhoutstraat lead from the market square onto a small roundabout. Take the first right turn which is Basculestraat. At the end of Basculestraat there is a crossroads and Zonnebeekseweg is the turning to the left. 7 km along the Zonnebeekseweg, in the village of Zonnebeke, lies the left hand turning onto the Langemarkstraat (further on this street changes its name to Zonnebeeksestraat). The cemetery lies 1.5 km along this road on the left hand side.

IDENTIFIED COMMONWEALTH HEROES

 295 35 46 97 8

 GRAVES OF INTEREST (P. 59)

Evans, II C 5

Speirs, VI E 15

Crain, VIII A 17

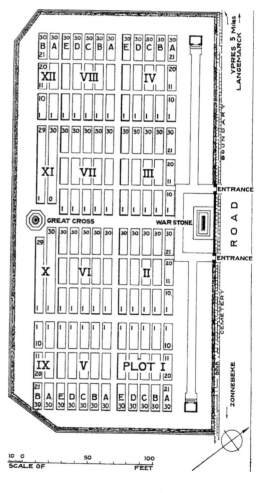

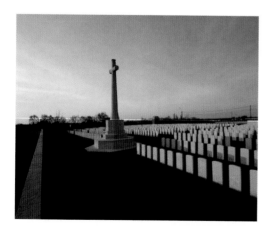

DOZINGHEM MILITARY CEMETERY

— WESTVLETEREN

Westvleteren is located north west of Poperinge near Krombeke. From the centre of Poperinge, follow the directions to Veurne. From Ypres follow the directions to Poperinge along the by-pass. At the end of the by-pass at the traffic lights turn right into Oostlaan. Follow Oostlaan over the roundabout to the end of the road. Turn left into Veurnestraat and follow along here to the first turning on the right. Turn into Sint-Bertinusstraat and follow this road up the rise and round a left hand bend. After the bend, take the right hand turning in the direction of Krombeke along the Krombeekseweg. Follow the Krombeekseweg past the 'De Lovie' centre where the road name changes to Leeuwerikstraat, and then past a cafe on the left, you will see a sign for the cemetery pointing to a track on the right in the woods. Dozinghem Military Centre is along here at the end of the track.

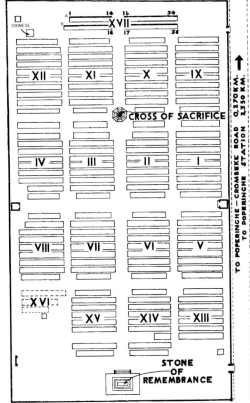

IDENTIFIED COMMONWEALTH HEROES

 3057 81 14 6 15

GRAVES OF INTEREST (P. 61-65)

Henshaw, III H 7

Denison, IV F 1

Osler, IV F 21

Foaley, IV G 22

Sterndale-Bennett, VI I 1

Lamb, VII I 18

Bayliss, VIII E 1

Collett, IX J 10

De Heriz, X I 1

Clarkson, XI E 5

DRANOUTRE CHURCHYARD

— DRANOUTER (HEUVELLAND)

Dranouter is part of Heuvelland and is located appr. 11 km south of Ypres town centre, on a road leading from N375, Dikkebusseweg. From Ypres town centre the Dikkebusseweg is reached via Elverdingestraat, straight over a roundabout onto Capronstraat, then immediately left along Fochlaan. After the train station, the first right hand turning is Dikkebusseweg. On passing through the village of Dikkebus the road continues for 6 km to the village of Loker. Continuing through the village of Loker, the road becomes Dikkebusstraat which runs for 2 km to the village of Dranouter. The church and churchyard are located in the centre of the village.

IDENTIFIED COMMONWEALTH HEROES

 77

'Spent all night trying to console, aid and remove the wounded. It was ghastly to see them lying there in the cold, cheerless outhouses, on bare stretchers with no blankets to cover their freezing limbs.'

Chaplain Francis Gleeson,
Royal Munster Fusiliers

DRANOUTRE MILITARY CEMETERY

— DRANOUTER (HEUVELLAND)

For the location of Dranoutre Military Cemetery, see info on Dranoutre Churchyard. 50 m before Dranouter village, coming from Dikkebusstraat, lies a right hand turning into a semi residential area. The cemetery is located 50 m after this turning on the left hand side of the road.

IDENTIFIED COMMONWEALTH HEROES

 419 19 1 16

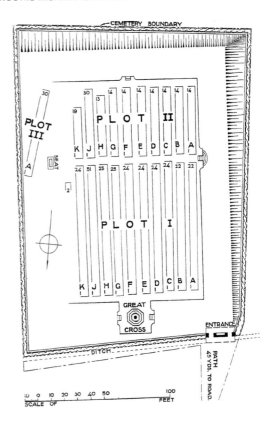

SAT NAV

See **www.poigraves.co.uk** for the exact location of all Commonwealth cemeteries of World War I.

www.inmemories.com is dedicated to the continued memory of those men and women of the Commonwealth who died as a result of the World Wars.

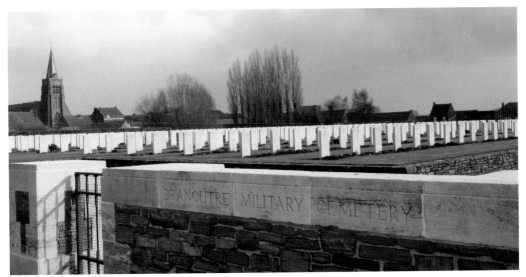

GODEZONNE FARM CEMETERY

— KEMMEL (HEUVELLAND)

Kemmel is part of Heuvelland and is located south of Ypres. From Ypres go through the Lille Gate (Rijselsepoort) and head towards Armentières (N365). After about 1 km on the right and just before the level crossing is the N331 Kemmelseweg. Follow this road for 5 km and then take the right turn onto Poperingestraat. A further 800 metres further take the left turn into Kriekstraat; Godezonne Farm Cemetery is a further 800 m on your left hand side.

IDENTIFIED COMMONWEALTH HEROES

 33 1 1

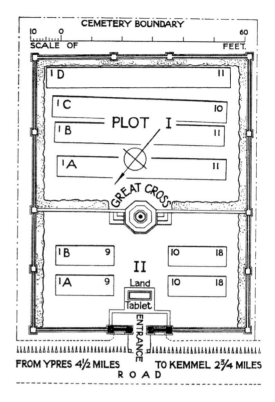

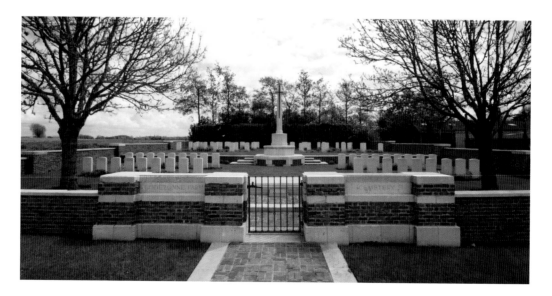

GROOTEBEEK BRITISH CEMETERY

— RENINGELST (POPERINGE)

GRAVES OF INTEREST (P. 83)

Lynn, Spec. Mem.

Reningelst is part of Poperinge and is located about 3 km south east of that town. Grootebeek British Cemetery is located about 1.5 km north east of Reningelst. From Ypres town centre the Poperingseweg (N308) is reached via Elverdingestraat, then go over two roundabouts into Capronstraat. The Poperingseweg is a continuation of this Capronstraat and begins after a prominent railway level crossing. On reaching the village of Vlamertinge take the left hand turning onto Bellestraat. After crossing the N38 (from Ypres to Poperinge), Grootebeek British Cemetery lies a further 5 km along Bellestraat which changes its name to Vlamertingseweg. The cemetery is on the right hand side of the road in the hamlet of Ouderdom; entrance next to no. 29. Grootebeek British Cemetery also contains two Second World War burials dating from May 1940 and the withdrawal of the British Expeditionary Force ahead of the German advance.

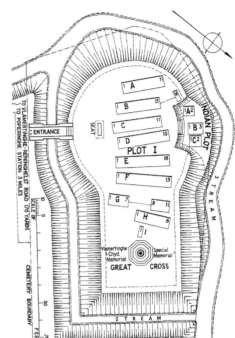

IDENTIFIED COMMONWEALTH HEROES

100 1 1 7

HUIS VERDONCK

Huis Verdonck is ideally located at the main market square of Veurne (Furnes), at only a stone's throw from the Flanders Fields memorials and cemeteries.

Huis Verdonck is a locally renowned tea-room, a vibrant gathering place for all to enjoy the fabulous home-made ice-cream (since 1924!), pancakes, waffles and pastry. Verdonck also includes a shop with local specialties, chocolates and gift-baskets, and serves breakfast, lunch and dinner in the tea-room.

Groups of up to 100 people can be accommodated in the tea-room, and up to 60 people on the first floor.

HUIS VERDONCK

Grote Markt 11 - 8630 Veurne
Tel: +32 (0)58 31 22 86
E-mail: verdonckijs@skynet.be
www.verdonckijs.be

GUNNERS FARM MILITARY CEMETERY

— COMINES-WARNETON

Gunners Farm Military Cemetery is located appr. 16 km from Ypres. Leave Ypres via the Lille Gate (Rijselsepoort). You go straight over the first roundabout in the direction of Armentières (N365) where the name of the road changes to Rijselseweg. You pass the village of Ploegsteert. 2 km after the village take the left turn onto the Chemin de la Blanche (Witteweg).

At the end of this road turn left onto the Rue du Touquet. The cemetery can be found 1 km along this road at your left hand side, only 200 m away from Calvaire (Essex) Military Cemetery. From Gunners Farm Military Cemetery you have a nice view on the church of Ploegsteert.

IDENTIFIED COMMONWEALTH HEROES

163 1 2 9

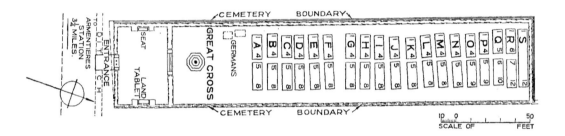

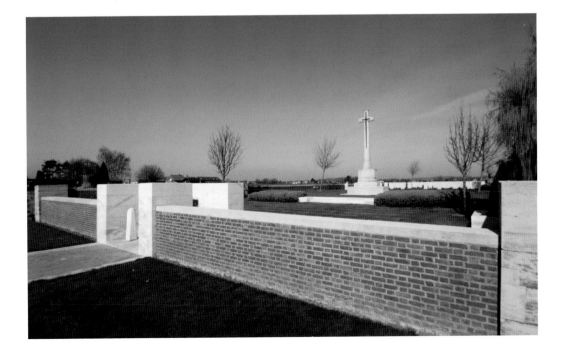

GWALIA CEMETERY

— POPERINGE

Gwalia Cemetery is located 8.5 km west of Ypres town centre on the Elverdingseweg (N333). Take the N8 Veurnseweg from Ypres in the direction of Elverdinge. Upon reaching Elverdinge turn left onto the N333 Steentjemolenstraat and a further 4.5 km along this road which changes its name to Elverdingseweg. The cemetery is on your right hand side. Access is via a 400 m grass track (next to the farm at Elverdingseweg no. 22, called 'Gwalia Farm') and can be difficult. Also buried here: 4 men of the Chinese Labour Corps and 3 German soldiers.

IDENTIFIED COMMONWEALTH HEROES

452 5 5 2 1

GRAVES OF INTEREST (P. 86-89)

Salmon, I E 33

Woods, I F 34

Whitrod, I H 30

Mc Kenzie, II A 19

Beresford, II E 9

West, II F3

Luxford, II F 17

Paterson, II G 20

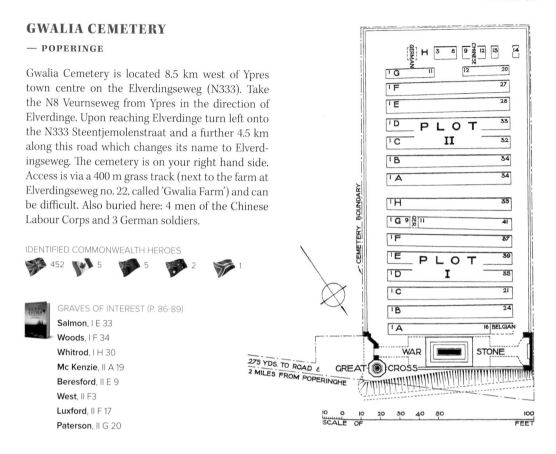

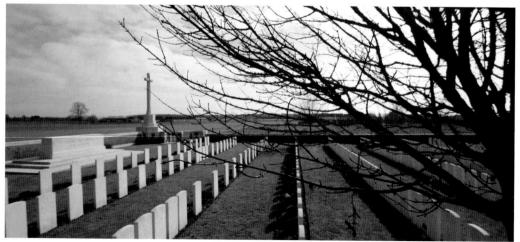

HARINGHE (BANDAGHEM) MILITARY CEMETERY

— HARINGHE (POPERINGE)

Haringhe is part of Poperinge and is located appr. 7 km north west of that town. Haringhe (Bandaghem) Military Cemetery is located 18 km from Ypres town centre on a road leading from the N308 connecting Ypres to Poperinge and on to Roesbrugge. From Ypres town centre the Poperingseweg (N308) is reached via Elverdingestraat, then directly over two small roundabouts in the Capronstraat. The Poperingseweg is a continuation of the Capronstraat and begins after a prominent railway level crossing. On reaching the ring road of Poperinge, the R33 Europalaan rejoins the N308 towards Oost Cappel. 10 km further lies the village of Roesbrugge. The second left hand turning in that village leads onto the Haringestraat and 2 km further to the village of Haringhe. The second right hand turning leads onto Nachtegaalstraat. Haringhe (Bandaghem) Military Cemetery lies 400 m along the Nachtegaalstraat, on the left hand side of the road.

IDENTIFIED COMMONWEALTH HEROES

 743 6 11 2 7

 GRAVES OF INTEREST (P. 90)

Furlonger, AM, III D 31

Johnson, AM, III D 32

Farren, AM, III D 33

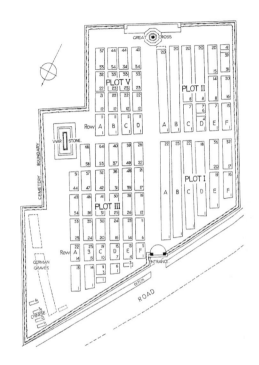

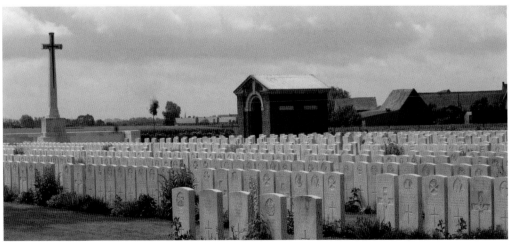

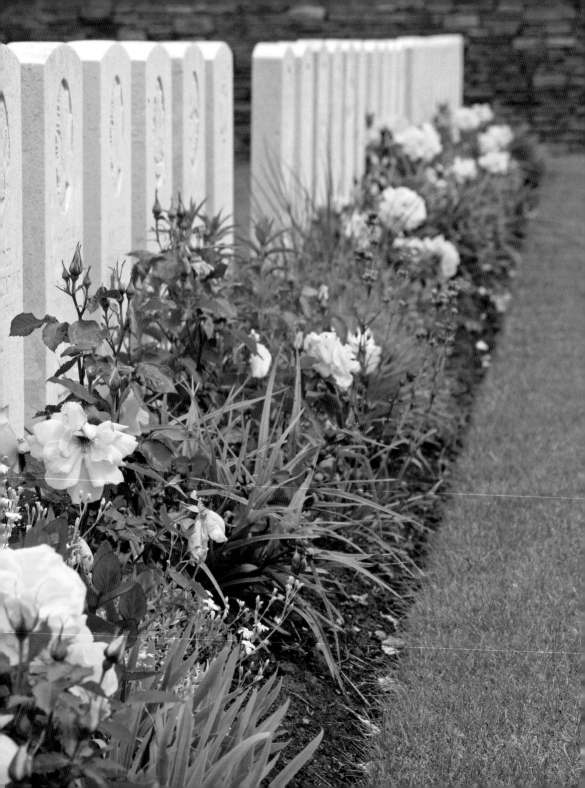

HYDE PARK CORNER (ROYAL BERKS) CEMETERY

— COMINES-WARNETON

Hyde Park Corner Cemetery is located 12.5 km south of Ypres town centre, on the Rijselseweg (N365), a road connecting Ypres to Armentières. You leave Ypres via the Lille Gate (Rijselsepoort) and go directly over the roundabout onto the N365. You pass the villages of Wijtschate and Messines. The cemetery is located on the left hand side of the road, opposite the Ploegsteert Memorial.

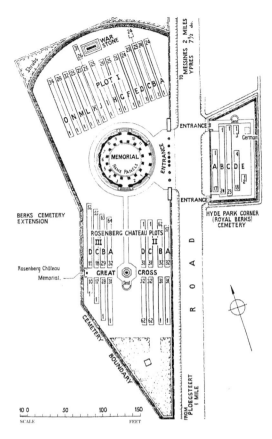

IDENTIFIED COMMONWEALTH HEROES

 81 1 1

 GRAVES OF INTEREST (P. 99-100)

French, B 2

Poulton-Palmer, B 11

William-Giles, B 13

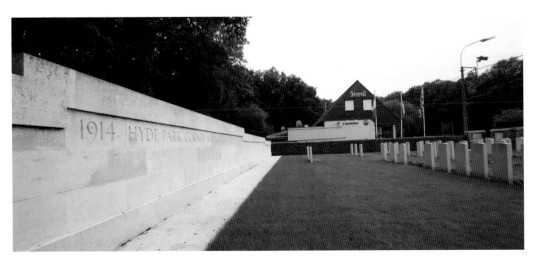

IRISH HOUSE CEMETERY

— KEMMEL (HEUVELLAND)

Kemmel is part of Heuvelland and is located south of Ypres. From Ypres go through the Lille Gate (Rijselsepoort) and head towards Armentières (N365). Upon reaching the village of Wijtschate the first right turn leads onto Hospicestraat, which leads to the village square. From the square take the Wijtschatestraat and after appr. 2 km turn right onto Savaardlindestraat. Irish House Cemetery is located 800 m along Savaardlindestraat, on the right hand side of the road.

IDENTIFIED COMMONWEALTH HEROES

 63 14

GRAVES OF INTEREST (P. 102)

Dobie, A 30

McWilliam, A 30

McKinlay, A 31

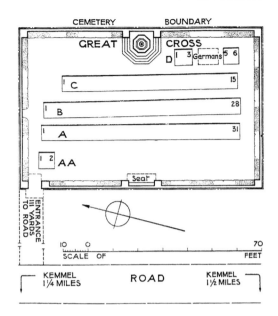

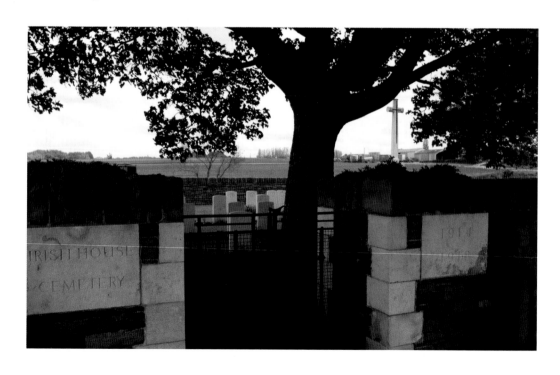

KANDAHAR FARM CEMETERY
— NIEUWKERKE (HEUVELLAND)

Nieuwkerke is part of Heuvelland and is located appr. 10 km south west of Ypres, and appr. 10 km south east of Poperinge. Leave Ypres via the Lille Gate (Rijselsepoort), go across the roundabout onto the N365 direction Armentières. Remain on this road until reaching Mesen (Messines), then take the first right turn onto Mesenstraat (N314). This road first goes to Wulvergem, then to Nieuwkerke. Kandahar Farm Cemetery is located 1 km beyond the village of Wulvergem on the left hand side of Nieuwkerkestraat.

IDENTIFIED COMMONWEALTH HEROES

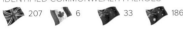 207 6 33 186

 GRAVES OF INTEREST (P. 103)

Sahr, II C 21

MacDonald, II F 9

Howie, II G 34

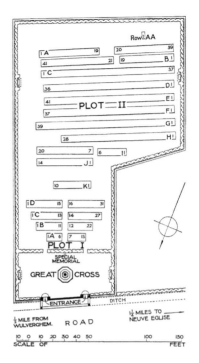

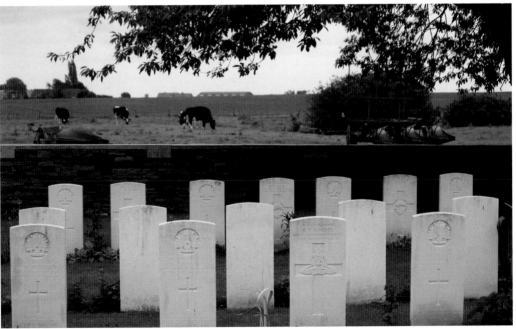

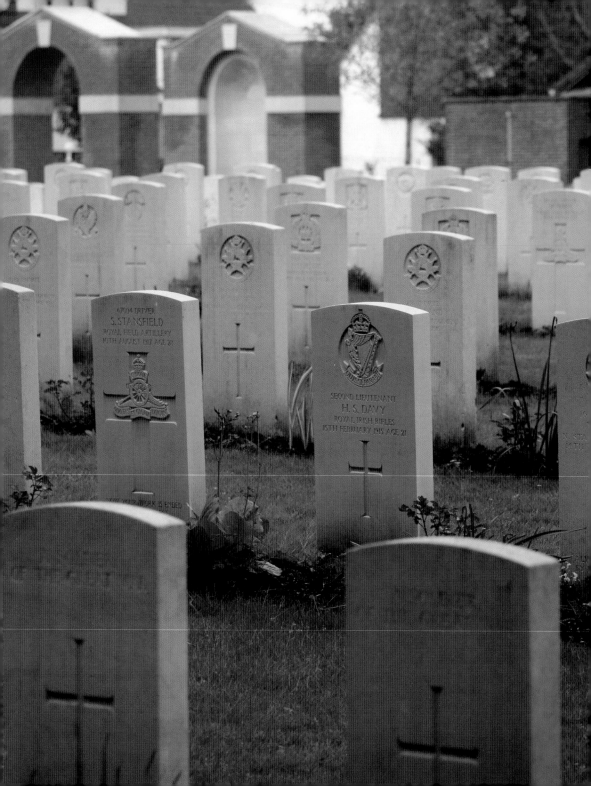

KEMMEL CHATEAU MILITARY CEMETERY
— KEMMEL (HEUVELLAND)

Kemmel is part of the village of Heuvelland. It was heavily damaged during the First World War, mainly because of the presence of Kemmel Mountain (156 m high) appr. 1,5 km south west of the village. Leave Ypres via the Lille Gate (Rijselsepoort) and follow the N365 signs (Ypres-Armentières). After 900 m, just before the railway crossing, turn right onto Kemmelseweg. Upon reaching the village of Kemmel, the first turn leads into Reningelststraat. A further 600 m along this road is a right turn into Nieuwstraat. The cemetery is on your right hand side.

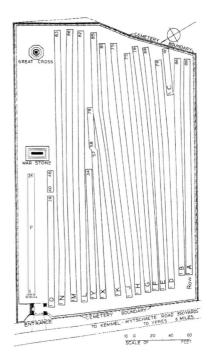

IDENTIFIED COMMONWEALTH HEROES

 1027 80 1 23

KEMMEL CHURCHYARD

— KEMMEL (HEUVELLAND)

Kemmel is part of the village of Heuvelland. For its exact location, see info on Kemmel Chateau Military Cemetery. 600 m along Reningelststraat is the church and churchyard of Kemmel.

IDENTIFIED COMMONWEALTH HEROES

 21 1

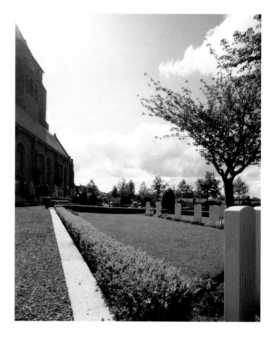

'In a matter of seconds, a hissing and shrieking pandemonium broke loose. The sky was splashed with light. Rockets, green, yellow and red, darted in all directions; and simultaneously, a cyclone of bursting shells enveloped us.'

JFB O'Sullivan,
6th Connaught Rangers

KEMMEL NO. 1 FRENCH CEMETERY

— KEMMEL (HEUVELLAND)

Kemmel is part of the village of Heuvelland. In April 1918, it was the scene of fierce fighting in which both Commonwealth and French forces were engaged. Leave Ypres via the Lille Gate (Rijselsepoort) and follow the N365 signes (Ypres-Armentières). After 900 m, just before the railway crossing, turn right onto Kemmelseweg. 5 km further go right into Vierstraat. You will find Kemmel No. 1 French Cemetery on your left hand side. Good parking facilities.

IDENTIFIED COMMONWEALTH HEROES

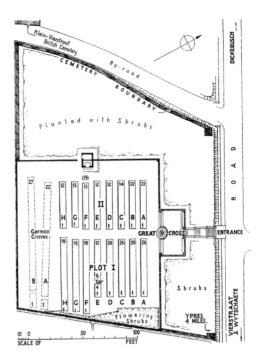

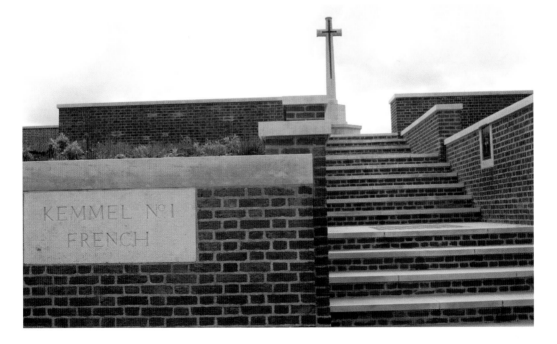

KLEIN VIERSTRAAT BRITISH CEMETERY

— KEMMEL (HEUVELLAND)

Kemmel is part of Heuvelland. Leave Ypres via the Lille Gate (Rijselsepoort), and follow the N365 signs Ypres-Armentières. Then follow the direction to Kemmel No. 1 French Cemetery (see text about that cemetery). There is a parking area. Walk across the road to Klein Vierstraat British Cemetery.

IDENTIFIED COMMONWEALTH HEROES

 673 7 7 8 1

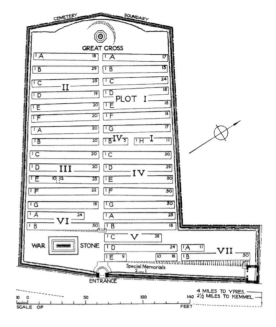

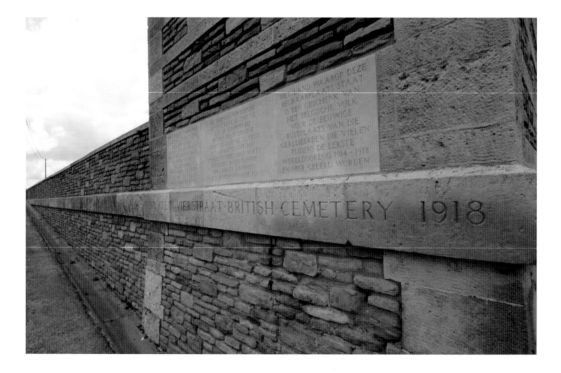

B&B HOP INN

Welcome to Bed & Breakfast Hop Inn! We are located in the centre of Poperinge, called 'Pop' by the Commonwealth officers and soldiers who fought in the Great War. We have a capacity of 10 people, of which 6 on the first floor.

We are a well run, spotlessly kept and privately owned B & B, with the battlefields, monuments and cemeteries of the Ypres Salient on its doorstep.

The rooms' decor represents a contemporary feel with stylish colours. Our extensive breakfast, with oven-fresh bread and bread rolls from the bakery, is a real treat.

B&B HOP INN

Sint-Bertinusstraat 57 - 8970 Poperinge
Tel: +32 (0) 472 55 46 36
E-mail: info@hopinn.be
 www.hopinn.be

LA CLYTTE MILITARY CEMETERY

— DE KLIJTE (HEUVELLAND)

De Klijte (formerly La Clytte) is part of Heuvelland.
Technically speaking, De Klijte is not a real 'deelge-
meente' of Heuvelland, because before it was part
of Reningelst, which is now part of Poperinge. La
Clytte Military Cemetery is located appr. 8 km west
of Ypres town centre on the N304 Klijtseweg, a road
leading from the N375 Dikkebusseweg, connecting
Ypres to Dikkebus, De Klijte and on to Loker. From
Ypres town centre the Dikkebusseweg is located via
Elverdingestraat, straight over a roundabout onto
Capronstraat (for 30 m), then left along Fochlaan.
Immediately after the train station, the first right
hand turning is Dikkebusseweg. 7 km along Dikke-
busseweg lies the village of De Klijte. The right hand
turning at the roundabout just before the village
leads onto Reningelststraat (N304). La Clytte Mili-
tary Cemetery lies 100 m after this right hand turn-
ing on the left hand side of the road.

IDENTIFIED COMMONWEALTH HEROES

 776 50 3 10 5

 GRAVES OF INTEREST (P. 109)

Hollowell, IV A 10

Stephen, IV B 3

Bamber Helm, V C9

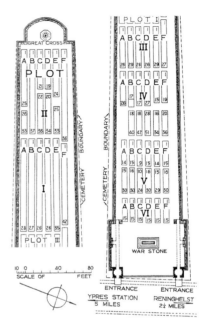

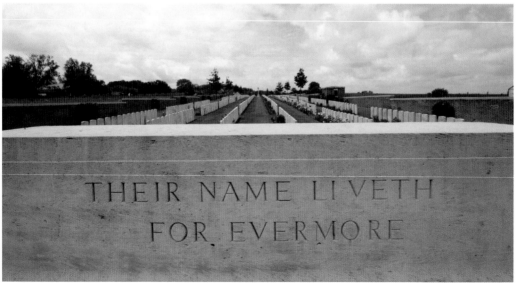

LA LAITERIE
MILITARY CEMETERY

— KEMMEL (HEUVELLAND)

Kemmel is part of Heuvelland and is located south of Ypres. From Ypres go through the Lille Gate (Rijselsepoort) and head towards Armentières (N365). After 900 m, just before the level crossing, is a right turn onto Kemmelseweg. La Laiterie Military Cemetery is a further 5 km on your right hand side.

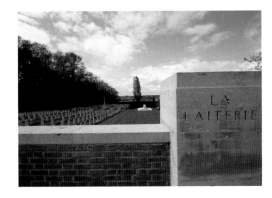

IDENTIFIED COMMONWEALTH HEROES

 378 190 3

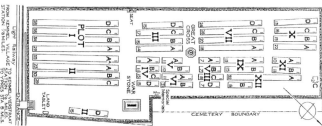

 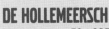

LA PLUS DOUVE FARM CEMETERY

— COMINES-WARNETON

The village of Comines-Warneton is located appr. 12 km south of Ypres, on the Rijselseweg (N365), a road connecting Ypres to Armentières. You leave Ypres via the Lille Gate (Rijselsepoort) and go directly over the roundabout onto the N365. You pass the villages of Wijtschate and Mesen (Messines). On reaching Mesen, the first right hand turning leads to Nieuwkerkestraat (N314). 2 km along Nieuwkerkestraat lies the left hand turning onto Plus Douve. The cemetery is to be found 600 m along Plus Douve, on your right hand side. There is a 100 m grassed access path which is unsuitable for cars.

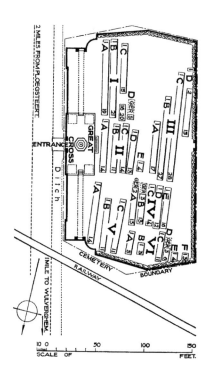

IDENTIFIED COMMONWEALTH HEROES

 101 88 61

 GRAVES OF INTEREST (P. 111)
Cuthbert, II B 7
Atkinson, IV E 12

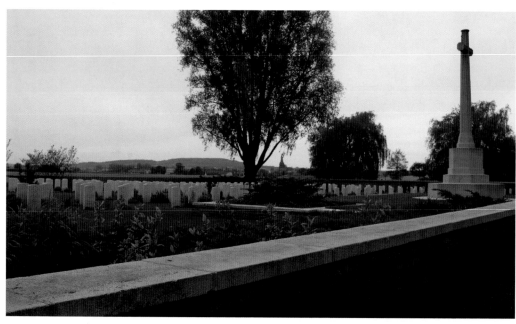

LANCASHIRE COTTAGE CEMETERY

— COMINES-WARNETON

Lancashire Cottage Cemetery is located approx. 11 km south of Ypres. Take the N365 Ypres-Armentières road. Continue to the village of Ploegsteert and upon reaching the village take the left turn onto Rue de Ploegsteert. The cemetery is 1 km further, on your right hand side.

IDENTIFIED COMMONWEALTH HEROES

 228 2 23

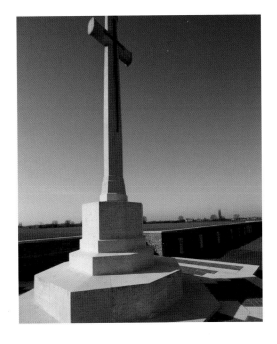

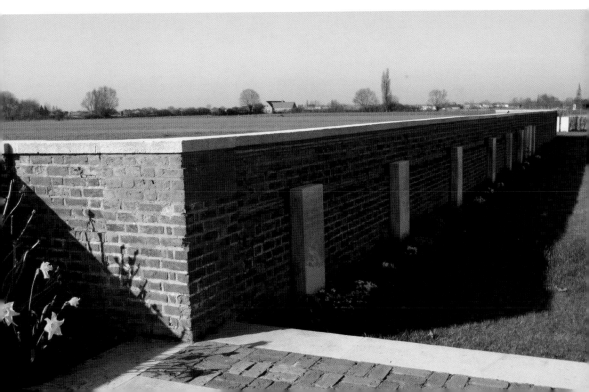

LANGEMARK GERMAN MILITARY CEMETERY

— LANGEMARK (LANGEMARK-POELKAPELLE)

IDENTIFIED COMMONWEALTH HEROES

 2

Langemark is part of Langemark-Poelkapelle and is situated north east of Ypres, off the N313, a road that runs between Ypres and Langemark-Poelkapelle. From Ypres market square, take Korte Ieperstraat, at the end turn right into Boezingestraat, then past the first turning left. From N313 turn off towards Langemark along the Zonnebekestraat (opposite the St. Julian Canadian Memorial). Follow the Zonnebekestraat into the village to the traffic lights, go straight over at the lights into Klerkenstraat, and Langemark German Military Cemetery is on your left hand side.

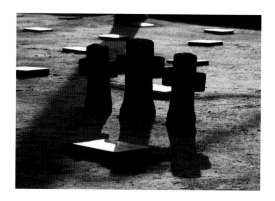

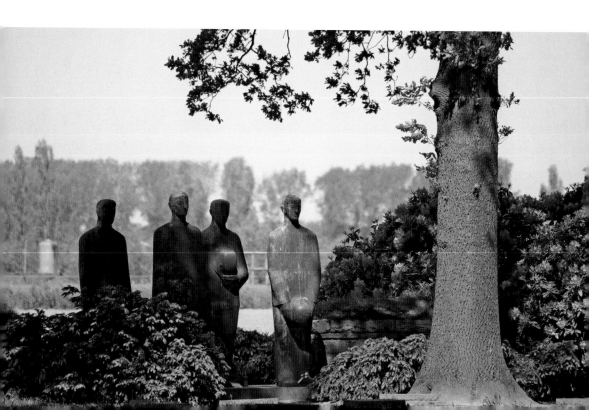

LE TOUQUET RAILWAY CROSSING CEMETERY

— COMINES-WARNETON

Le Touquet Railway Crossing Cemetery is located approx. 15 km south of Ypres town centre, on a road leading from the Rijselseweg (N365), which connects Ypres to Wijtschate, Mesen, Ploegsteert and onto Armentières. 2 km after the village of Ploegsteert is a left turn onto the Chemin de la Blanche. At the end of this road turn left onto the Rue du Touquet. The cemetery can be found 1 km along this road, on your left hand side.

IDENTIFIED COMMONWEALTH HEROES

 50

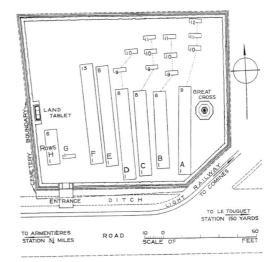

LIJSSENTHOEK MILITARY CEMETERY

— POPERINGE

Lijssenthoek Military Cemetery is located at Poperinge and appr. 12 km west of Ypres town centre, on the Boescheepseweg, a road leading from the N308 connecting Ypres to Poperinge. From Ypres town centre the Poperingseweg (N308) is reached via Elverdingestraat, then over small roundabouts into Capronstraat. The Poperingseweg is a continuation of this Capronstraat and begins after a prominent railway level crossing. On reaching Poperinge, the N308 joins the left hand turning onto the R33 (Poperinge ring road). The R33 continues to the left hand junction with the N38 Frans-Vlaanderenweg. 800 m along the N38 lies the left hand turning onto Lenestraat. The next immediate right hand turning leads onto Boescheepseweg. The cemetery itself is located 2 km along Boescheepseweg, on the right hand side of the road.

IDENTIFIED COMMONWEALTH HEROES

 7366 1058 291 1131

 28 3

GRAVES OF INTEREST (P. 114-125)

Ogilvie-Grant, II A 4
Sargent, III A 17 A
Hewitt, V C 13
Fernald, VI A 36
Lynn, VII D 32 A
Crabbe, XI B 18 A
Barnes, XI B 20
Spindler, XVI A 3
Morrison, XVIII A3 A
Jones, XIX A1A
Tubb, XIX C5
Glass, XX H15
Bendall, XXI AA18
Singh, XXI FF21
King, XXI H17
Duncan, XXII A12
Mountford, XXII C12
Seabrook, XXIII B5
Baker, XXV B22
Jefferies, XXXI BB5
Beattie, XXXII C14
Pigue, XXXII E9

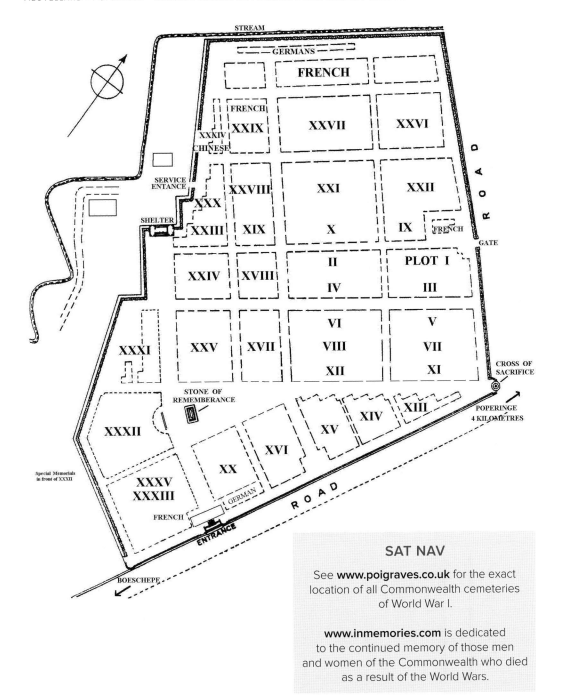

SAT NAV

See **www.poigraves.co.uk** for the exact
location of all Commonwealth cemeteries
of World War I.

www.inmemories.com is dedicated
to the continued memory of those men
and women of the Commonwealth who died
as a result of the World Wars.

'T RUSTPLEKJE

' t Rustplekje is the ideal location for those people who want to have a quiet holiday in beautiful surroundings. 'Rustplekje' by the way is Flemish for 'quiet place'.

We are located in Beveren aan de IJzer (Alveringem), very close to the valley of the river Yser, so important in the history of World War One.

't Rustplekje offers accommodation for eight, including two bathrooms and four bedrooms. We have a nice terrace with garden furniture, BBQ, and a small playground for children. Extensive walking and cycling possibilities.

'T RUSTPLEKJE

Hondschotestraat 15
8691 Beveren a/d IJzer (Alveringem)
Tel: +32 (0) 57 30 04 23
or +32 (0) 472 67 13 48
E-mail: info@rustplekje.be
 www.rustplekje.be

LINDENHOEK CHALET MILITARY CEMETERY

— KEMMEL (HEUVELLAND)

Kemmel is part of the village of Heuvelland. Leave Ypres via the Lille Gate (Rijselsepoort) and follow the N365 signs (Ypres-Armentières). After 900 m, just before the railway crossing, turn right onto Kemmelseweg. After passing the village of Kemmel lies Gremmerslinde. Take the right turn off the N331. Lindenhoek Chalet Military Cemetery can be found a further 500 m on the right.

IDENTIFIED COMMONWEALTH HEROES

 217 15 7 9

GRAVES OF INTEREST (P. 126-127)

Shoemake, I B 4

Baum, I C 6

Blowers, I G 13

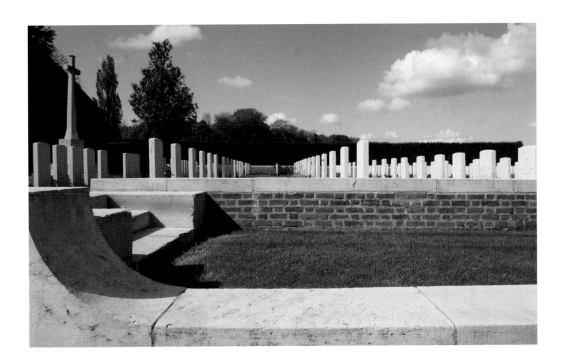

LOCRE CHURCHYARD

— LOKER (HEUVELLAND)

Loker (formerly Locre) is located at about 11 km south west from Ypres. From Ypres town centre take Elverdingestraat (direction Elverdinge), then left along Fochlaan. Immediately after the train station, the first right hand turning is Dikkebusseweg (N375), which will lead you to Loker, after having passed through the village of Dikkebus. Loker is about 6 km from Dikkebus. The church and churchyard are to be found in the centre of the village of Loker itself.

IDENTIFIED COMMONWEALTH HEROES

 182 32

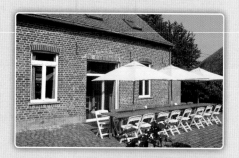

LOCRE HOSPICE CEMETERY

— LOKER (HEUVELLAND)

For information on Loker and its location, see the previous part on Locre Churchyard. At Loker take Kemmelbergweg and then immediately Godtschalckstraat. The cemetery is on this road, about 1 km further.

IDENTIFIED COMMONWEALTH HEROES

 229 1 1 1

 GRAVES OF INTEREST (P. 128-129)

Kellett, III A 2

Redmond, separate location

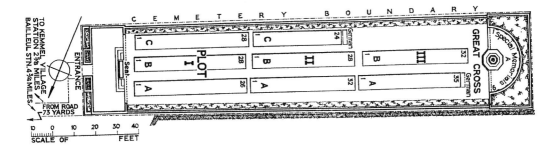

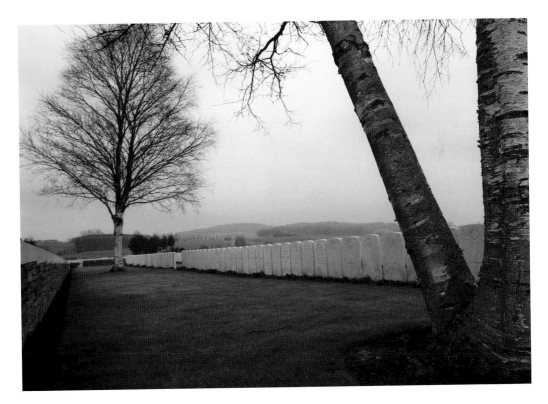

LOCRE NO. 10 CEMETERY

— LOKER (HEUVELLAND)

For information on Loker and its location, see the part on Locre Churchyard. For Locre No. 10 Cemetery, go the same way as was indicated in the case of Locre Churchyard. Continue through the village of Loker. Dikkebusseweg (N375) becomes Dikkebusstraat, a road that goes further in the direction of Dranouter. Locre No. 10 Cemetery is located about 1.5 km further, on your right hand side.

IDENTIFIED COMMONWEALTH HEROES

 44

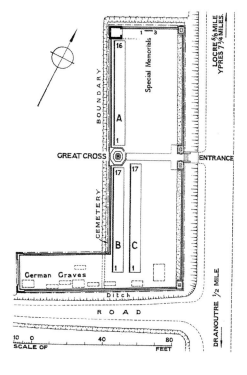

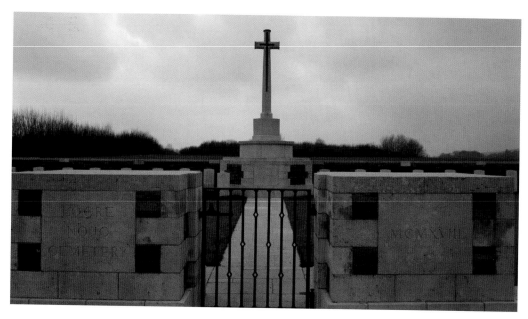

LONDON RIFLE BRIGADE CEMETERY

— COMINES-WARNETON

This cemetery can easily be found on the Ypres-Armentières N365 road. Continue on this road through the village of Ploegsteert. London Rifle Brigade Cemetery is located appr. 1 km further, on your right hand side.

IDENTIFIED COMMONWEALTH HEROES

262 34 38

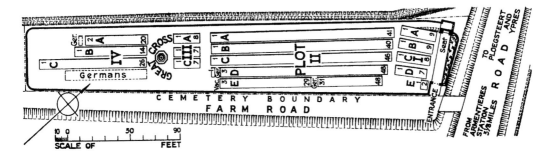

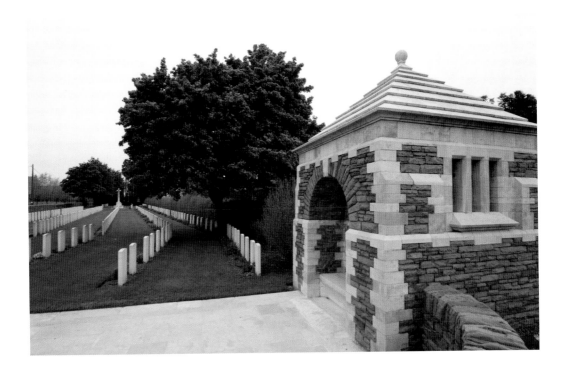

LONE TREE CEMETERY

— WIJTSCHATE (HEUVELLAND)

Wijtschate (previously Wytschate / White Sheet) is part of the village of Heuvelland. In fact, when one talks about 'Messines Ridge', the correct geographical indication would be the hills around Wijtschate. To reach Wijtschate from Ypres, leave the city via the Lille Gate (Rijselsepoort in Flemish), go directly over the crossroads with the Ypres Ring and take the N365 that goes to Armentières. Upon reaching the village of Wijtschate the first street to the right is Hospicestraat, which leads to the village square. From that square take Wijtschatestraat. 2 km further, turn left (Kruisstraat). You will find Lone Tree Cemetery in the fields, about 1 km on your right hand side. Access can be a bit difficult when it rains, although a concrete access path has been built recently.

IDENTIFIED COMMONWEALTH HEROES

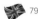 79

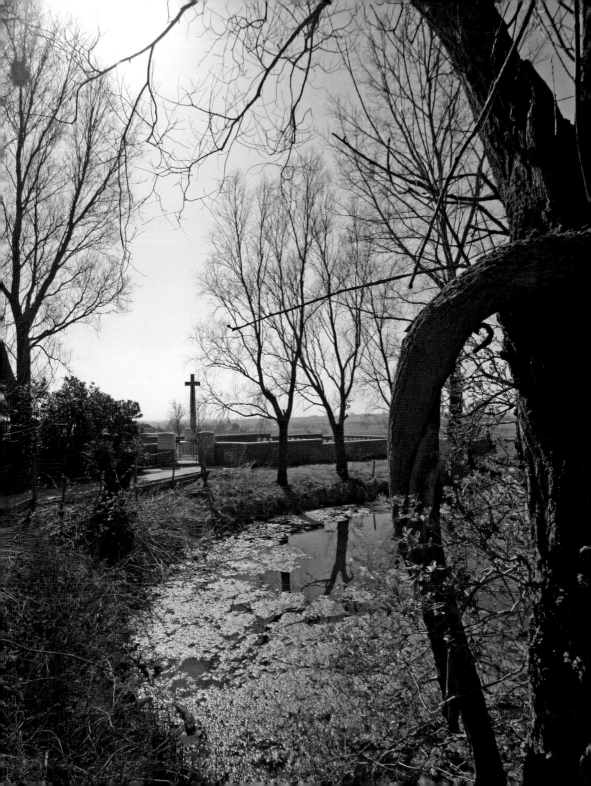

MAPLE LEAF CEMETERY

— COMINES-WARNETON

The village of Comines-Warneton is located appr. 12 km south of Ypres town centre. Take the N365 Ypres-Armentières road. Continue to the village of Ploegsteert and upon reaching the village turn right (at the church) into Rue du Romarin. At the end of this road lies the left hand turning onto Niepkerkestraat (for only 50 m), then immediately right onto Zakstraat. Maple Leaf Cemetery is located 50 m beyond the turn onto Zakstraat.

IDENTIFIED COMMONWEALTH HEROES

80 39 43 4 1

GRAVES OF INTEREST (P. 135)

Parry, K 4

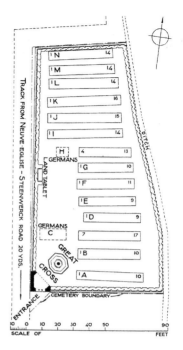

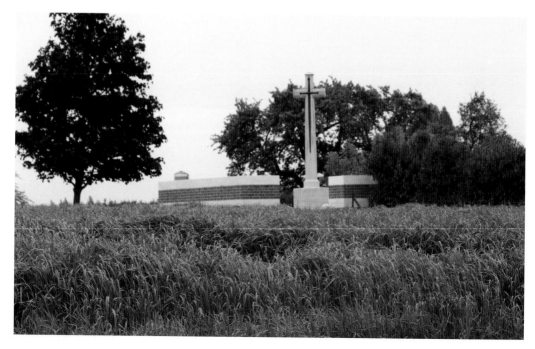

MENDINGHEM
MILITARY CEMETERY

— PROVEN (POPERINGE)

The village of Proven, part of Poperinge, is to be found at appr. 6 km north west of Poperinge. Starting from Ypres, take the Poperingseweg (N308) that starts after the prominent railway crossing. After reaching the Poperinge ring road (R33, Europalaan), the route circles the town of Poperinge and rejoins the N308 towards Oost Cappel. 6.5 km further is the village of Proven. Then a further 500 m and Mendinghem Military Cemetery, designed by Sir Reginald Blomfield, is on the left hand side of the road, which is now called Roesbruggestraat. Visitors to this site should note a 200 m gravelled access road which is suitable for small vehicles.

IDENTIFIED COMMONWEALTH HEROES

🇬🇧 2292 🇨🇦 31 🇳🇿 12 🇦🇺 15

🇿🇦 33 🇮🇳 26

GRAVES OF INTEREST (P. 136-137)

Powell, I F 12

Griffin, I F 12

Best-Dunkley, VC, III D 1

Glasgow, IV F 18

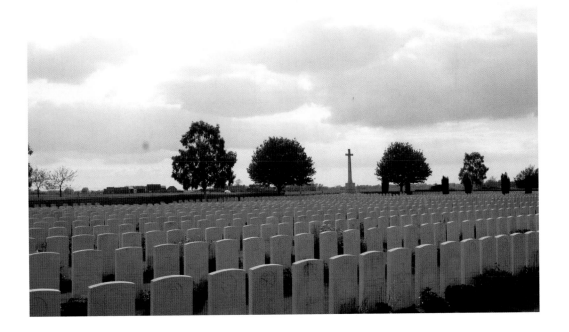

MESSINES RIDGE
BRITISH CEMETERY

— MESEN (MESSINES)

The village of Mesen (Messines) is located appr. 8 km south of Ypres. From Ypres town centre go through the Lille Gate (Rijselsepoort) and continue directly over the crossroads with the Ypres ring road. The road name then changes to Rijselseweg (N365). Follow this road to the town of Mesen, then take a right turn into Nieuwkerkestraat. Messines Ridge British Cemetery can be found a further 250 m, on your left hand side.

IDENTIFIED COMMONWEALTH HEROES

 295 1 67 204 10

 GRAVES OF INTEREST (P. 140)
Rundle, I B 60

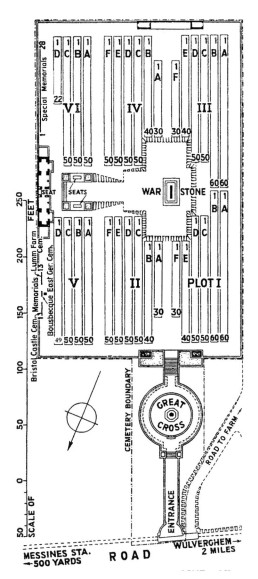

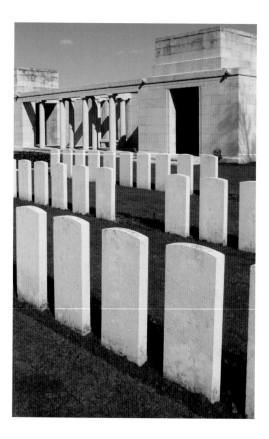

MOTOR CAR CORNER CEMETERY

— COMINES-WARNETON

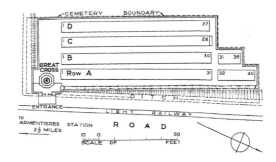

The village of Comines-Warneton is located appr. 12 km south of Ypres. Motor Car Corner Cemetery can be reached by taking the N365 from Ypres towards Armentières. 2 km after the village of Ploegsteert lies the left hand turning onto Witteweg (Chemin de la Blanche). Follow this Witteweg for 300 m and turn right into Drève de la Rabecque. Motor Car Corner Cemetery lies 300 m further, on the right hand side of the road.

IDENTIFIED COMMONWEALTH HEROES

 36 81 9

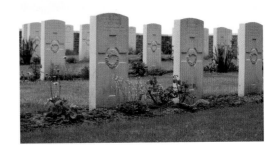

 GRAVES OF INTEREST (P. 141)
Allan Holz and **Ernest John Holz** , A 15/16

MUD CORNER CEMETERY

— COMINES-WARNETON

Comines-Warneton is appr. 12 km south of Ypres. From Ypres town centre take Rijselstraat running from the market square, through the Lille Gate (Rijselsepoort) and directly over the crossroads with the Ypres ring road. The road name then changes to Rijselseweg. Take the N365 Ypres-Armentières road to Mesen (Messines). After reaching Mesen continue for 2 km and take a left turn onto rue St Yvon. Continue along this road and park your vehicle outside Prowse Point Military Cemetery. Just further on is a right turn which is unsuitable for vehicles; Mud Corner Cemetery is 300 m after this junction. Access to Mud Corner Cemetery is only possible via a track in the woods. (If disabled visitors cannot get to this cemetery without being driven by a car, they should contact the CWGC office in Ypres well in advance of their visit, so that arrangements can be made to open up the track.)

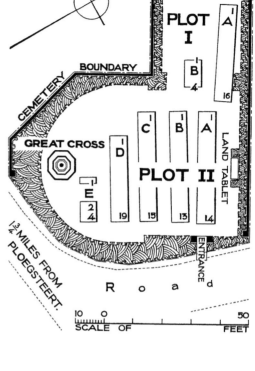

IDENTIFIED COMMONWEALTH HEROES

 52 31

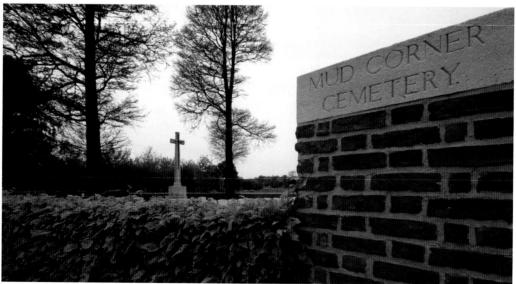

NIEUWKERKE CHURCHYARD

— NIEUWKERKE (HEUVELLAND)

Nieuwkerke (also known as Neuve-Eglise) is part of Heuvelland and is located appr. 10 km south west of Ypres, and approx. 10 km south east of Poperinge. Leave Ypres via the Lille Gate (Rijselsepoort), go across the roundabout onto the N365 direction Armentières. After 900 m, just before the railway crossing, turn right onto Kemmelseweg (N331). Upon reaching the village of Kemmel the N331 continues for a further 4 km towards Nieuwkerke. On reaching Nieuwkerke the first right hand turning leads onto Kemmelstraat. The churchyard is located 100 m along Kemmelstraat, on the left hand side of the road (facing the market square).

IDENTIFIED COMMONWEALTH HEROES

75 1 5 10 1

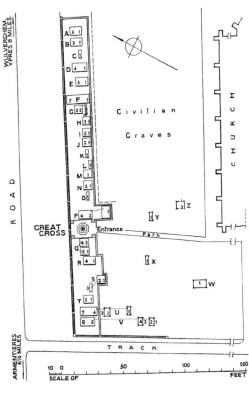

GRAVES OF INTEREST (P. 146)

Mazzei, G 2

NINE ELMS BRITISH CEMETERY
— POPERINGE

Nine Elms British Cemetery is located west of Poperinge on Helleketelweg, a road leading from the N33 Poperinge ring road. From Ypres follow the signs to Poperinge. On reaching the R33, the left hand clockwise route circles the town and rejoins the N308 in the direction of Oost Cappel. 2.5 km around the ring road lies the left hand turning onto Helleketelweg. Nine Elms British Cemetery can be found a further 700 m on the left.

IDENTIFIED COMMONWEALTH HEROES

 960 299 117 150

26 1

 GRAVES OF INTEREST (P. 147)

Brookes, II F 7

Gilbert, III D 13

Edwards, III E 10

Hawkes, V E 9

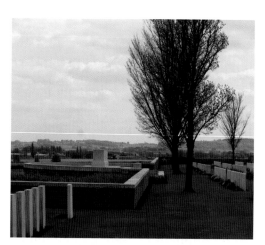

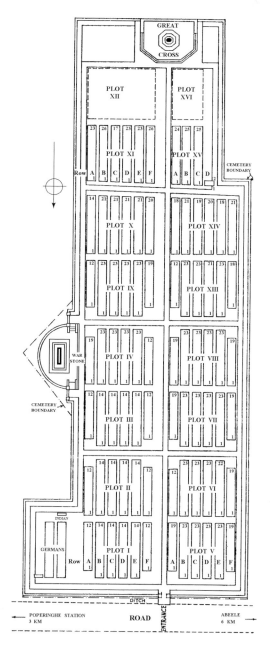

HOTEL CALLECANES

A warm welcome awaits you at Hotel Callecanes, situated on the Belgian-French border, 3 kms from Watou and 5 kms from Poperinge. Obviously many points of interest regarding World War One, both in France and Belgium, are close to the hotel.

In this idyllic corner of Flanders, gastronomy and hospitality have no limits. Hotel Callecanes has 37 comfortable, handsomely appointed rooms. Each room is equipped with TV, storage space and a luxurious bathroom. Wireless internet is possible and we also have different rooms for disabled persons.

We guarantee you an experience and atmosphere … without borders!

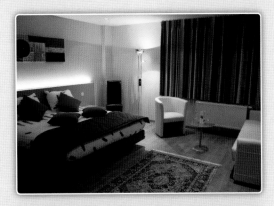

HOTEL CALLECANES

Callicanesweg 12 - 8978 Watou (Poperinge)
Tel: +32 (0) 57 38 88 08
Fax: +32 (0) 57 38 87 83
E-mail: info-reservatie@hotel-callecanes.be
www.hotel-callecanes.be

OOSTTAVERNE WOOD CEMETERY

— WIJTSCHATE (HEUVELLAND)

Wijtschate is part of Heuvelland and is located appr. 6 km south of Ypres. Leave Ypres through the Lille Gate (Rijselsepoort) and take the N365 Rijselseweg. After 3 km the road forks; take the left fork towards Lille (N336). Oosttaverne Wood Cemetery is located approx. 2 km after the fork, on the right hand side of the road.

IDENTIFIED COMMONWEALTH HEROES

296 21 2 16 1

GRAVES OF INTEREST (P. 149)
Walford, VIII E 12

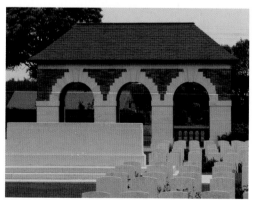

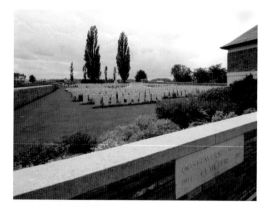

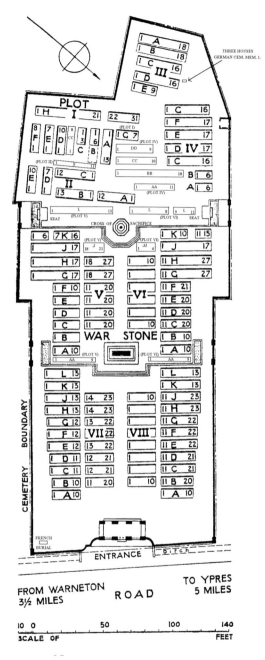

PACKHORSE FARM SHRINE CEMETERY

— WULVERGEM (HEUVELLAND)

Wulvergem is part of Heuvelland and is located appr. 9 km south west of Ypres. Leave Ypres via the Lille Gate (Rijselsepoort), then take the N336 towards Armentières. 900 m after the crossroads is the right hand turn onto Kemmelseweg (N331), just by the railway crossing. Continue down this road until you reach the village of Kemmel. 2 km after reaching the village of Kemmel is a left turn onto Hooghofstraat. After 500 m take the left turn into Lindestraat. Packhorse Farm Cemetery can be found on the right of this road.

IDENTIFIED COMMONWEALTH HEROES

 59

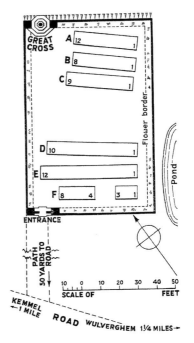

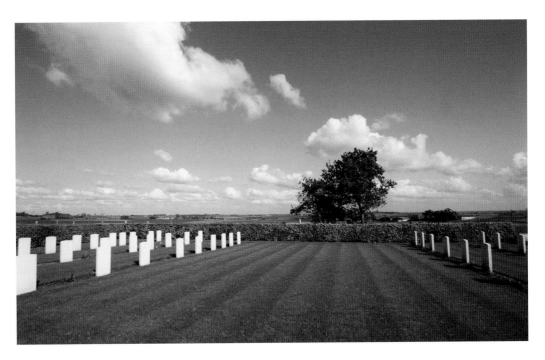

PLOEGSTEERT CHURCHYARD

— PLOEGSTEERT (COMINES-WARNETON)

Ploegsteert Churchyard is located appr. 14 km south of Ypres town centre, on the Rijselseweg (N365), which connects Ypres to Wijtschate, Mesen (Messines), Ploegsteert, and on to Armentières. On reaching the village of Ploegsteert, the church is located on the right hand side of the N365.

IDENTIFIED COMMONWEALTH HEROES

 7 2

 GRAVES OF INTEREST (P. 158)
Dolphin, A 4

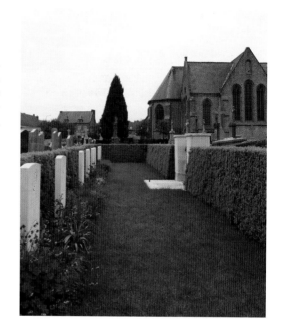

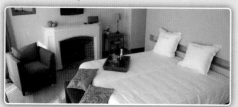

'As it was, the Ypres battleground
just represented one gigantic slough
of despond into which floundered battalions,
brigades and divisions of infantry without end
to be shot to pieces or drowned,
until at last and with immeasurable slaughter
we had gained a few miles of liquid mud.'

Charles Miller,
2nd Royal Inniskilling Fusiliers

PLOEGSTEERT WOOD MILITARY CEMETERY

— COMINES-WARNETON

Comines-Warneton is located approx. 12 km south of Ypres. From Ypres town centre, take the Rijsel-straat running from the market square, go through the Lille Gate (Rijselsepoort) and directly over the crossroads with the Ypres ring road. The road name then changes to Rijselseweg. Take this N365 road (Ypres-Armentières) to Mesen. After reaching Mes-en (Messines) continue for 2 km and take a left turn onto Rue St Yvon. Continue along this road and park your vehicle outside Prowse Point Cemetery. Just further on is a right turn which is blocked to vehi-cles. Walk down this road and into the wood. Con-tinue to follow the track through the wood and at the junction turn right and continue walking. Ploeg-steert Wood Cemetery is on your right hand side.

IDENTIFIED COMMONWEALTH HEROES

 116 28 18 1

GRAVES OF INTEREST (P. 158)

Mawhinney, III A 9

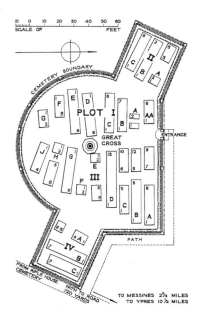

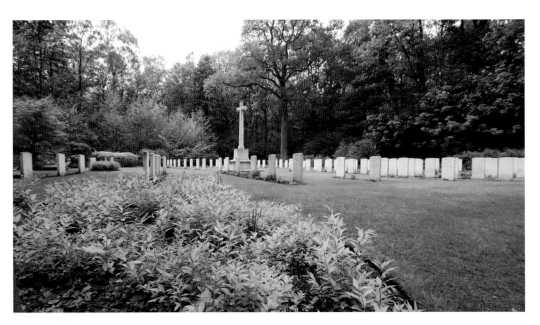

POELCAPELLE
BRITISH CEMETERY

— POELKAPELLE (LANGEMARK-POELKAPEL-
LE)

Poelkapelle is part of Langemark-Poelkapelle and is situated north east of Ypres. Leave Ypres via Torhoutstraat (Lange Torhoutstraat and Korte Torhoutstraat), this leads into Kalfvaartstraat. At the end of

the road is a large junction. Take the first right into Brugseweg (N313). The cemetery is 10 km further along this road, on your right hand side.

IDENTIFIED COMMONWEALTH HEROES

 1043 116 46 38 5

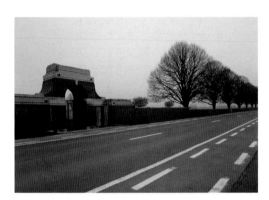

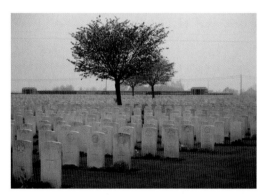

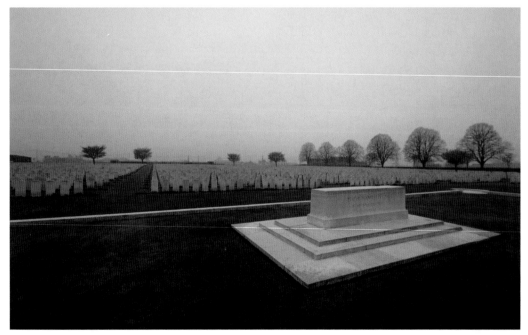

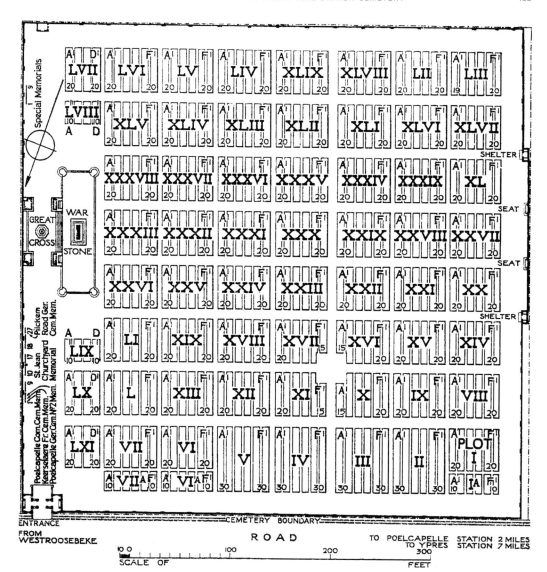

POND FARM CEMETERY

— WULVERGEM (HEUVELLAND)

Wulvergem is part of Heuvelland and is located appr. 9 km south west of Ypres. Leave Ypres via the Lille Gate (Rijselsepoort), then take the N336 towards Armentières. 900 m after the crossroads is the right hand turn onto Kemmelseweg (N331), just by the railway crossing. Continue down this road until you reach the village of Kemmel. 1 km further is a left turn into Gremmerslinde. A further 1 km brings you to the right hand turn into Vrooilandstraat. The cemetery is along here, 800 m further on your right hand side. Attention: this cemetery is probably one of the most difficult to visit. It has a 400 m grass access path, which then leads into a farm yard. You must pass through this yard which is usually very muddy, and continue through to the cemetery. Parking is very difficult; there is no decent place to leave the car and it is necessary to leave the vehicle on a grass verge of a narrow road.

IDENTIFIED COMMONWEALTH HEROES

 292

 GRAVES OF INTEREST (P. 165)

Hewitt, I 4

Snowden, N 17

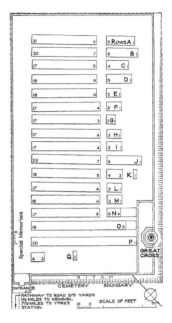

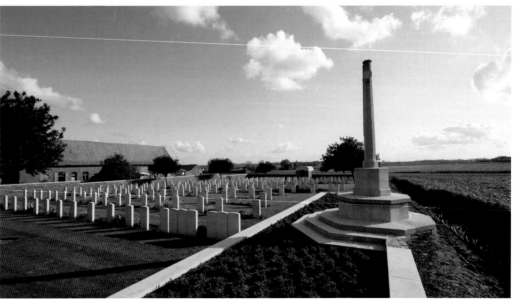

POPERINGE COMMUNAL CEMETERY

— POPERINGE

Poperinge Communal Cemetery is located 10.5 km west of Ypres town centre, in the town of Poperinge itself. On reaching Poperinge the left hand turning from the N308 leads onto the R33 Poperinge ring road. 1 km along the N33 lies the right hand turning onto Deken de Bolaan. Poperinge Communal Cemetery is located 800 m along the Deken De Bolaan, on the corner with Rekhof.

IDENTIFIED COMMONWEALTH HEROES

 21

POPERINGHE NEW MILITARY CEMETERY

— POPERINGE

Poperinghe New Military Cemetery is located 10.5 km west of Ypres town centre, in the town of Poperinge itself. On reaching Poperinge, the left hand turning from the N308 leads onto the R33 Poperinge ring road. 1 km along the N33 lies the right hand turning onto Deken De Bolaan. Poperinghe New Military Cemetery is located 100 m from the ring road level with Onze Vrouwedreef, on the right hand side of the road.

IDENTIFIED COMMONWEALTH HEROES

 596 55 3 20

 GRAVES OF INTEREST (P. 167-169)

Tite, Shot at Dawn, II F 9

Baker, II G 1

Yu Eu Peng

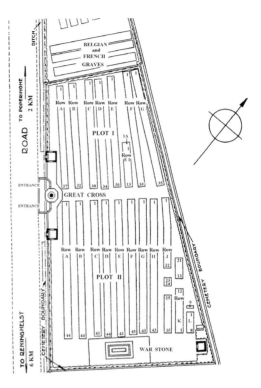

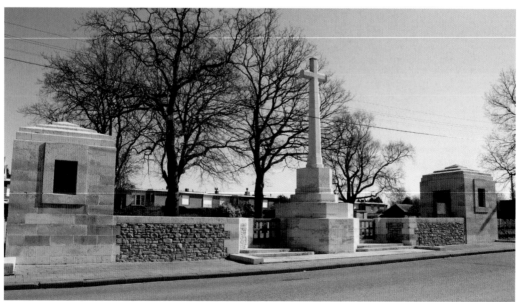

POPERINGHE OLD MILITARY CEMETERY

— POPERINGE

Poperinghe Old Military Cemetery is located 10.5 km west of Ypres town centre, in the town of Poperinge itself. On reaching the town of Poperinge, the left hand turning from the N308 leads onto the R33 Poperinge ring road. 1 km along the N33 lies the right hand turning onto Deken De Bolaan. Poperinghe Old Military Cemetery is located 200 m from the ring road level with the junction with Polenlaan, on the right hand side of the road.

IDENTIFIED COMMONWEALTH HEROES

 381 46

 GRAVES OF INTEREST (P. 166)
Wang, Shot at Dawn, II O 54

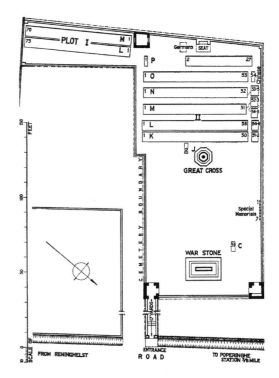

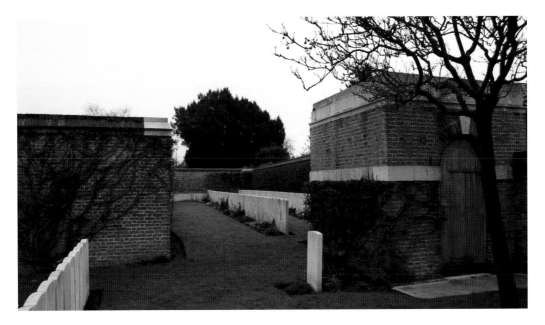

PROWSE POINT
MILITARY CEMETERY

— COMINES-WARNETON

Comines-Warneton is located appr. 12 km south of Ypres. Take the N365 Ypres-Armentières road to Mesen (Messines). After reaching Mesen continue for about 2 km and then take a left turn onto rue St Yvon. Continue along this road and Prowse Point Military Cemetery can be found on the right hand side. The cemetery is located very close to Mud Corner Cemetery.

IDENTIFIED COMMONWEALTH HEROES

159 1 42 13

GRAVES OF INTEREST (P. 173)

Wilkinson, I A 7

Mole, I B 6

Davis, I F 14

Long, II A3

Connor, III B 7

Lancaster, III C 1B

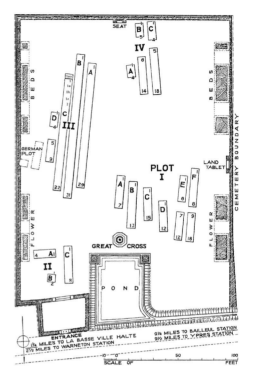

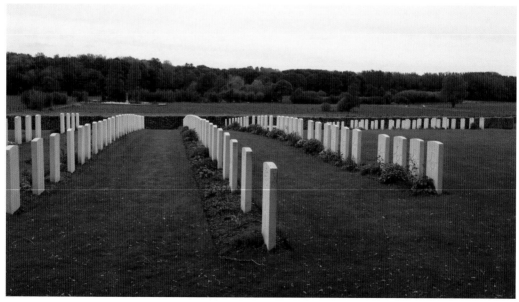

R. E. FARM CEMETERY

— WIJTSCHATE (HEUVELLAND)

R.E. Farm Cemetery is located 9.5 km south of Ypres town centre, on a road leading from the Rijselseweg N365, which connects Ypres to Wijtschate, Mesen and on to Armentières. From Ypres town centre the Rijselstraat runs from the market square, through the Lille Gate (Rijselsepoort) and directly over the crossroads with the Ypres ring road. The road name then changes to Rijselseweg (N 365). On reaching the village of Mesen, the first right hand turning leads onto Mesenstraat, towards Wulvergem. On reaching the village of Wulvergem the first right hand turning at the church leads onto Wulvergemstraat. 500 m along this road lies the junction with Vrooiland-straat. The cemetery lies 500 m beyond this junction on the left hand side of Wulvergemstraat.

IDENTIFIED COMMONWEALTH HEROES

 121 47

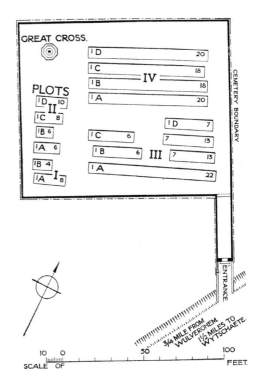

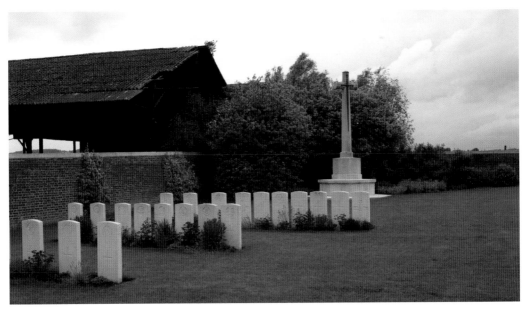

RATION FARM (LA PLUS DOUVE) ANNEXE

— PLOEGSTEERT (COMINES-WARNETON)

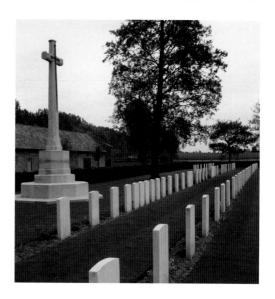

Ploegsteert is part of Comines-Warneton. It is located appr. 12 km south of Ypres. Take the N365 Ypres-Armentières road to Mesen (Messines). The first right hand turning in the village of Messines leads onto Mesenstraat. 2 km along Mesenstraat, on the left hand side, lies the street Plus Douve. Ration Farm (La Plus Douve) Annexe is located 500 m along Plus Douve on the right hand side of the track. Complete turf renovation has been taking place in this cemetery; this was finished in 2012.

IDENTIFIED COMMONWEALTH HEROES

 177 4 12

RENINGELST CHURCHYARD AND EXTENSION

— RENINGELST (POPERINGE)

Reningelst is part of Poperinge and is located appr. 5 km south east of that town, and 9.5 km south west of Ypres. From Ypres town centre the Poperingseweg (N308) is reached via Elverdingestraat, then directly over two roundabouts into Capronstraat. The Poperingseweg is a continuation of Capronstraat and begins after a prominent railway level crossing. On reaching the main crossroads in the village of Vlamertinge take the left hand turning onto Bellestraat. After crossing the N38 Ypres-Poperinge road, the village of Reningelst is located 6 km beyond Vlamertinge. On reaching the village, turn right onto Zevekotestraat and continue to Reningelstplein, where the churchyard is clearly visible.

IDENTIFIED COMMONWEALTH HEROES CHURCHYARD

 3

IDENTIFIED COMMONWEALTH HEROES EXTENSION

 54 1

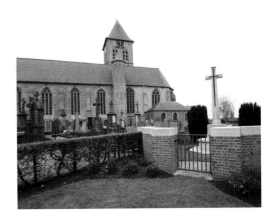

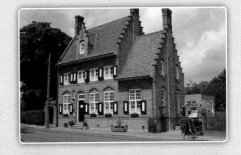

RENINGHELST NEW MILITARY CEMETERY

— RENINGELST (POPERINGE)

Reningelst is part of Poperinge and is located appr. 5 km south east of that town, and 9.5 km south west of Ypres. See info on the location of Reningelst Churchyard and Extension. From Reningelstplein take Baljuwstraat (N304); the cemetery is 500 m along this road on the left. Access and parking are easy, although it should be noted that there is a short grassed access path to the cemetery.

IDENTIFIED COMMONWEALTH HEROES

 456 229 2 104 1

 GRAVES OF INTEREST (P. 182)

Thurston, I F 11

Whittingham, II C 24

Street, III A 19

Keep, III F 26

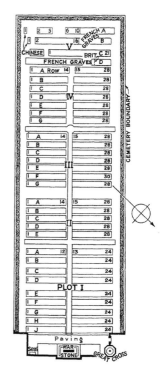

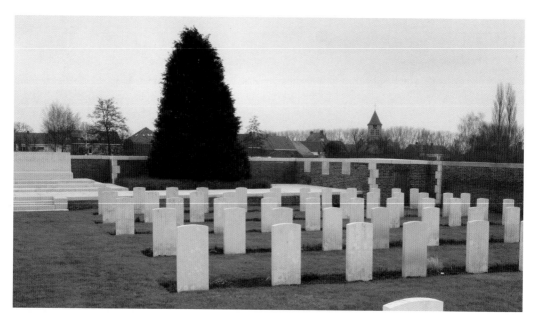

RIFLE HOUSE CEMETERY
— COMINES-WARNETON

Comines-Warneton is located appr. 12 km south of Ypres. From Ypres town centre take Rijselstraat and drive through the Lille Gate (Rijselsepoort), then directly over the crossroads with the Ypres ring road. The road then changes its name and becomes Rijselseweg. Take the N365 Ypres-Armentières road to Mesen (Messines). After reaching Mesen continue for about 2 km and take the left hand turning onto Rue St. Yvon. Immediately after passing Prowse Point Military Cemetery, where you can park your vehicle, there is a right turn (blocked to vehicles). Walk down this road and into the wood, continue to follow the track through the wood and at the junction turn right and continue walking. First you pass Ploegsteert Wood Cemetery (on the right); Rifle House Cemetery is a further 150 m straight ahead. Attention: although access to the cemetery is easy, it should be noted that the wood can be very wet and boggy. (If disabled visitors or wheelchair users cannot get to this cemetery without being driven by car, they should contact the CWGC office in Ypres well in advance of their visit.)

IDENTIFIED COMMONWEALTH HEROES

 227 1

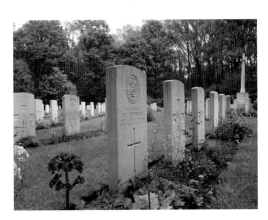

GRAVES OF INTEREST (P. 183)

Penton, III B 4
Sales, III D 3
Barnett, IV E 10
Prittie, IV F 5

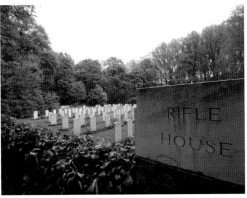

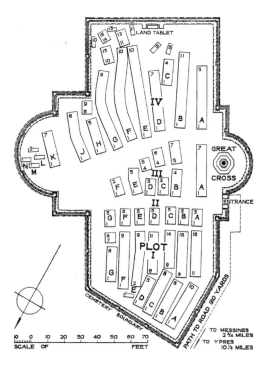

RUISSEAU FARM CEMETERY

— LANGEMARK (LANGEMARK-POELKAPELLE)

Langemark is part of Langemark-Poelkapelle and is located appr. 6 km north east of Ypres. From the market square at Langemark take Statiestraat in the direction of Bikschote, continue over the disused railway and then take the first turning left, Melkerijstraat. Follow this road for appr. 800 m, past the milk factory where there is a sharp right hand bend. This is followed by a sharp left bend. At this left hand bend there is a track going straight on, leading to Ruisseau Farm Cemetery.

IDENTIFIED COMMONWEALTH HEROES

 76

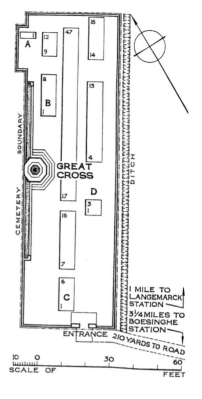

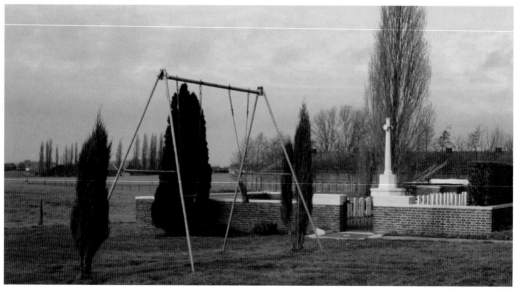

SEAFORTH CEMETERY, CHEDDAR VILLA

— SINT-JULIAAN (LANGEMARK-POELKAPELLE)

Sint-Juliaan is part of Langemark, Langemark being part of the village Langemark-Poelkapelle. Leave Ypres via Torhoutstraat (Lange Torhoutstraat and Korte Torhoutstraat), this leads onto Kalfvaart. At the end of this road is a large junction of which Brugseweg is the first right turn. Take this turn and continue for about 4 km. Seaforth Cemetery, Cheddar Villa is on your left hand side.

IDENTIFIED COMMONWEALTH HEROES

 126 1

GRAVES OF INTEREST (P. 186)
Devine, A 35

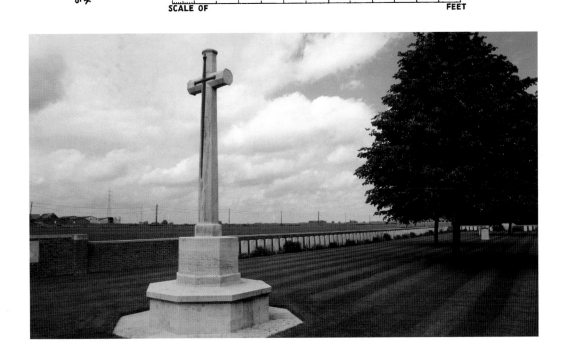

SOMER FARM CEMETERY

— WIJTSCHATE (HEUVELLAND)

Wijtschate is part of Heuvelland and is located appr. 7 km south of Ypres. From Ypres town centre the Rijselstraat runs from the market square, through the Lille Gate (Rijselsepoort) and directly over the crossroads with the Ypres ring road. The road name then changes to Rijselseweg (N365, direction Armentières). Upon reaching the village of Wijtschate, turn left into Hollebekestraat. Somer Farm Cemetery is on the right hand side of the road, about 70 m further.

IDENTIFIED COMMONWEALTH HEROES

 66 24

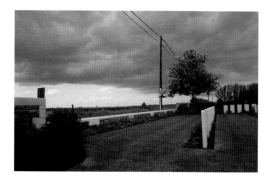

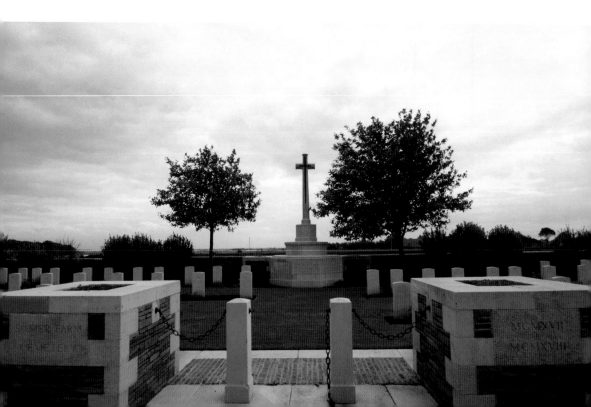

SPANBROEKMOLEN BRITISH CEMETERY
— WIJTSCHATE (HEUVELLAND)

Wijtschate is part of Heuvelland and is located appr. 7 km south of Ypres. See also info on Somer Farm Cemetery. Upon reaching the village of Wijtschate, the first right turn leads onto Hospicestraat, which leads to the village square. From the square take Wijtschatestraat for about 1.5 km before turning left into Scheerstraat. Spanbroekmolen British Cemetery is in the fields, approx. 500 m on your left hand side. Attention: access to this cemetery is via a 200 m grass path. Parking is extremely difficult and is only possible by leaving the vehicle on the verge of a very narrow road.

IDENTIFIED COMMONWEALTH HEROES

 52

 GRAVES OF INTEREST (P. 188)

Rock, A 9

Watson, B 5

O'Sullivan, B 12

Bridgett, D 4

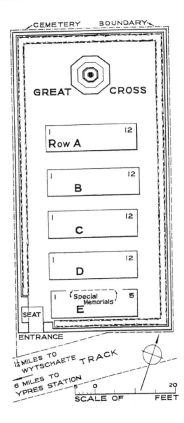

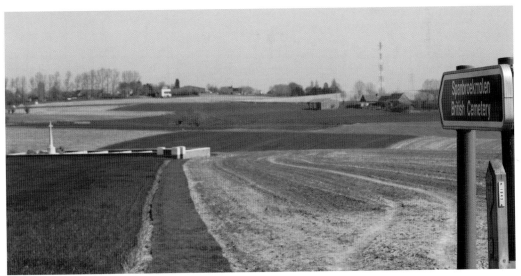

ST. JAN-TER-BIEZEN COMMUNAL CEMETERY

— ST. JAN-TER-BIEZEN (POPERINGE)

St. Jan-ter-Biezen is part of Poperinge and is located appr. 14 km west of Ypres on the Poperinge to Watou road (Watou also being part of Poperinge). The N308 connects Ypres to Poperinge. From Ypres town

centre the Poperingseweg (N308) is reached via Elverdingestraat, then over two small roundabouts into Capronstraat. The Poperingseweg is a continuation of Capronstraat and begins after a prominent railway level crossing. On reaching Poperinge the N308 meets the left hand turning onto the Poperinge ring road, R33. The R33 rejoins the N308 on the west side of Poperinge, where it continues for 1 km to the junction with Watouseweg. Watouseweg continues for 3 km to the village of St. Jan-ter-Biezen. The first left hand turning in the village leads onto Kapellestraat. The cemetery itself is located 600 m down Kapellestraat on the left hand side of the road, 150 m after passing the village church on the right hand side.

IDENTIFIED COMMONWEALTH HERO

 1

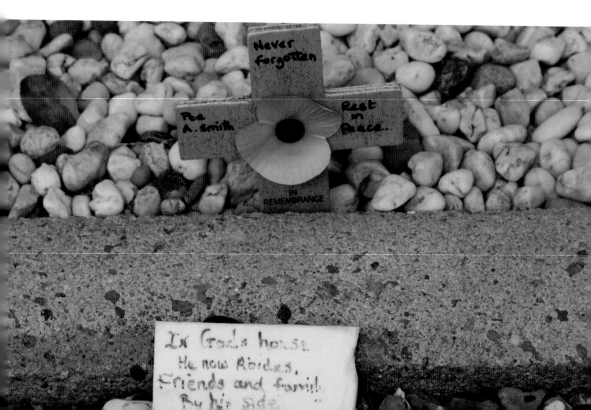

ST. JULIEN DRESSING STATION CEMETERY

— SINT-JULIAAN (LANGEMARK-POELKAPELLE)

Sint-Juliaan is part of Langemark, Langemark itself being part of Langemark-Poelkapelle, situated north east of Ypres. Leave Ypres via Torhoutstraat (Lange Torhoutstraat and Korte Torhoutstraat), this street leads onto Kalfvaart. At the end there is a large junction of which Brugseweg is the first right turn. Take Brugseweg and continue for 5 km. Just before the village of Sint-Juliaan take the right turn onto Peperstraat. St. Julien Dressing Station Cemetery lies immediately after this turn on the left hand side. Parking and access are easy.

IDENTIFIED COMMONWEALTH HEROES

 232 4 1 6 5

GRAVES OF INTEREST (P. 189)

Hodgson, III B 10

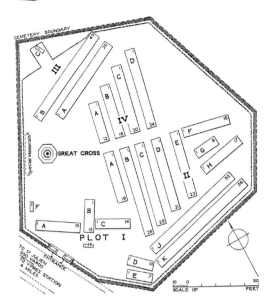

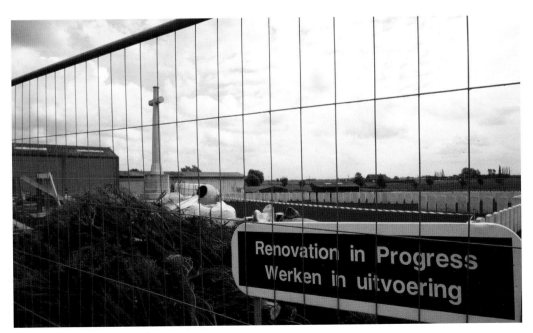

ST. QUENTIN CABARET MILITARY CEMETERY

— PLOEGSTEERT (COMINES-WARNETON)

Ploegsteert is part of Comines-Warneton and is located appr. 12 km south of Ypres. St. Quentin Cabaret Military Cemetery is located very close to Ploegsteert's north west border with Wulvergem. Leave Ypres via the Lille Gate (Rijselsepoort), go over the crossroads with the Ypres ring road and follow the signs for N365 towards Armentières and Mesen (Messines). Upon reaching the village of Mesen, turn first onto Mesenstraat (N314) in the direction of Wulvergem. On reaching the village of Wulvergem, the first left hand turn leads onto Sint-Kwintenstraat. 200 m along this road, on your left hand side, is St. Quentin Cabaret Military Cemetery.

IDENTIFIED COMMONWEALTH HEROES

 315 68 64 7

 GRAVES OF INTEREST (P. 190)

Constant, I A 1
Barratt, I E 17
Bremner, I G 11
Scanlon, II E 6

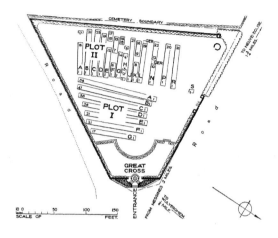

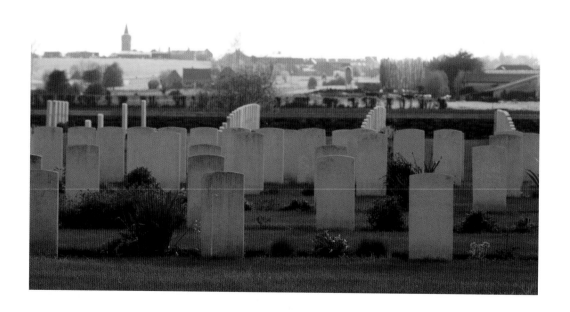

HOTEL RECOUR

Welcome to Hotel Recour, a romantic luxury hotel with its own town garden. We are peacefully located in the heart of Flanders Fields, at a mere 100 metres from Poperinge town market square, and also very close to Talbot House.

We offer you 15 sumptuously furnished rooms and 4 guestrooms (at 50 m from the hotel), each with its own distinctly styled identity.

In 'Pegasus', Hotel Recour also offers an exquisite quality restaurant, with a unique salon and a delightful garden terrace.

HOTEL RECOUR

Guido Gezellestraat 7 - 8970 Poperinge
Tel: +32 (0)57 33 57 25
Fax: +32 (0) 57 33 54 25
E-mail: info@pegasusrecour.be
 www.pegasusrecour.be
 www.wellnessrecour.be

STRAND MILITARY CEMETERY

— COMINES-WARNETON

Comines-Warneton is located appr. 12 km south of Ypres. From Ypres town centre take Rijselstraat and drive through the Lille Gate (Rijselsepoort), then directly over the crossroads with the Ypres ring road. The road then changes its name and becomes Rijselseweg. Take the N365 Ypres-Armentières road to Mesen (Messines). After reaching Mesen continue for about 4 km. Strand Military Cemetery is located immediately before the village of Ploegsteert on the left hand side of the road.

IDENTIFIED COMMONWEALTH HEROES

 413 16 86 278 1

 GRAVES OF INTEREST (P. 191)
Clutterbuck, IX | 7

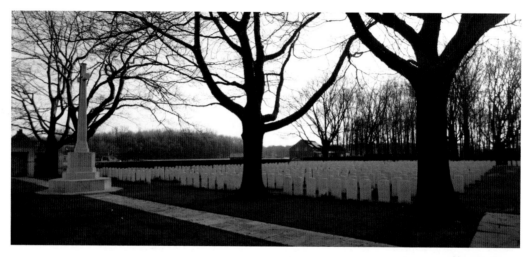

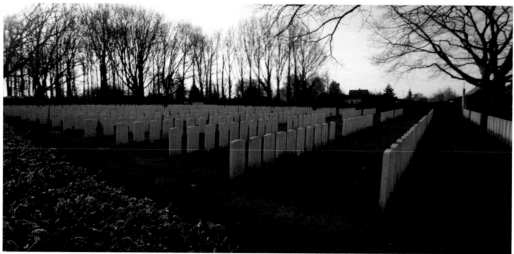

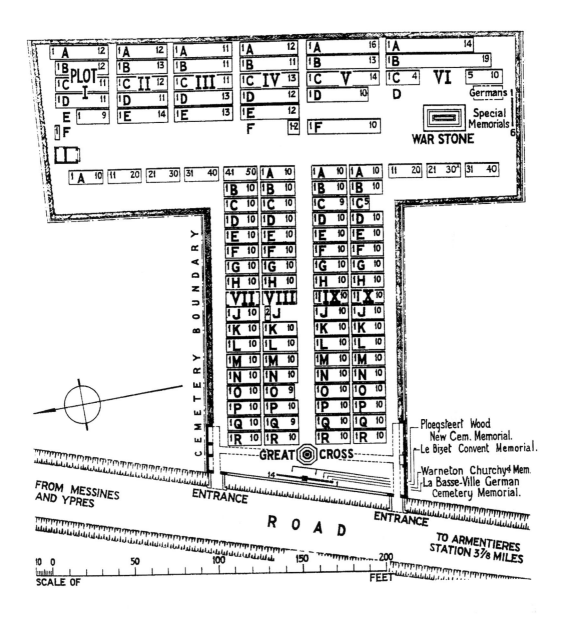

SUFFOLK CEMETERY

— KEMMEL (HEUVELLAND)

Kemmel is part of Heuvelland and is situated south west of Ypres and south east of Poperinge. Suffolk Cemetery is located 6 km south west of Ypres town centre, on the Kriekstraat, a road leading from Kemmelseweg (Ypres-Kemmel road N 331). At the Lille Gate (Rijselsepoort), take the N365 towards Armentières. 900 m after the crossroads is the right hand turning onto Kemmelseweg (made prominent by a railway level crossing). 5 km along Kemmelseweg lies the right hand turning onto Vierstraat. 800 m along Vierstraat is the left hand turning onto Kriekstraat. The cemetery is located 50 m further on the right hand side of the road.

IDENTIFIED COMMONWEALTH HEROES

 39

 GRAVES OF INTEREST (P. 191)
Brookfield, C 15

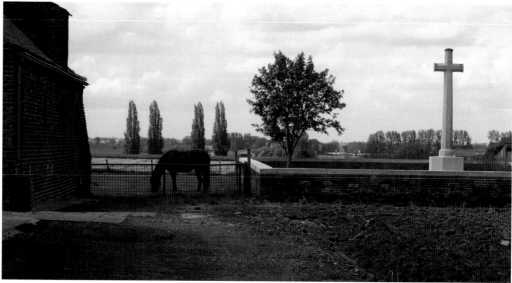

TANCREZ FARM CEMETERY

— COMINES-WARNETON

Comines-Warneton is located appr. 12 km south of Ypres. From Ypres town centre take Rijselstraat and drive through the Lille Gate (Rijselsepoort), then directly over the crossroads with the Ypres ring road. The road then changes its name and becomes Rijselseweg. Take the N365 Ypres-Armentières road to Mesen (Messines). Upon reaching the village of Ploegsteert, continue for a further 2 km and turn left onto Chemin de la Blanche (Witteweg), then take the first right and continue past Motor Car Corner Cemetery. At the end of this road, the road turns left towards Touquet. The cemetery is located 500 m along Rue du Touquet on your left hand side.

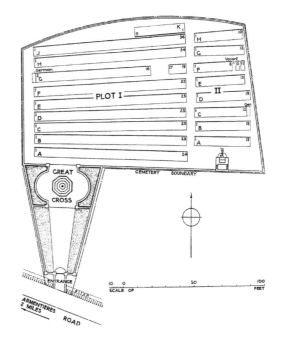

IDENTIFIED COMMONWEALTH BURIALS

 301 3 19 4

 GRAVES OF INTEREST (P. 193)
Umbers, II A 6
Lipscomb, II D 13
Swift, II H 10

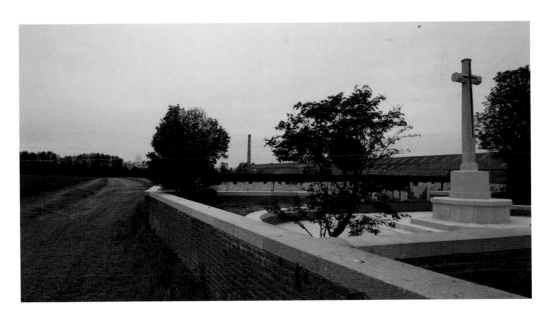

TORONTO AVENUE CEMETERY

— COMINES-WARNETON

Comines-Warneton is located appr. 12 km south of Ypres. From Ypres town centre take Rijselstraat and drive through the Lille Gate (Rijselsepoort), then directly over the crossroads with the Ypres ring road. The road then changes its name and becomes Rijselseweg. Take the N365 Ypres-Armentières road to Mesen (Messines). After reaching Mesen continue for about 2 km and take the left hand turning onto Rue St. Yvon. Continue along this road and park your vehicle outside Prowse Point Cemetery. Just further on is a right turn which is blocked to vehicles. Walk down this road and into the wood, continue to follow the track through the wood and at the junction turn left and continue walking. Toronto Avenue Cemetery is a further 70 m along this path.

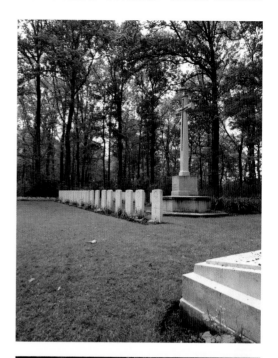

IDENTIFIED COMMONWEALTH HEROES

 76

 GRAVES OF INTEREST (P. 195)

Luff, A 35

Hennessy, B 11

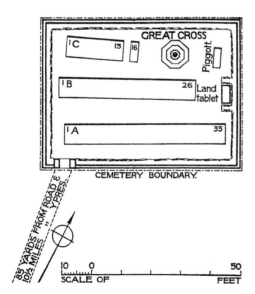

TORREKEN FARM CEMETERY NO. 1

— WIJTSCHATE (HEUVELLAND)

Wijtschate is part of Heuvelland and is located 7 km south of Ypres. From Ypres town centre the Rijselstraat runs from the market square. Go through the Lille Gate (Rijselsepoort) and directly over the crossroads with the Ypres ring road. The road name then changes to Rijselseweg (N365 connecting Ypres to Armentières). Just beyond the village of Wijtschate, Langebunderstraat is located by turning left from the N365. Torreken Farm Cemetery No. 1 is located 200 m along Langebunderstraat on the left hand side of the road.

IDENTIFIED COMMONWEALTH HEROES

 69 20

 GRAVES OF INTEREST (P. 196)

Farquarson, A 3

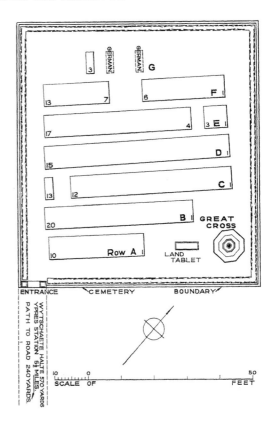

UNDERHILL FARM CEMETERY

— COMINES-WARNETON

Comines-Warneton is located appr. 10 km south of Ypres. You leave Ypres via the Lille Gate (Rijselse-poort) and go directly over the roundabout onto the road to Armentières (N365). The cemetery is 12.5 km along this road. You pass the villages of Wijtschate and Mesen (Messines). 3 km after Mesen, turn right onto the Rue du Petit Pont (Kleine Brugstraat). Underhill Farm Cemetery is 1 km on the right hand side.

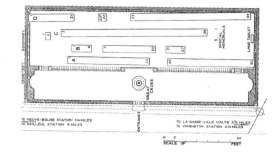

IDENTIFIED COMMONWEALTH HEROES

 94 1 39 47

WATOU CHURCHYARD

— WATOU (POPERINGE)

Watou is part of Poperinge and is located appr. 8 km west of that town, or 19 km west of Ypres town centre. The Watouseweg is a road leading from the N308 connecting Ypres to Poperinge. On reaching Poperinge from Ypres the N308 meets the left hand turning onto the Poperinge ring road, R33. This R33 rejoins the N308 on the west side of Poperinge where it continues for 1 km to the junction with the Watouseweg. 8 km along the Watouseweg lies the village of Watou.

IDENTIFIED COMMONWEALTH HEROES

 11 1

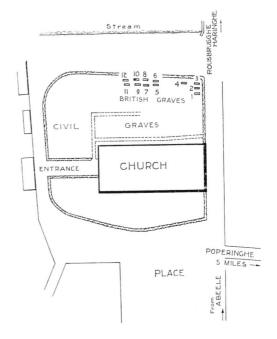

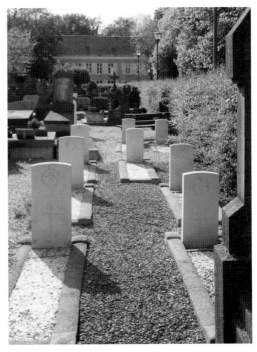

WESTHOF FARM CEMETERY

— NIEUWKERKE (HEUVELLAND)

Nieuwkerke is part of Heuvelland and is located appr. 12 km south east of Poperinge. Leave Ypres via the Lille Gate (Rijselsepoort), and follow the signs for Armentières (N365). After 900 m, just before the railway crossing, turn right onto Kemmelseweg (N331). Upon reaching the village of Kemmel the N331 continues for a further 4 km towards Nieuwkerke. On reaching Nieuwkerke the road continues as Seulestraat. After 1.5 km there is a right turn into Eikelstraat. The cemetery is a further 1.4 km along this street on the left hand side. Access and parking are easy.

IDENTIFIED COMMONWEALTH HEROES

 73 1 14 43

 GRAVES OF INTEREST (P. 218)
Browne, II D 4

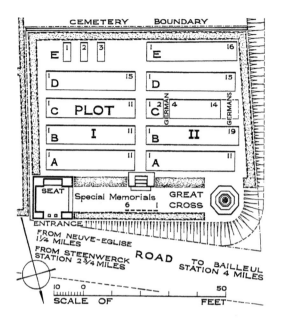

LA BONNE PLANCHE

La Bonne Planche ('The Good Shelf') serves 42 different and well-priced dishes and is renowned for its out-of-the-ordinary steaks.

The restaurant is located only 2 km from Lijssenthoek Military Cemetery. Accomplished cooking, carefully prepared menus using local produce. 32 different beers are available, 2 special beers each month.

Hostess Aude serves on demand La Bonne Planche's famous mess-tin soldiers' meals. Groups up to 80 people. Restaurant also suited to the needs of the youngest (childrens' menu).

LA BONNE PLANCHE

Poperingestraat 57 - 8954 Westouter
Tel: +32 (0) 57 30 07 99
E-mail: audedammerey@wanadoo.fr

REDMONDS IRISH PUB & RESTAURANT

Irish, your smilin' face were at Redmonds! To be found at Loker (Heuvelland), a few km from the French border (Bailleul): Redmonds Irish Pub & Restaurant, a wonderful green island in the middle of all the major WWI battlefields in France and Belgium, and only 12 km from Ypres. This intimate pub serves honest food and knows its secret in the real Irish soul. One of the specialities of the house: the famous military 'gamelle' meals. And yes indeed, it looks like boss Franky Vanacker emigrated from Ireland to Brave Little Belgium! May St. Patrick and St. Guinness guard you wherever you go, preferably at Redmonds, where every story knows its song.

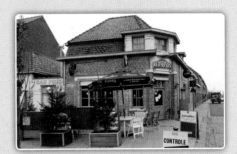

REDMONDS IRISH PUB & RESTAURANT

Dikkebusstraat 135 - 8958 Loker
Tel: + 32 (0)473 23 92 68
E-mail: redmondsirishpubloker@hotmail.com

REQUIEM AETERNAM
DONA EI, DOMINE
ET LUX PERPETUA
LUCEAT EI

WESTOUTRE BRITISH CEMETERY
— WESTOUTER (HEUVELLAND)

Westouter is part of Heuvelland and is located appr. 6 km south of Poperinge. Take the N375 Dikkebusseweg in Ypres, this can be found on the right immediately after Ypres railway station in the direction of Poperinge. After 10 km along Dikkebusseweg (N375) turn right into Sulferbergstraat (N315). After 2.5 km you reach the village of Westouter. The cemetery is located on the Poperingestraat, 200 m from the centre of the village, opposite the fire station.

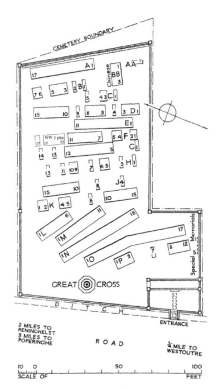

IDENTIFIED COMMONWEALTH HEROES

 118 2 3

 GRAVES OF INTEREST (P. 219)
Dougall, VC, Spec. Mem. 1

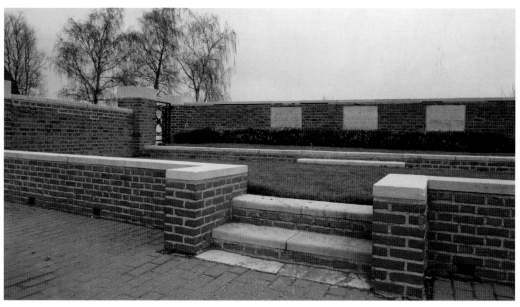

WESTOUTRE CHURCHYARD AND EXTENSION

— WESTOUTER (HEUVELLAND)

Westouter is part of Heuvelland and is located appr. 6 km south of Poperinge. For exact directions from Ypres, see info on Westoutre British Cemetery. The cemetery of Westoutre Churchyard and Extension is located in the centre of the village of Westouter; the Commonwealth plot can be found on the far right.

IDENTIFIED COMMONWEALTH HEROES

 76 18 1 1 1

GRAVES OF INTEREST (P. 220)

Charles Frederick and **James Alfred Robinson**, II A 5

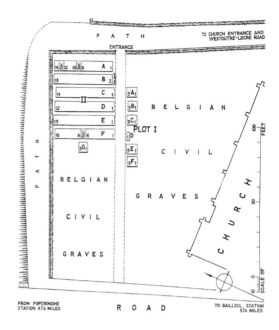

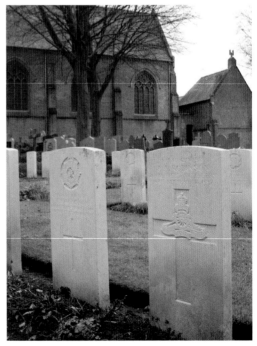

WESTVLETEREN BELGIAN MILITARY CEMETERY

— VLETEREN

Vleteren is a village appr. 8 km north of Poperinge, Westvleteren obviously being the western part of the village. Westvleteren is also on the N8 which runs from Ypres to Veurne (direction Belgian coast). From Ypres follow the N8 to Oostvleteren, and at the traffic lights turn left on the N321 direction Poperinge. In the village you go around a sharp right hand bend, just after it turn right into Sint-Maartenstraat. You will find this beautiful Belgian cemetery on the right hand side. Westvleteren Belgian Military Cemetery was started in Autumn 1914, with burials from the Boezinge region. Next to the cemetery was a girls' school, where the Belgian army installed a war hospital. After the war many graves were added, coming from different places in the region. In 1968 123 graves were added from Reninge Military Cemetery.

IDENTIFIED COMMONWEALTH HERO

 1

 GRAVES OF INTEREST (P. 220)
Kennedy

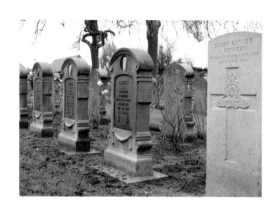

WULVERGEM CHURCHYARD

— WULVERGEM (HEUVELLAND)

Wulvergem is part of Heuvelland and is located 13 km south of Ypres town centre. From Ypres take Rijselstraat (which runs from the market square), through the Lille Gate (Rijselsepoort) and directly over the crossroads with the Ypres ring road (the road name then changes to Rijselseweg). On reaching the town of Mesen (Messines) the first right hand turning leads onto Mesenstraat. 3 km along Mesenstraat lies the village of Wulvergem. The churchyard lies next to the village church on Dorpstraat.

IDENTIFIED COMMONWEALTH HEROES

 32

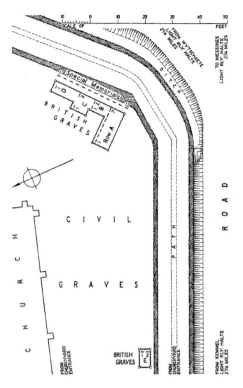

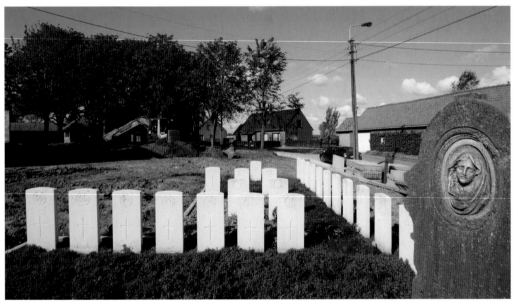

WULVERGHEM-LINDENHOEK ROAD MILITARY CEMETERY

— WULVERGEM (HEUVELLAND)

Wulvergem is part of Heuvelland and is located 13 km south of Ypres town centre. Wulverghem-Lindenhoek Road Military Cemetery is located on a road leading from Kemmelseweg. This Kemmelseweg is reached via the Rijselstraat in Ypres, through the Lille Gate (Rijselsepoort) and straight on in the direction of Armentières (N365). 900 m after the crossroads is the right hand turning onto the Kemmelseweg (at the railway crossing). 2 km after passing the village of Kemmel take the left hand turning onto Hooghofstraat. The cemetery lies 1.5 km along Hooghofstraat, on the right hand side of the road.

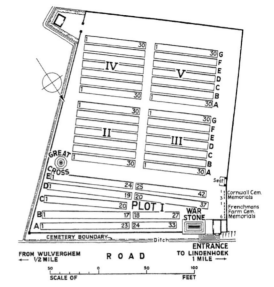

IDENTIFIED COMMONWEALTH HEROES

 511 52 64 30 1

 GRAVES OF INTEREST (P. 223)
Hyland, IV G 23
Faulknall, V E 24

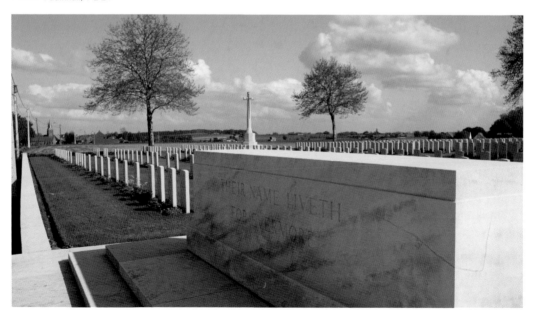

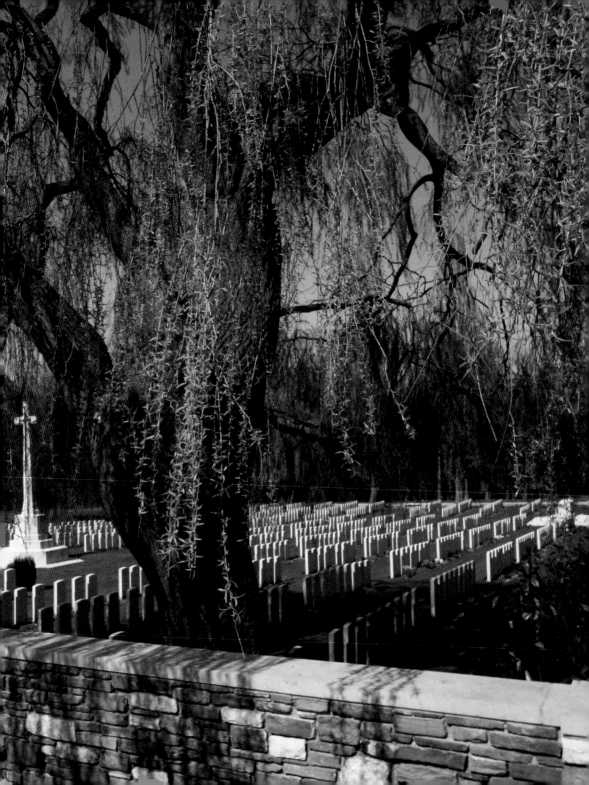

WYTSCHAETE
MILITARY CEMETERY

— WIJTSCHATE (HEUVELLAND)

Wijtschate is part of Heuvelland and is located appr.
6 km south of Ypres. Leave Ypres via the Lille Gate
(Rijselsepoort), go directly over the crossroads with
the Ypres ring road and take the N365 in the direc-
tion of Armentières. Upon reaching the village of
Wijtschate, take the first right turn onto Hospice-
straat, which leads to the village square. From the
square take the Wijtschatestraat. Wytschaete Mili-
tary Cemetery is after 500 m, on the right hand side
of the road. Easy access and parking.

IDENTIFIED COMMONWEALTH HEROES

 311 5 1 11 1

 GRAVES OF INTEREST (P. 224)

Needham, I C 10
Airley, III D 20

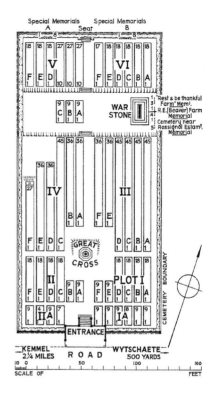

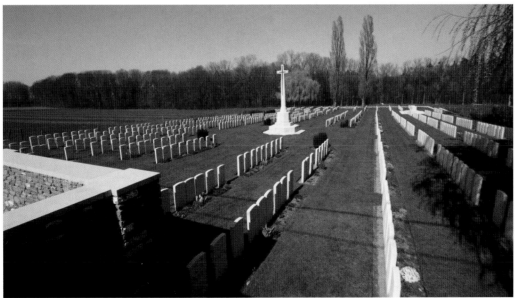

PART 3

COMMONWEALTH CEMETERIES FIRST WORLD WAR
WEST FLANDERS

AALBEKE COMMUNAL CEMETERY
— AALBEKE (KORTRIJK)

The village of Aalbeke is situated about 6 km south west of Kortrijk. Coming along the N43 from Kortrijk you go under the motorway and into the village. Take the second turning right into Ledeganckstraat and afterwards the 1st right into Nachtegaalstraat. You will find Aalbeke Communal Cemetery on the left. This cemetery contains one Commonwealth burial of the First World War. You will find it in plot B. Walk in through the front entrance and plot B is on your right.

IDENTIFIED COMMONWEALTH HEROES

 1

ADINKERKE CHURCHYARD EXTENSION
— ADINKERKE (DE PANNE)

Adinkerke is part of De Panne. The village is located appr. 2 km south of De Panne. It is also located west of Veurne on the N39. From the roundabout at the junction of the N39 and N34 follow the N34 in the direction of De Panne along Stationstraat. Follow Stationstraat past the church and then take the first road on your left hand side (Helderweg). The cemetery is at the end of this road behind the church.

IDENTIFIED COMMONWEALTH HEROES

 67

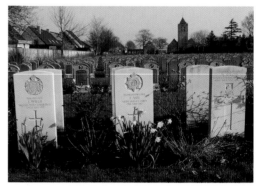

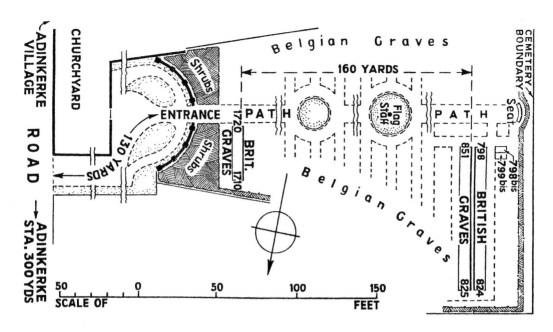

HOTELS CAJOU AND EUROPE

Hotels Cajou and Europe are centrally located in De Panne, but in quiet surroundings. Enjoy the summer terrace on a sunny day and walk to the beach which is only 50 m away. Both hotels are located in the shopping area of De Panne and close to a number of bars and restaurants. Parking is possible at the hotels.

Dinner in restaurant Cajou is a special experience. Here you can taste the famous fish and grill dishes, or choose from a varied menu, which is changed regularly.

The village of De Panne played a major role in the Great War. The Belgian royal family stayed here for three years; at De Panne and nearby Adinkerke you'll find two of the most impressive WW I cemeteries in Belgium. Distance De Panne-Calais: 60 km. De Panne-Ypres: 35 km.

HOTEL CAJOU

Nieuwpoortlaan 42 - 8660 De Panne

Tel: +32 (0) 58 41 13 03
Fax: +32 (0) 58 42 01 23
E-mail: info@cajou.be
 www.cajou.be

ADINKERKE
MILITARY CEMETERY
— ADINKERKE (DE PANNE)

Adinkerke is part of De Panne. From Veurne take the
N39, Duinkerkestraat. After 6 km you will reach the
village of Adinkerke. Take the first street on your left
hand side, this is the Kromfortstraat. You will find
the cemetery at your left hand side. Visitors should
note a 50 m grassed access path which is not suitable for vehicles.

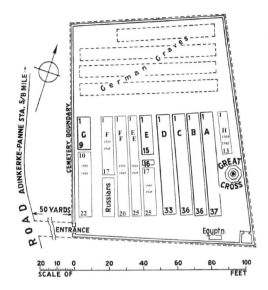

IDENTIFIED COMMONWEALTH HEROES

 161 2 5

GRAVES OF INTEREST (P. 236)

Nafar Sabit Harun, Egyptian Labour Corps.
McGee, A 21.

ANZEGEM COMMUNAL CEMETERY

— ANZEGEM

The village of Anzegem is about 20 km east of Kortrijk, off the N382 Waregem-Ronse road. From the motorway E17 take exit 4 at Deerlijk, and turn onto the N382 direction Ronse. Continue along this road through the village of Anzegem past the junction with the N494. Take the first turning left past this junction and you will find Anzegem Communal Cemetery at the end of the road. The cemetery contains one WW I grave, which is located in the middle of the cemetery. There are also 18 WWII graves, located to the right of the main entrance against the boundary hedge.

IDENTIFIED COMMONWEALTH HEROES

 1

BISSEGEM COMMUNAL CEMETERY

— BISSEGEM (KORTRIJK)

Bissegem is part of Kortrijk, and is located appr. 2 km west of that city, and also 26 km east of Ypres. From Ypres town centre take the N8 Meenseweg, a road connecting Ypres to Menen and onto Bissegem. 500 m after crossing the Kortrijk ring road (R8), take the right hand turning from the N8 onto Driekerkenstraat. The cemetery lies 1 km after this right hand turning, on the left hand side of Driekerkenstraat on the junction with Kerkvoetweg.

IDENTIFIED COMMONWEALTH HEROES

 25

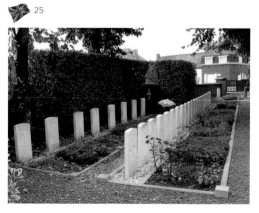

BLANKENBERGE TOWN CEMETERY

— BLANKENBERGE

The village of Blankenberge is situated on the Belgian coast, 4 km west of Zeebrugge and 20 km east of Ostend. The N34 runs from Zeebrugge to Ostend via Blankenberge. From Zeebrugge or Ostend Koning Albertlaan (N34) leads directly to the central town square. The cemetery itself is located via Kerkstraat (N371), then right onto Zuidlaan for 500 m, finally turning left along Landdijk for 100 m to the cemetery itself. Attention: Blankenberge Town Cemetery is not an open site and access is limited by normal opening hours.

IDENTIFIED COMMONWEALTH HEROES

 10

GRAVES OF INTEREST (P. 237)
Bradford, VC.

BREDENE CHURCHYARD

— **BREDENE**

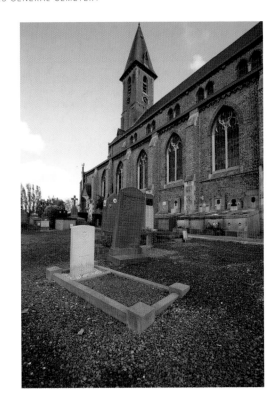

Bredene is located appr. 7 km east of Ostend. You can reach the village by taking the N316 (Sluizenstraat), a road leading from the N9 connecting Ostend to Bruges. From Ostend the N9 leads from Sas Slijkens for 3 km to the left hand junction with the N316 Sluizenstraat. The village of Bredene lies 2 km further. The communal churchyard is located on the Dorpstraat which in fact is a continuation of Sluizenstraat in the village itself. Bredene Churchyard contains 1 Commonwealth burial of the First World War, and 12 of the Second World War. Attention: the churchyard is not an open site and access is limited by normal cemetery hours.

IDENTIFIED COMMONWEALTH HEROES

 1

BRUGES GENERAL CEMETERY

— **BRUGES**

Bruges General Cemetery is located in the south east district of Bruges. The N50 leads from the R30 Bruges ring road, in the direction of Oostkamp. 2 km along the N50 (Baron Rusettelaan) you take the left hand turning onto Brugs-Kerkhofstraat. The cemetery is located at the end of this street.

IDENTIFIED COMMONWEALTH HEROES

 1

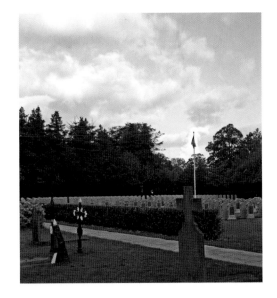

DOMEIN WESTHOEK

Domein Westhoek is ideally located at 700 m from the beach at Oostduinkerke. The beautiful yacht harbour of Nieuwpoort and all the World War One points of interest in Nieuwpoort and Diksmuide are closeby. Oostduinkerke is also very close to Ostend (30 km), Ypres (35 km), Bruges (40 km), Calais (70 km) and Ghent (80 km).

Domein Westhoek boasts 91 rooms with bathroom, telephone and television. Westhoek Club offers you 36 apartments (standard, luxury and prestige) for four people, with 2 bedrooms, living-room with television, kitchen, shower, and terrace with garden furniture.

Half board and full board stays are possible, both in the rooms and apartments. Enjoy your meal in our cosy bistro or classy restaurant, from a fine snack in the afternoon to a gastronomic dish in the evening. Special conditions for large groups.

DOMEIN WESTHOEK VZW

Centrum voor sociaal toerisme
Noordzeedreef 6-8 - 8670 Oostduinkerke
Tel: +32 (0) 58 22 41 00
Fax: +32 (0) 58 22 41 99
E-mail: sales@domein-westhoek.be
 www.domein-westhoek.be

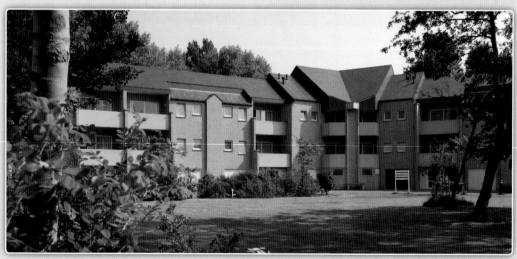

COXYDE MILITARY CEMETERY
— KOKSIJDE

Coxyde Military Cemetery is located appr. 500 m beyond the village of Koksijde on the N396 in the direction of De Panne. From the village of Koksijde the Houtsaegerlaan (N396) crosses the Zeelaan and at the same time changes its name to Robert Vandammestraat. You will find Coxyde Military Cemetery 1 km along this Robert Vandammestraat (N369), on your right hand side.

IDENTIFIED COMMONWEALTH HEROES

 1426 30 20 20 2

GRAVES OF INTEREST (P. 238)

McKenzie, III J 10.

Hulme, IV C 2.

Harwood Moore, IV D 26.

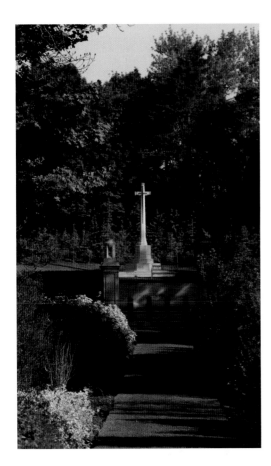

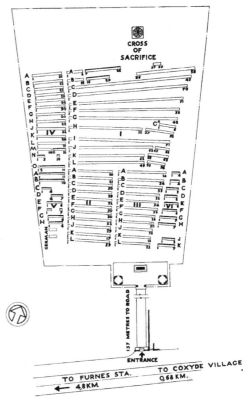

DADIZELE COMMUNAL CEMETERY

— DADIZELE (MOORSLEDE)

Dadizele Communal Cemetery is located 16 km east of Ypres town centre on a road leading from the N8 Meenseweg, connecting Ypres to Menen via Geluwe. 12 km along the N8 lies the village of Geluwe and the left hand turning onto Nieuwstraat (later called Derde Lansiersstraat, towards Dadizele). 5 km along this road lies the village of Dadizele. The cemetery is located on the junction with Geluwestraat and Beselarestraat in the village of Dadizele.

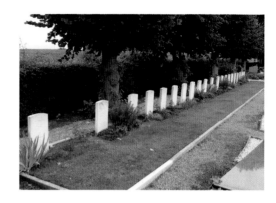

IDENTIFIED COMMONWEALTH HEROES

 26

DADIZEELE NEW BRITISH CEMETERY

— DADIZELE (MOORSLEDE)

Dadizele New British Cemetery is located in the village of Dadizele (for the road to this village, see Dadizele Communal Cemetery), 100 m after the left hand turning with Geluwestraat and Beselarestraat.

IDENTIFIED COMMONWEALTH HEROES

 852 19

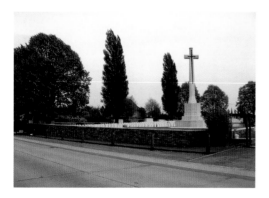

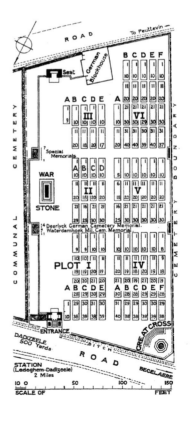

DE PANNE
COMMUNAL CEMETERY

— DE PANNE

De Panne Communal Cemetery is located 6 km west of Veurne on the N34 Kerkstraat, a road leading from the N35 Pannestraat connecting Veurne to De Panne. From Veurne the N35 leads for 6 km to the coastal village of De Panne. On reaching the village of De Panne the N35 meets the N34 towards Adinkerke. 2 km along the N34 lies the Communal Cemetery of De Panne.

IDENTIFIED COMMONWEALTH HEROES

 1

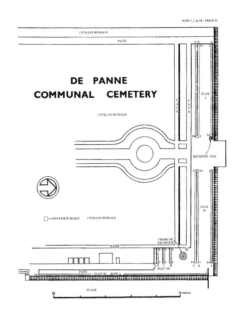

HARLEBEKE NEW BRITISH CEMETERY

— HARELBEKE

Harelbeke is located 32 km east of Ypres. From Ypres, take the N8 (Ypres-Menen road) in the direction of Kortrijk passing through Menen and Wevelgem. 1.5 km past Wevelgem take the A17 road for 4 km until it meets the E17. Then take this road in the direction of Ghent. Continue for 12 km and take the junction for the N36 Deerlijk-Vichte towards Harelbeke. After approx. 3 km, take the exit N43 Kortrijk-Ghent. Turn left here towards Kortrijk and take a left turn onto Deerlijksestraat. Harlebeke New British Cemetery is a further 250 m on your left hand side.

IDENTIFIED COMMONWEALTH HEROES

 883 29 7 4 2

GRAVES OF INTEREST (P. 241)

Hutchins, II C 16.

Garrett, Mem. 20.

Holebrook, V C 11.

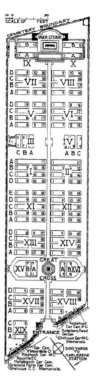

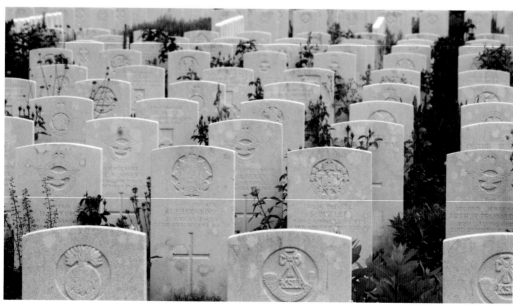

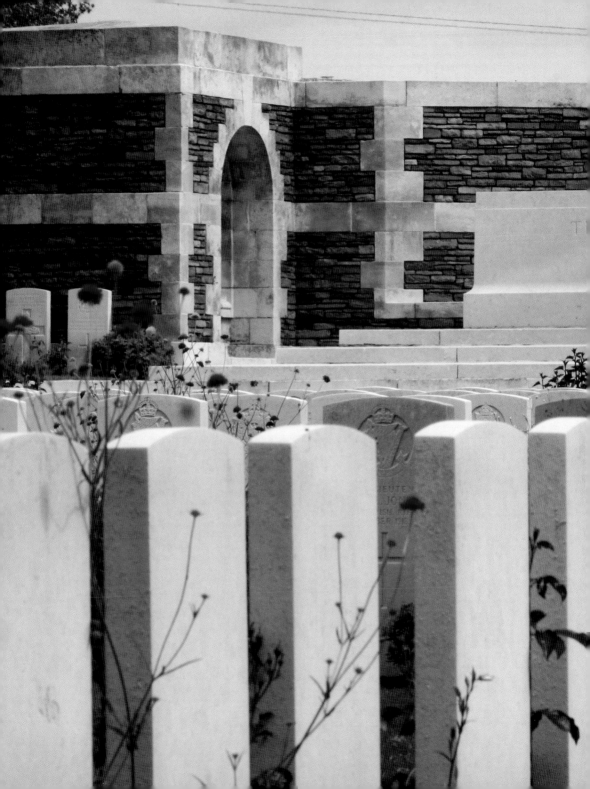

HEESTERT MILITARY CEMETERY

— HEESTERT (ZWEVEGEM)

Heestert is part of Zwevegem. The location of Zwevegem is about 5 km south east of Kortrijk, Heestert itself located appr. 5 km southeast of the centre of Zwevegem. From the E17 motorway take junction 3 (Kortrijk-Oost) and drive onto the N8 towards Zwevegem. Continue along this road through Zwevegem and into Heestert. Once into the village take the third road to the right, go past the church and you will find the cemetery on your left hand side. 57 German soldiers are also buried in this cemetery.

IDENTIFIED COMMONWEALTH HEROES

101

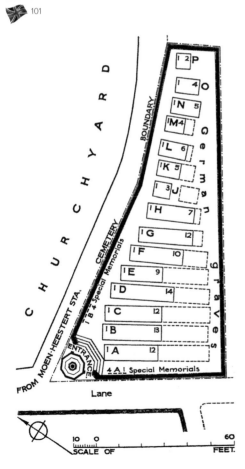

HELKIJN (HELCHIN) CHURCHYARD

— HELKIJN (SPIERE-HELKIJN)

The village of Helkijn, now part of Spiere-Helkijn, is located south of the town of Kortrijk off the N50 which runs between Kortrijk and Pecq. Driving from Kortrijk follow the N50 until you come to the junction with the N512, turn left here and head for Spiere. In the village you come to a T junction; turn left onto Oudenaardseweg and follow this road to Helkijn. In the village there is a junction of four roads. Turn right into Kerkstraat. The church is at the end of the road. The First World War graves are directly in front of the entrance.

IDENTIFIED COMMONWEALTH HEROES

3

HOOGSTADE
BELGIAN MILITARY CEMETERY
— HOOGSTADE (ALVERINGEM)

The village of Hoogstade is located south of the town of Veurne on the N8, which runs between Veurne and Ypres. Driving north from Ypres pass the cross-roads for the junction with the N364 and Hoogstade is the next village. Take the first turning on the left into Brouwerijstraat, and you will find the cemetery on your left.

IDENTIFIED COMMONWEALTH HEROES

 20

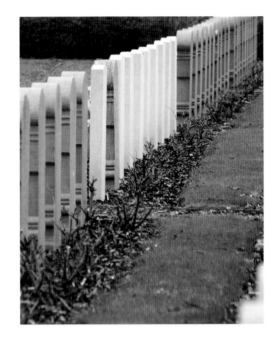

'So here, while the mad guns curse overhead,
and tired men sigh, with mud for couch
and floor, know that we fools, now with
the foolish dead, died not for Flag,
nor King, nor Emperor, but for a dream born
in a herdman's shed, and for the sacred
scripture of the poor.'

Tom Kettle,
9th Royal Dublin Fusiliers

HOUTAVE CHURCHYARD

— HOUTAVE (ZUIENKERKE)

The village of Houtave is part of Zuienkerke and is located west of the city of Bruges (Brugge) on the N9 which runs between Bruges and Ostend. Driving from Bruges follow the N9 to the village of Houtave. On entering the village take the first turning left called Kapellestraat. Then take the first turning left into Pastoriestraat. The church is at the end of this street.

IDENTIFIED COMMONWEALTH HEROES

 1

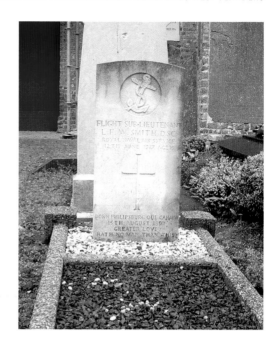

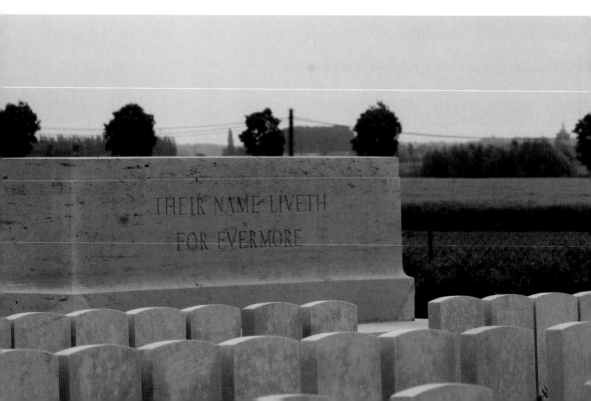

HULSTE COMMUNAL CEMETERY

— HULSTE (HARELBEKE)

The village of Hulste is part of Harelbeke and is located north of the town of Kortrijk off the N50 which runs between Kortrijk and Brugge (Bruges). Driving out of Kortrijk go past the junction with the N36 and take the next turning on the right called Brugsestraat. This then becomes Hulstedorp. Follow this road into the village centre and turn left into Kapelstraat; this is a short street which leads into Tieltsestraat. As you enter Tieltsestraat the cemetery is on the right behind the houses. The Commonwealth burial of the First World War is located in the front left hand side of the cemetery.

IDENTIFIED COMMONWEALTH HEROES

 1

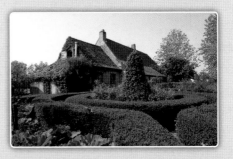

INGOYGHEM MILITARY CEMETERY

— INGOOIGEM (ANZEGEM)

Ingooigem is part of Anzegem and is located approx. 14 km east of Kortrijk. A lot of streets in Belgium are named after writer Stijn Streuvels and priest/poet Hugo Verriest. Both lived in Ingooigem; the local churchyard contains their graves. Ingoyghem Military Cemetery is located in the fields in the north east side of the village, on a track which leaves the Ronse (Renaix) road near the church.

IDENTIFIED COMMONWEALTH HEROES

 54 3

KEZELBERG MILITARY CEMETERY

— WEVELGEM

Wevelgem is a town about 5 km west of Kortrijk. Kezelberg Military Cemetery is located 19 km east of Ypres. In Ypres, take the N8 road. On reaching the town of Menen take the left turn onto Bruggestraat (N32) in the direction of Roeselare. After 3 km take a right turn onto Ieperstraat, 400 m further there is a right turn onto Korteweg. You will find Kezelberg Military Cemetery along this Korteweg on the left hand side.

IDENTIFIED COMMONWEALTH HEROES

 145 1

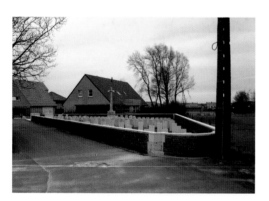
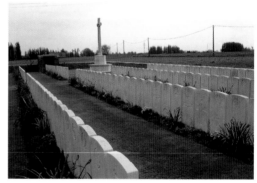
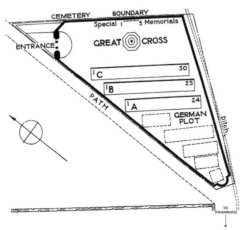
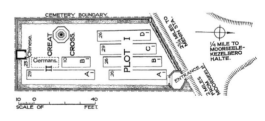

KOOIGEM CHURCHYARD
— KOOIGEM (KORTRIJK)

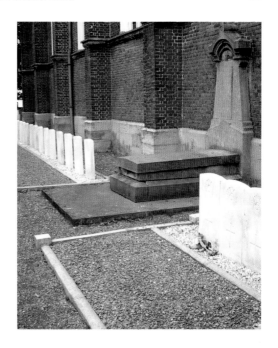

The village of Kooigem is part of Kortrijk. It is located 10 km south of the town of Kortrijk on the N50 which runs between Kortrijk and Pecq. Driving from Kortrijk enter the village and take the turning on the left called Koninklijkestraat. The church is at the end of this street. The Commonwealth plot is on the right hand side of the church.

IDENTIFIED COMMONWEALTH HEROES

 17

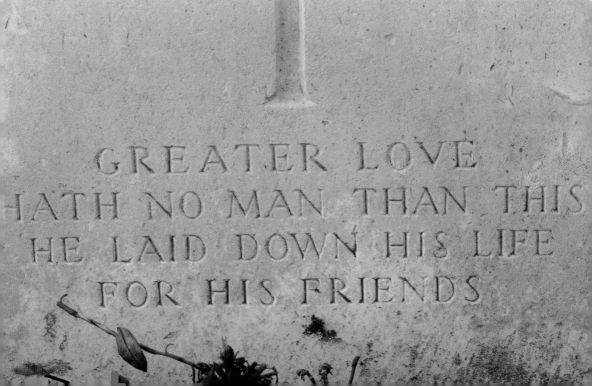

KORTRIJK (ST. JAN) COMMUNAL CEMETERY

— KORTRIJK

Kortrijk (St. Jan) Communal Cemetery is located 28 km east of Ypres town centre on the N8 Meenseweg. From Ypres, Kortrijk is reached via the N8 Meenseweg, which is a continuous road running from Ypres to Kortrijk via Menen and Wevelgem. On reaching the town of Kortrijk the N8 crosses the R8 ring road. 2 km beyond this landmark lies the cemetery on the left hand side of the road.

IDENTIFIED COMMONWEALTH HEROES

 190 11 1 3 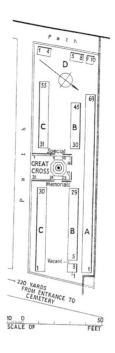 5

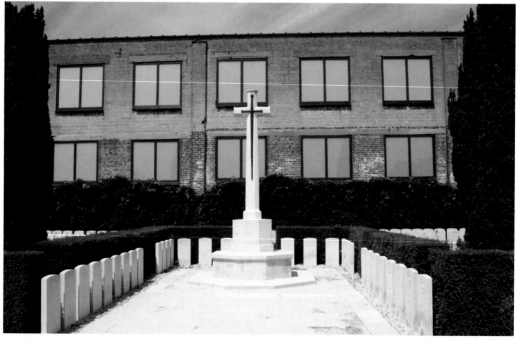

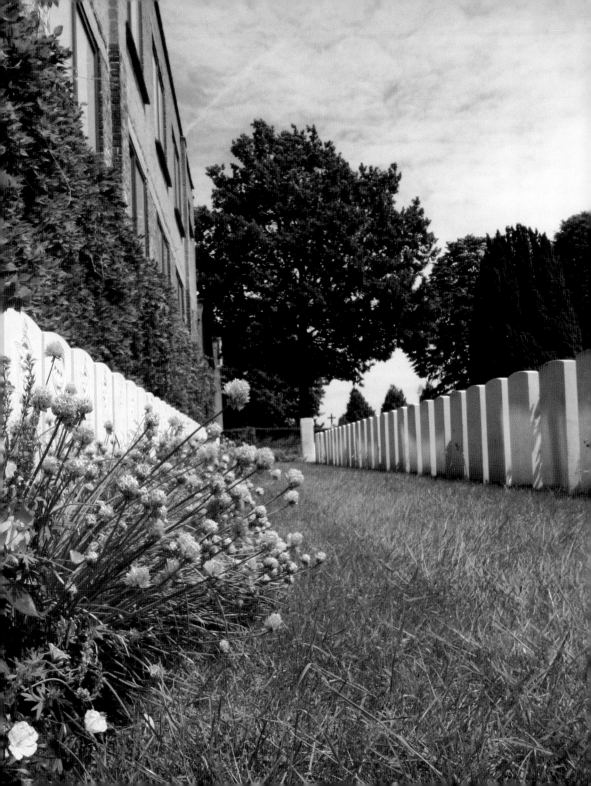

LEDEGHEM MILITARY CEMETERY

— LEDEGEM

Ledegem is located appr. 15 km east of Ypres. Take
the N8 towards Menen. Upon reaching Menen take
a left turn onto Bruggestraat (N32, direction Roese-
lare). After 5 km turn right into Papestraat which
goes to Ledegem. Upon reaching the village of Lede-
gem, the first right hand turn along the Sint-Eloois-
Winkelstraat leads onto Hugo Verriestlaan. You can
reach the cemetery by a short path off this road.

IDENTIFIED COMMONWEALTH HEROES

 68

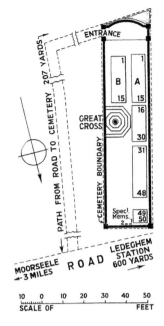

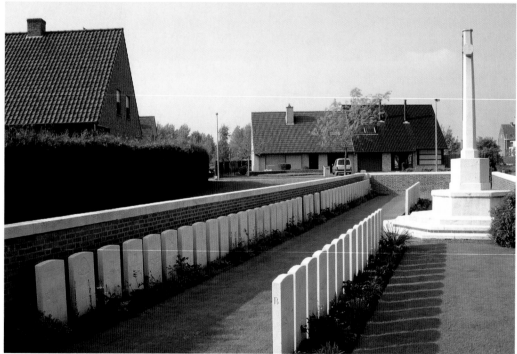

MARKE COMMUNAL CEMETERY

— MARKE (KORTRIJK)

The village of Marke is located south west of the town of Kortrijk (Courtrai) on the N43 which runs between Kortrijk and Aalbeke. From junction 12 of the R8 take the N43 direction Aalbeke, and take the major road turning on the right called Hellestraat. Follow this road and then take the third turning on the right called Spinnerstraat. Marke Communal Cemetery is on your left hand side. Enter the cemetery at the main entrance. Walk from the gate to the main central path and turn right. The Commonwealth grave is located about 75 m along this path on the left.

IDENTIFIED COMMONWEALTH HEROES

 1

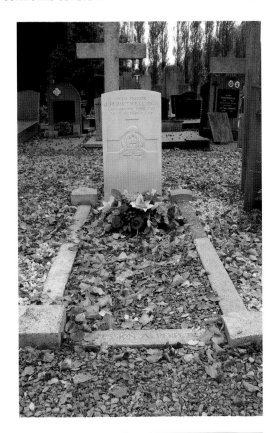

MENEN COMMUNAL CEMETERY

— MENEN

Menen Communal Cemetery is located 18 km east of Ypres town centre on the N8, a continuous road from Ypres to Menen, via the village of Geluveld. On reaching the town of Menen the cemetery is located immediately after the left hand turning into Zandputstraat. The Commonwealth War Graves Commission plot is located centrally in the cemetery.

IDENTIFIED COMMONWEALTH HEROES

 8 4

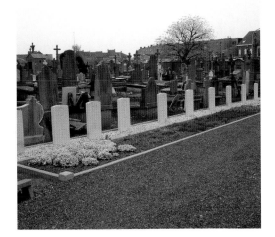

MOORSEELE MILITARY CEMETERY

— MOORSEELE (WEVELGEM)

Moorseele Military Cemetery is located 20 kms east of Ypres town centre on a road leading from the N8, connecting Ypres to Menen and onto Wevelgem. On reaching Wevelgem the left hand turning onto Lode de Boningestraat leads onto the Roeselarestraat and on for 3.5 kms to Moorseele. On reaching Moorseele the cemetery is to be accessed by entering a small housing estate called Minister de Taeyelaan, situated off Secretaris Vanmarckelaan.

IDENTIFIED COMMONWEALTH HEROES

 88 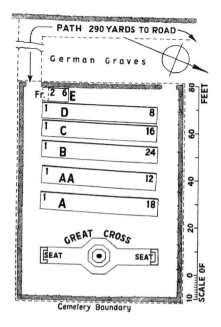 8

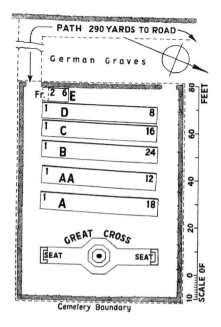

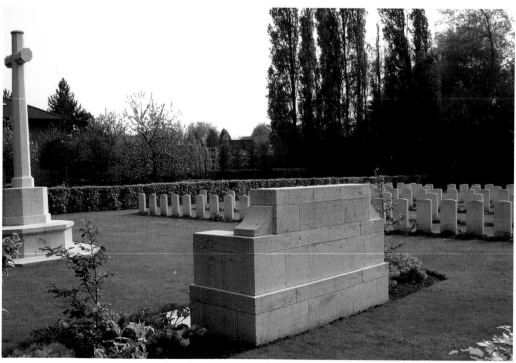

MOORSLEDE
COMMUNAL CEMETERY

— MOORSLEDE

The village of Moorslede is located north east of the town of Ypres off the N313 which runs between Ypres and Roeselare. Driving from Ypres follow the

N313 through Langemark-Poelkapelle to Westrozebeke. In Westrozebeke you come to the junction with the N303 to Passendale. Turn right here and follow this road to Passendale and into the town centre. From the centre take Statiestraat, a turning on the left to Moorslede. You come into Moorslede on Stationstraat and come to a crossroads, go straight on into Roeselarestraat. At the end of this street go right into Nieuwstraat, at the crossroads turn right into Pater Lievensstraat. The cemetery is on your left hand side, immediately after the junction. The graves are located on the right hand side in the centre. From the entrance walk up the centre path to the first roundabout and take the path to the right. Walk to the end of the path and turn right again down the small path where you will find the two graves on your left hand side.

IDENTIFIED COMMONWEALTH HEROES

 2

*'I wish the sea were not so wide
that parts me from my love,
I wish that things men do below
were known to God above. I wish that
I were back again in the Glens of Donegal;
they'll call me coward if I return,
but a hero if I fall.'*

Patrick MacGill,
London Irish Rifles

NIEUWPOORT
COMMUNAL CEMETERY

— NIEUWPOORT

Nieuwpoort Communal Cemetery is located in the town of Nieuwpoort, which is 20 km south west of Ostend. From Ostend, the N34 carries on to the N367 immediately after the King Albert Monument and the Achterhaven. 2 kms along the N367 Brugse-steenweg lies Nieuwpoort Communal Cemetery, on the right hand side of the road.

IDENTIFIED COMMONWEALTH HEROES

 65 2

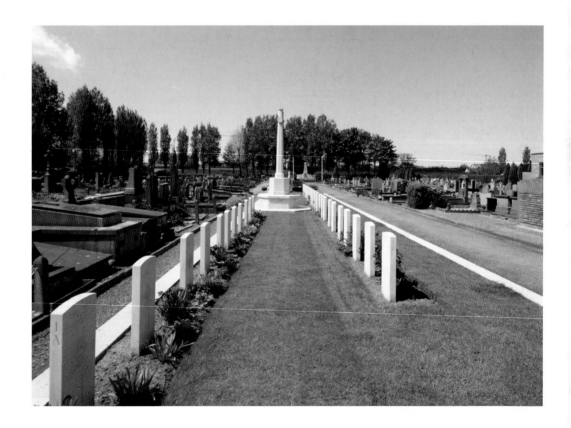

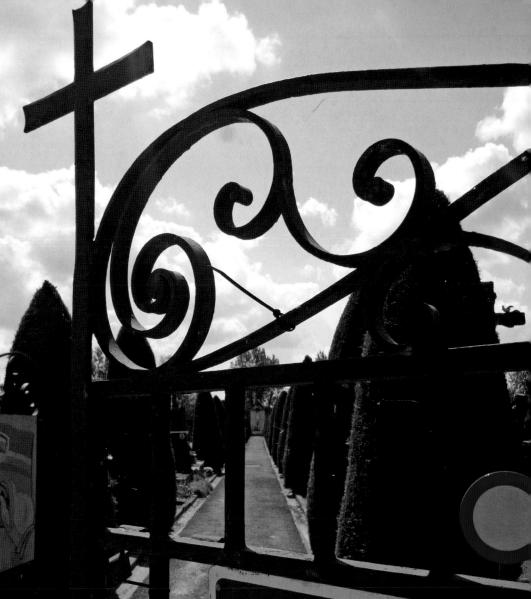

HOTEL BERO

Welcome to your cosy 'home port' in the heart of Ostend. Hotel Bero**** is the most environmentally friendly hotel of the city and offers something for everybody. Our guests have free access to our leisure centre 'Ninfea' with indoor swimming pool, sauna, bio sauna, steam bath, infra-red beamers and gym. There is also free highspeed wifi in the entire hotel. Children can play in our fun indoor playground and adults can go 24/7 for a drink in our cosy bar with Whisky Lounge.

Hotel Bero is centrally located, just a few steps away from the beach; the traffic free shopping streets, and many nice restaurants and pubs. Hotel Bero is also close to Bruges (25 km) and the battlefields and cemeteries of the Great War.

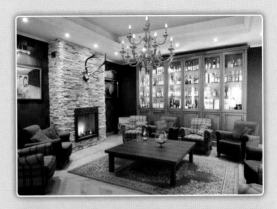

HOTEL BERO

Hofstraat 1A - 8400 Ostend
Tel: +32 (0) 59 70 23 35
Fax: +32 (0) 59 70 25 91
E-mail: info@hotelbero.be
 www.hotelbero.be

OOSTENDE
NEW COMMUNAL CEMETERY

— OOSTENDE

Oostende New Communal Cemetery is located in the town of Ostend on the Stuiverstraat, a road leading from the R31 Elisabethlaan. Travelling towards Brussels on the R31 the Stuiverstraat is located 500 m after the junction with the N33. Oostende New Communal Cemetery is located 800 m along the Stuiverstraat on the right hand side of the road.

IDENTIFIED COMMONWEALTH HEROES

 43

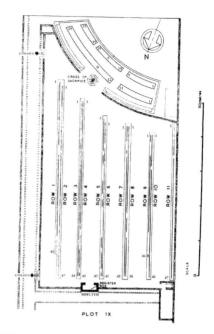

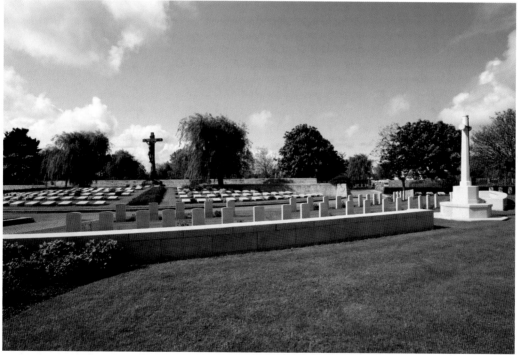

OOSTROZEBEKE COMMUNAL CEMETERY

— OOSTROZEBEKE

The village of Oostrozebeke is located east of Ingelmunster off the N357 which runs between the towns or Roeselare (Roulers) and Waregem. Driving from

Ingelmunster enter the village of Oostrozebeke and after passing through the centre of the village and past the church take the fourth left into Veldstraat. Take the first left which then bends to the right. At the next junction turn left into Lindestraat. At the T junction turn left into Kalbergstraat. The cemetery is appr. 150 m from the junction and is accessed via a narrow lane that passes between two houses. The entrance is between numbers 5 & 7. On entering take the first path to the right; the war graves are on the left of this path.

IDENTIFIED COMMONWEALTH HEROES

 2

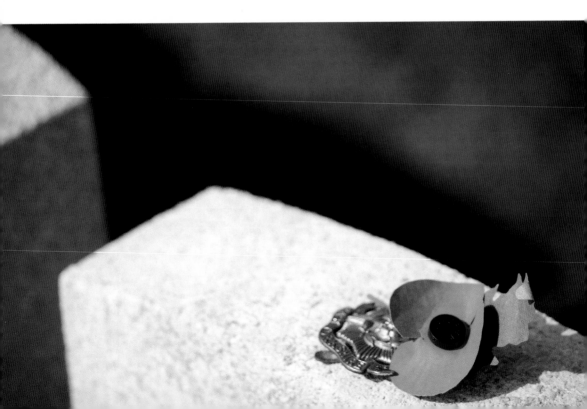

OUTRIJVE CHURCHYARD
— OUTRIJVE (AVELGEM)

Outrijve Churchyard is located 40 kms east of Ypres town centre on a road leading from the N8 Meenseweg, connecting Ypres to Avelgem, via Menen (Menin), Wevelgem, Kortrijk, and Zwevegem.

On reaching the village of Avelgem the right hand turning onto the N353 leads for 3 km to the village of Outrijve. The village is approached along the N353 Doorniksesteenweg, which continues to the village square. The churchyard itself is located just beyond the church on the Sint-Pietersstraat.

IDENTIFIED COMMONWEALTH HEROES
 13

RAMSCAPPELLE ROAD MILITARY CEMETERY

— NIEUWPOORT

Ramscappelle Road Military Cemetery is located 2 km east of Nieuwpoort on the N367, which leads from Nieuwpoort to Sint-Joris. Nieuwpoort itself is located appr. 15 km west of Ostend, not far from the Belgian coast. From Nieuwpoort town centre the Willem Deroolaan leads for 500 metres onto the N367 Brugsesteenweg. The cemetery lies 1 km £along the N367 on the junction with the N356 Ramskapellestraat.

IDENTIFIED COMMONWEALTH HEROES

 518 2 8 1

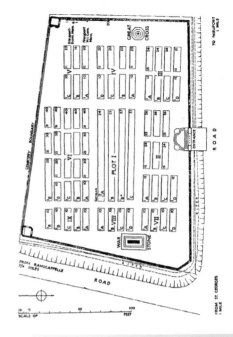

HOTEL RESTAURANT DE VREDE

Fancy a nice excursion or sampling some culinary delights in charming surroundings? Then book a stay at hotel-restaurant De Vrede (in English: 'Peace') at the lovely market place of Diksmuide (Dixmude).
Dixmude was an important city in the history of the Great War; here you can visit a.o. the impressive Yser Tower and the 'Trench of Death', symbol of the fierce resistance by Belgian troops during WW I.

The many cycling and rambling routes around the area will take you to some of the nicest places you can imagine. At De Vrede you'll find comfortable rooms, as well as an attractive restaurant, pleasant bistro and covered terrace.

New B & B 't Withuis at Grote Markt 33, see www.withuisdiksmuide.be
Also Pax Hotel at Dixmude belongs to this group, call Hotel De Vrede for more info.

DE VREDE

Grote Markt 35 - 8600 Diksmuide
Tel: +32 (0) 51 50 00 38
Fax: +32 (0) 51 51 06 21
E-mail: de.vrede@skynet.be
 www.hoteldevrede.be

ROESELARE
COMMUNAL CEMETERY

— ROESELARE

Roeselare Communal Cemetery is located 20 km north-east of Ypres town centre via the villages of Zonnebeke and Moorslede (N332). Roeselare is approached via the Iepersestraat and crosses the R32 Roeselare ring road. Before reaching the town centre turn left into Molenstraat, then take the second right onto Kermisstraat followed by the first left into Blekerijstraat. The cemetery entrance is on the left opposite Arme-Klarenstraat.

IDENTIFIED COMMONWEALTH HEROES

 58 25

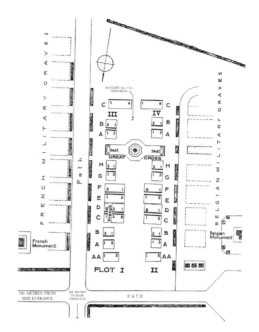

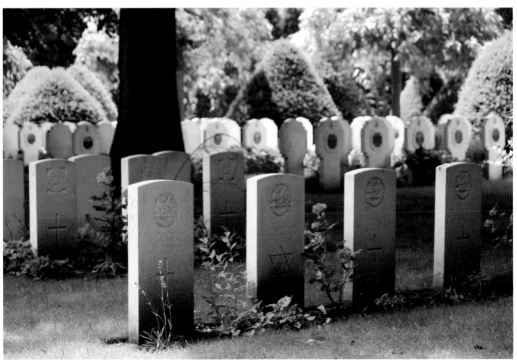

RUDDERVOORDE COMMUNAL CEMETERY

— OOSTKAMP

The town of Oostkamp is located appr. 10 km south of Bruges. Ruddervoorde is part of Oostkamp and is located appr. 20 km south of Bruges, on the N50 which runs between Bruges and Courtrai (Kortrijk). Driving from Bruges follow the N50 under the E40 motorway and through the village of Oostkamp, then through the village of Waardamme. You then pass an old castle on the left. Take the next turning right at the crossroads to Ruddervoorde. Then turn right onto the N368, Sint-Elooisstraat. Follow this road into the village to the church, which is on the left. You can also reach Ruddervoorde from the A17 motorway which also runs between Bruges and Courtrai. Take junction 11, the N368 towards Ruddervoorde. Drive into the village to the church which is on your right hand side. On arriving at the church, drive into the car park which is directly opposite. Continue to the rear of the car park where there is a narrow lane to the right that leads to the cemetery. On entering the cemetery walk around the small chapel, then turn right up the centre path. The four war graves are on the left hand side of the path close to the old entrance in plot no. 15.

IDENTIFIED COMMONWEALTH HEROES

 4

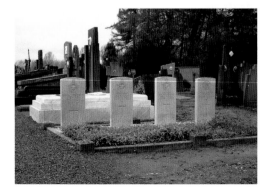

SLYPSKAPELLE PLOT OF HONOUR

— MOORSLEDE

Moorslede is located appr. 10 km east of Ypres town centre. The village of Slypskapelle is situated to the north of Dadizele off the N32. From the motorway A19 which runs between Ypres and Courtrai, turn off at junction 2 onto the N32 in the direction of Roeselare. Follow the N32 through Dadizele and just past the town of Dadizele follow the left hand turn to Slypskapelle. The Plot of Honour is situated on Dorpsplein (central square) of Slypskapelle, left of the church.

IDENTIFIED COMMONWEALTH HEROES

 1

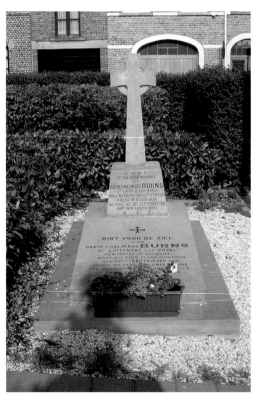

SPIERE (ESPIERRES) CHURCHYARD

— **SPIERE-HELKIJN (ESPIERRES-HELCHIN)**

The village of Spiere-Helkijn (Espierres-Helchin) is located 12 km south of Kortrijk (Courtrai) off the N50 which runs between Kortrijk and Pecq. Driving from Kortrijk follow the N50 until you come to the junction with the N512. Turn left here and head for Spiere-Helkijn. The church is in the middle of the village next to the square. At the start of the square turn right into Robecijnplein and follow the road to the church. Enter the churchyard up the steps and at the top turn left where the nine war graves will be found to the left of the church.

IDENTIFIED COMMONWEALTH HEROES

 9

STALHILLE CHURCHYARD

— **STALHILLE (JABBEKE)**

Jabbeke is located between Bruges and Ostend. The village of Stalhille is located west of the town of Bruges (Brugge), off the N9 which runs between Bruges and Ostend. Driving from Bruges follow the N9 through the village of Houtave to the junction with the N377. Turn left here direction Jabbeke. Take the second turning on the right called Spanjaardstraat, go to the end and turn right there. The church entrance is 20 m from the junction. The two First World War graves are located half way between the church and the churchyard boundary.

IDENTIFIED COMMONWEALTH HEROES

 1 1

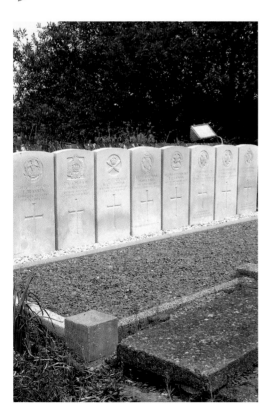

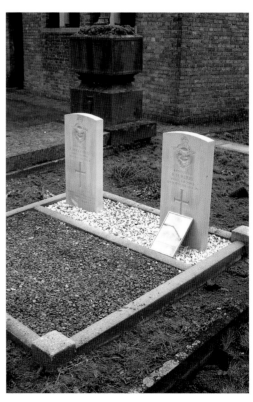

STASEGEM COMMUNAL CEMETERY

— STASEGEM (HARELBEKE)

Stasegem Communal Cemetery is located 36 km east of Ypres town centre and 4 km east of Courtrai town centre on a road leading from the N8 Meenseweg. From Ypres the N8 passes through Menen, Wevelgem and Courtrai (Kortrijk). The N8 continues towards Zwevegem on the Kortrijkstraat. On reaching Zwevegem the left hand turning at the village square leads onto Harelbekestraat. The road name then changes to Beneluxlaan and after passing under the E17 reaches Stasegem. The cemetery itself is located after turning left at the T junction at the end of the Beneluxlaan onto the Steenbrugstraat. 1 km along this road lies the right hand turning onto Groendreef. Stasegem Communal Cemetery is located 50 m along this lane on the left hand side of the lane.

IDENTIFIED COMMONWEALTH HEROES
 21

ST. BAAFS-VIJVE CHURCHYARD

— ST. BAAFS-VIJVE (WIELSBEKE)

The village of Wielsbeke is located 5 km east of Ingelmunster (Ingelmunster is 10 km north of Kortrijk/Courtrai). The village of St. Baafs-Vijve (formerly Vive-St. Bavon) is located east of the town of Ingelmunster off the N357 which runs between Ingelmunster and Waregem. Driving from Ingelmunster go through the village of Oostrozebeke and follow the N357 through Wielsbeke. You then go round a sharp left hand bend and a bit further on a right hand bend, past the right hand bend is St. Baafs-Vijve. Take the second turning right in the village called Vlasstraat. The church is on your right hand side.

IDENTIFIED COMMONWEALTH HEROES
 1

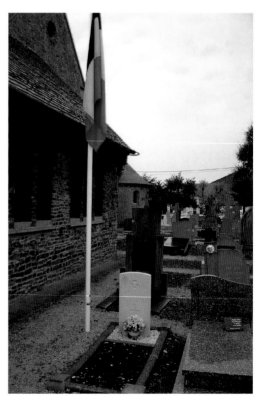

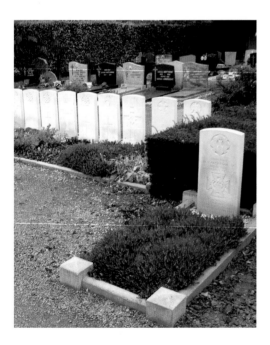

STEENKERKE
BELGIAN MILITARY CEMETERY

— STEENKERKE (VEURNE)

IDENTIFIED COMMONWEALTH HEROES

 30

The village of Steenkerke is located south of the town of Veurne off the N8 which runs between Veurne and Ypres. Veurne is located appr. 25 km east of Dunkirk (France), and 65 km east of Calais. Driving from Veurne take the first turning left after the motorway which is called Steengracht West. Follow this road into the village and at the first junction turn left into Steenkerkestraat. Then take the first turning right to the church. The cemetery is located behind the church, and the Commonwealth graves are located in rows A, B and C at the right hand side in the centre of the cemetery.

SAT NAV

See **www.poigraves.co.uk** for the exact location of all Commonwealth cemeteries of World War I.

www.inmemories.com is dedicated to the continued memory of those men and women of the Commonwealth who died as a result of the World Wars.

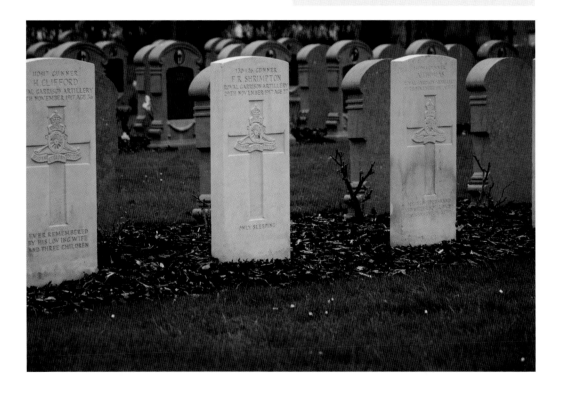

VEURNE COMMUNAL CEMETERY

— VEURNE

Veurne Communal Cemetery is located in the north-east district of the town of Veurne, which is located appr. 25 km east of Dunkirk (France). From the Grote Markt at Veurne the Ooststraat leads for 500 m to the left hand turning onto Oude Vestingstraat. The cemetery is located 500 m along Oude Vestingstraat on the right hand side of the road.

IDENTIFIED COMMONWEALTH HEROES

 1

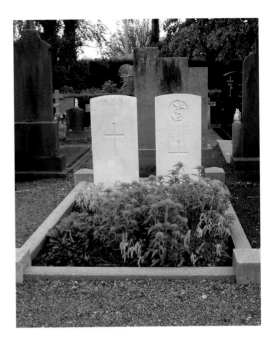

VICHTE MILITARY CEMETERY

— VICHTE (ANZEGEM)

Vichte Military Cemetery is located 40 km east of Ypres town centre and 13 km east of Courtrai. From the E17 (Courtrai-Ghent) motorway, turn off at junction 4 onto the N36 towards Vichte. The village of Vichte is located 6 km along the N36. At the traffic lights in the village turn right into Beukenhofstraat, then take the second right hand turning into Lendedreef, and the first left into Elf Novemberlaan. The cemetery is located on the left hand side of Elf Novemberlaan.

IDENTIFIED COMMONWEALTH HEROES

 169 8

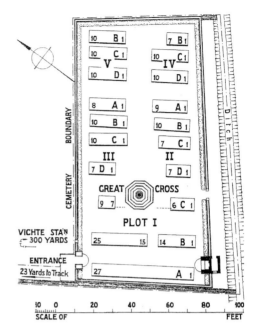

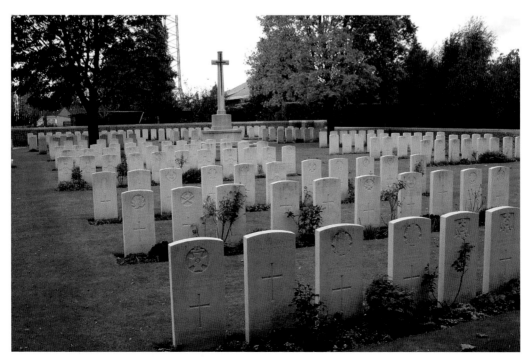

WEVELGEM COMMUNAL CEMETERY

— WEVELGEM

Wevelgem Communal Cemetery is located 22 km east of Ypres town centre on the Meenseweg (N8), connecting Ypres to Menen (Menin), Wevelgem and onto Kortrijk (Courtrai). Wevelgem is approached via the Meenseweg N8. The cemetery itself is located on the junction with the Moorselestraat and is accessed from the N8 Vanackerstraat.

IDENTIFIED COMMONWEALTH HEROES

 3

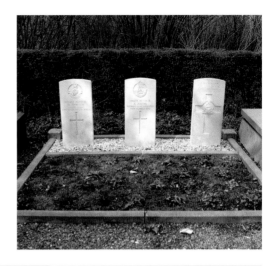

WIELSBEKE COMMUNAL CEMETERY

— WIELSBEKE

The village of Wielsbeke is located east of the town of Ingelmunster off the N357 road which runs between Roeselare (Roulers) and Waregem. Driving from Ingelmunster go through the village of Oostrozebeke and follow the N357 to Wielsbeke. Follow the N357 which becomes Rijksweg straight through the village until it bends sharp left. At the bend turn right into Stationstraat and then immediately left into Dertiende Liniestraat. The cemetery is on the left about 100 m from the junction. To locate the First World War graves, enter the cemetery through the left hand gate and follow the path for approximately 50 metres to where the graves will be found on the left hand side of the path.

IDENTIFIED COMMONWEALTH HEROES

 3

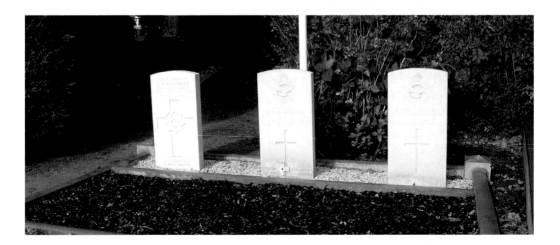

ZEEBRUGGE CHURCHYARD

— ZEEBRUGGE (BRUGGE)

Zeebrugge Churchyard is located in the port town of Zeebrugge itself on the Sint-Donaaskerkstraat. The cemetery is approached via the N34 Kustlaan which passes through the town of Zeebrugge. Having passed the ferry port terminal continue northwards along the N34 (following the route of the tramlines) for 1.5 km. Saint Donaas church is a large red brick building with a slate roof. Having seen the church on the right hand side, turn right of the N34 onto the Sint-Donaaskerkstraat. The CWGC cemetery is at the far right side of the churchyard, surrounded by a red brick wall.

IDENTIFIED COMMONWEALTH HEROES

 13

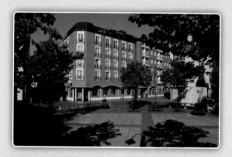

PART 4

BELGIAN CEMETERIES
FIRST WORLD WAR
WEST FLANDERS

ADINKERKE BELGIAN MILITARY CEMETERY

— ADINKERKE (DE PANNE)

The village of Adinkerke is part of De Panne and is located appr. 2 km south of that city. It is also located west of Veurne on the N39. From the roundabout at the junction of the N39 and N34 follow the N34 in the direction of De Panne along Stationstraat.

Follow Stationstraat past the church and then take the first road on your left hand side (Helderweg). The cemetery is at the end of this road behind the church.

IDENTIFIED BELGIAN HEROES

 1651

RAMADA OSTEND HOTEL

Ramada Hotel is located only 250 metres from the sandy beach at Ostend, within a stone's throw of the shopping streets and the Casino. Ostend is also close to Furnes, Diksmuide, and the cemeteries and memorials of Flanders Fields.

Ramada Hotel's 94 comfortable rooms are furnished in cool, calm tones. Each has TV with movie channels, tea & coffee making facilities, and a fully equipped private bathroom with hairdryer.

Enjoy a seasonal menu in our Premtimecafe, or meet up with friends or colleagues in our bar. With its unmatched standard of services and facilities, Ramada Ostend is an ideal venue for leisure and business travel, as well as the perfect setting for conferences.

Our Special Offers are bookable on www.ramada-ostend.com

RAMADA OSTEND HOTEL

Leopold II laan 20 - 8400 Ostend
Tel: +32 (0)59 70 76 63
E-mail: gm@ramada-ostend.com
 www.ramada-ostend.com

BRUGGE BELGIAN MILITARY CEMETERY

— BRUGGE (BRUGES)

Bruges General Cemetery is located in the south east district of that city. The N50 leads from the R30 Bruges ring road, in the direction of Oostkamp. 2 km along the N50 (Baron Ruzettelaan) you take the left hand turning onto Brugs-Kerkhofstraat. The cemetery is located at the end of this street.

IDENTIFIED BELGIAN HEROES

 594

PRO
PATRIA

DE PANNE BELGIAN MILITARY CEMETERY

— DE PANNE

De Panne Belgian Military Cemetery is located 6 km west of Veurne on the N34 Kerkstraat, a road leading from the N35 Pannestraat connecting Veurne to De Panne. From Veurne the N35 leads for 6 kilometres to the coastal village of De Panne. On reaching the village the N35 meets the N34 towards Adinkerke. 2 km along the N34 on the left hand side lies the Communal Cemetery of De Panne. De Panne Belgian Military Cemetery is located at the back of the Communal Cemetery. Both cemeteries are forewarned by a distinct bending of the road immediately prior to reaching them. It should be noted that this cemetery is not an open site and access is limited by normal cemetery hours.

IDENTIFIED BELGIAN HEROES

 2555

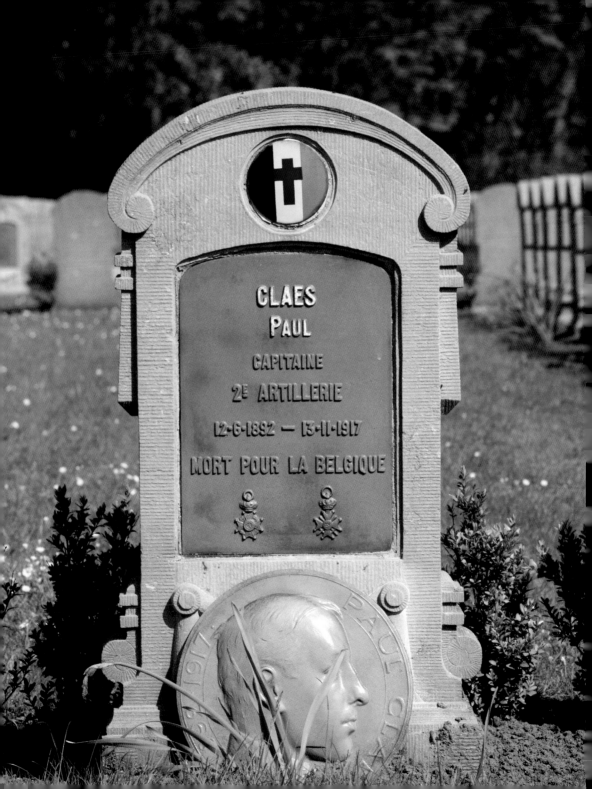

CLAES
PAUL

CAPITAINE

2E ARTILLERIE

12·6·1892 — 13·11·1917

MORT POUR LA BELGIQUE

HOOGSTADE BELGIAN MILITARY CEMETERY

— HOOGSTADE (ALVERINGEM)

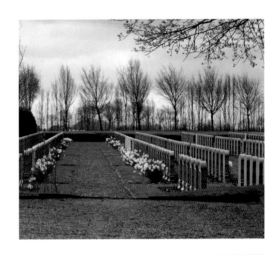

The village of Hoogstade is part of Alveringem. Hoogstade is located south of the town of Veurne on the N8, which runs between Veurne and Ypres. Driving north from Ypres pass the crossroads for the junction with the N364 and Hoogstade is the next village. Take the first turning left into Brouwerijstraat , and you will find the cemetery on your left, close to the church of Hoogstade.

IDENTIFIED BELGIAN HEROES

 788

HOUTHULST BELGIAN MILITARY CEMETERY

— HOUTHULST

Houthulst is located between Diksmuide and Ypres. From Diksmuide the N301 goes to Houthulst. Houthulst Belgian Military Cemetery is located on the Poelkapellestraat, southwards of the centre of the village (about 1,200 metres from the church), close to the forest of Houthulst.

IDENTIFIED BELGIAN HEROES

 1230

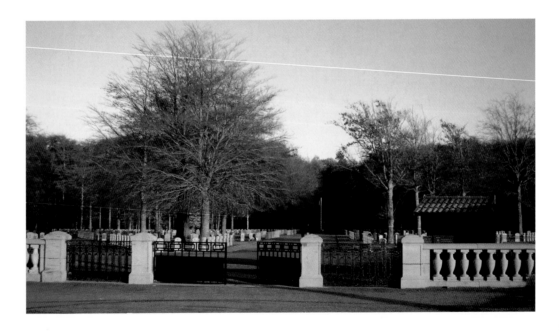

KEIEM BELGIAN MILITARY CEMETERY

— KEIEM (DIKSMUIDE)

Keiem is part of Diksmuide. On the E40 motorway between Bruges and Veurne (Furnes), take exit Middelkerke in the direction of Sint-Pieters-Kapelle (Diksmuidestraat). The road name changes into Oostendestraat. At the crossroads with Kruiskalsijdestraat, take Keiemdorpstraat. Keiem Belgian Military Cemetery is located at nr. 170 Keiemdorpstraat.

IDENTIFIED BELGIAN HEROES:

 225

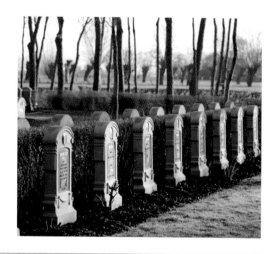

OEREN BELGIAN MILITARY CEMETERY

— OEREN (VEURNE)

Oeren is part of Veurne (Furnes) and is located appr. 3 km south of that city. On the E40 motorway from Bruges to Veurne (Furnes), take the N8 at Veurne in the direction of Ypres (Ieperse Steenweg). After appr. 3 km, take Oerenstraat on your left. The cemetery is located around the church of Oeren.

IDENTIFIED BELGIAN HEROES

 508

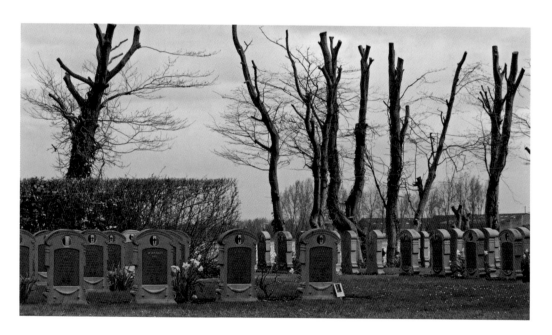

RAMSKAPELLE BELGIAN MILITARY CEMETERY

— RAMSKAPELLE (NIEUWPOORT)

Ramskapelle is part of Nieuwpoort (Nieuport during World War I). The Belgian Military Cemetery of Ramskapelle is located on Ramskapellestraat, about 500 m north of the village of Ramskapelle, also very close to the E40 motorway at Nieuwpoort.

IDENTIFIED BELGIAN HEROES

 232

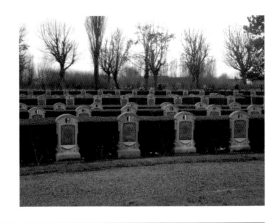

STEENKERKE BELGIAN MILITARY CEMETERY

— STEENKERKE (VEURNE)

Steenkerke is part of Veurne (Furnes). It is located south of the town of Veurne off the N8 which runs between Veurne and Ypres. Veurne is located appr. 25 km east of Dunkirk (France), and 65 km east of Calais. Driving from Veurne take the first turning left after the motorway which is called Steengracht West. Follow this road into the village and at the first junction turn left into Steenkerkestraat. Then take the first turning right to the church. The cemetery is located behind the church.

IDENTIFIED BELGIAN HEROES

 481

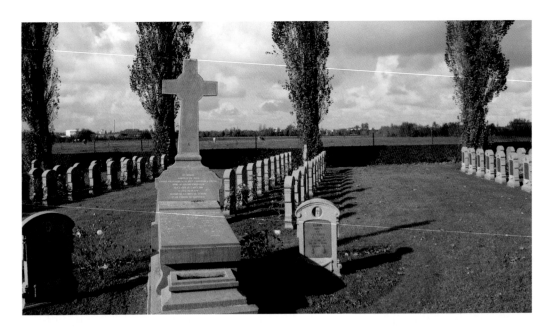

WESTVLETEREN BELGIAN MILITARY CEMETERY

— **VLETEREN**

The village of Vleteren is located appr. 8 km north of Poperinge. Westvleteren is located on the N8 which runs from Ypres to Veurne (Furnes). From Ypres follow the N8 to Oostvleteren, and at the traffic lights turn left on the N321 direction Poperinge. In the village you go around a sharp right hand bend, and just after this bend turn right into Sint-Maartenstraat. Westvleteren Belgian Military Cemetery is on your right hand side.

IDENTIFIED BELGIAN HEROES

 1175

PART 5

GERMAN CEMETERIES FIRST WORLD WAR WEST FLANDERS

HOOGLEDE GERMAN WAR CEMETERY

(HOOGLEDE DEUTSCHER SOLDATENFRIEDHOF)

— **HOOGLEDE**

Hooglede German War Cemetery is located in the town of Hooglede, six km north west of Roeselare. Roeselare is located 20 km north east of Ypres town centre and is reached via the villages of Zonnebeke and Moorslede (N332). In the village of Hooglede, take Beverenstraat to the right. The cemetery is located about 800 m east of St Amandus Church, on Beverenstraat.

LANGEMARK GERMAN WAR CEMETERY

(LANGEMARK DEUTSCHER SOLDATENFRIEDHOF)

— **LANGEMARK (LANGEMARK-POELKAPELLE)**

Langemark is part of Langemark-Poelkapelle and is situated north east of Ypres, off the N313, a road that runs between Ypres and Langemark-Poelkapelle. At Ypres take Boezingestraat, then past the first turning left. From N313 turn off towards Langemark along the Zonnebekestraat (opposite the St. Julian Canadian Memorial). Follow the Zonnebekestraat into the village to the traffic lights, go straight over at the lights into Klerkenstraat, and Langemark German Military Cemetery is on your left hand side.

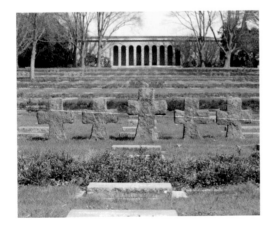

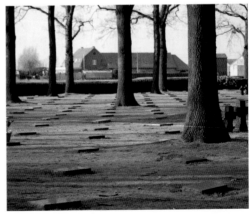

MENEN WALD GERMAN WAR CEMETERY
(MENEN WALD DEUTSCHER SOLDATENFRIEDHOF)

— MENEN

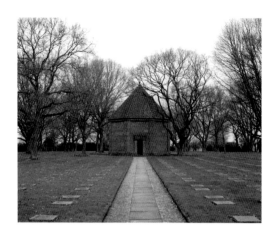

The village of Menen is located 18 km east of Ypres town centre on the N8, a continuous road from Ypres to Menen, via the village of Geluveld. On reaching the town of Menen, the communal cemetery is located immediately after the left hand turning into Zandputstraat. From this communal cemetery, take Moorselestraat and then Kruisstraat to the left. This road changes its name into Groenstraat. Menen Wald German War Cemetery is located on this Groenstraat, at your right hand side.

VLADSLO GERMAN WAR CEMETERY
(VLADSLO DEUTSCHER SOLDATENFRIEDHOF)

— VLADSLO (DIKSMUIDE)

Vladslo is part of Diksmuide (Dixmude). From Ypres take the N369 in the direction of Dixmude. When approaching Dixmude, follow the signs for Vladslo. In the centre of Vladslo, keep following the N369. When arriving in the village of Beerst, turn right (N363). After appr. two km, go left in the direction of Praatbos. You will find Vladslo Deutscher Soldatenfriedhof one km further, on your left hand side.

PART 6 & 7

FRENCH & AMERICAN CEMETERIES FIRST WORLD WAR WEST FLANDERS

SAINT-CHARLES-DE-POTYZE FRENCH CEMETERY

— IEPER

Saint-Charles-de-Potyze French Cemetery is located 3.5 km north east of Ypres town centre on the Zonnebeekseweg. From Ypres market square take Korte and Lange Torhoutstraat onto the small roundabout, then go right into Basculestraat, and at the crossroads turn left into Zonnebeekseweg. The cemetery is 3.5 km on your right hand side.

IDENTIFIED FRENCH HEROES

 3447

FLANDERS FIELD AMERICAN CEMETERY

— WAREGEM

Flanders Field American Cemetery is located on the southeast edge of the town of Waregem, along the Lille-Ghent Motorway E17 (exit 5 Waregem, then Wortegemseweg). The cemetery is within 44 miles of Bruges and 22 miles of Ghent.

IDENTIFIED AMERICAN HEROES

 368

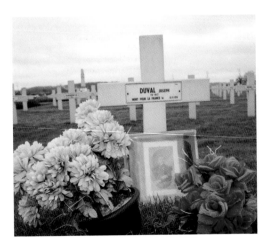